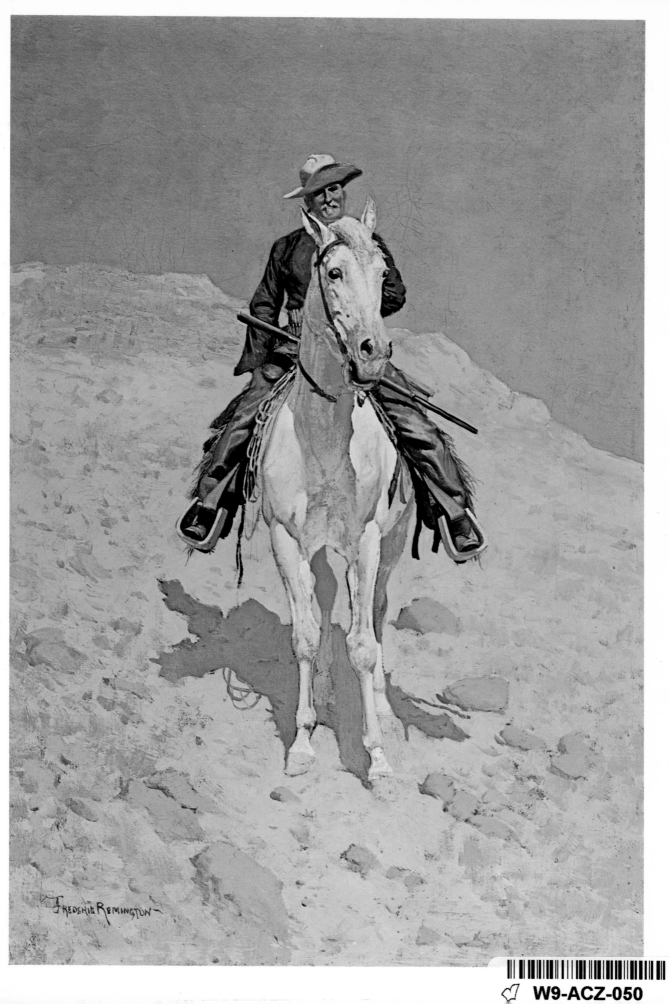

◀ *Self-Portrait on a Horse*

Contrary to his public image, Remington was never a cowboy. Yet he did have considerable firsthand knowledge of the West, of ranches and of horses, all of which played an important role in his art. The trappings were as familiar to him as the feel of the horse between his legs.

"What success I have had," he told one reporter, "has been because I have a horseman's knowledge of a horse. No one can draw equestrian subjects unless he is an equestrian himself." Remington both painted and rode horses well. Appropriately, his only known finished self-portrait shows him dressed as a puncher, mounted on a white horse, with a cobalt-blue Western sky as his backdrop.

Sid W. Richardson Foundation Collection. c. 1890. Oil on canvas. 29³/₁₆ x 19⅜" (74.0 x 48.8 cm.)

FREDERIC REMINGTON

FREDERIC

NEW CONCISE N A L EDITION

REMINGTON

PAINTINGS, DRAWINGS, AND SCULPTURE

IN THE AMON CARTER MUSEUM AND

THE SID W. RICHARDSON FOUNDATION COLLECTIONS

by Peter H. Hassrick

FOREWORD BY RUTH CARTER JOHNSON

PUBLISHED BY HARRY N. ABRAMS, INC.

IN ASSOCIATION WITH THE AMON CARTER MUSEUM OF WESTERN ART

DISTRIBUTED BY NEW AMERICAN LIBRARY

Dedicated to the memory of Helen Card, a devoted student and collector of Frederic Remington and western Americana whose writings, research, and advice provided a basis for study of the two collections brought together here.

The Amon Carter Museum was established in 1961 under the will of the late Amon G. Carter for the study and documentation of westering North America. The program of the Museum, expressed in publications, exhibitions, and permanent collections, reflects many aspects of American culture, both historic and contemporary.

Nai Y. Chang, Vice-President, Design and Production
John L. Hochmann, Executive Editor
Margaret L. Kaplan, Managing Editor
Barbara Lyons, Director, Photo Department, Rights and Reproductions
Michael Sonino, Abridgment
Carla Reifel, Designer

Library of Congress Cataloging in Publication Data

Hassrick, Peter H.
 Frederic Remington: paintings, drawings, and
sculpture in the Amon Carter Museum and the Sid W.
Richardson Foundation collections.

 Bibliography: p.
 1. Remington, Frederic, 1861-1909. 2. The West
in art. I. Remington, Frederic, 1861-1909.
II. Amon Carter Museum of Western Art, Fort Worth,
Tex. III. Sid W. Richardson Foundation.
N6537.R4H38 1975 709'.2'4 74-31085
ISBN 0-8109-2054-9

CONTENTS

FOREWORD

THE PUBLICATION of this book is a testament to the unique friendship of two men, Amon G. Carter (1879–1955) and Sid W. Richardson (1891–1959), and their parallel personalities and interests, which are reflected in their both acquiring works by Frederic Remington. Fort Worth became Sid Richardson's home in the mid-1920s, when he left his native Athens in East Texas. He lived in the old Metropolitan Hotel between trips to the West Texas oil fields. His friendship with my father began in the early 1930s, after the collapse of petroleum prices in 1929–30 had wiped out Sid Richardson's assets. My father's financial position at this time was none too stable either, for, having ventured into petroleum exploration, he had drilled numerous dry holes in Wilbarger, Young, and Shackelford counties. He did not strike oil until 1937. These two hardheaded and strong-willed men on occasion met head on. Inevitably clashes occurred, but their mutual respect and admiration for each other was the element that bound together their friendship. In later years, they argued and stormed at one another just for the fun of it, thoroughly enjoying a good needling and hot verbal exchange.

To an extraordinary degree the two men's lives ran in parallel courses, varying as to detail, for Dad and Uncle Sid were assuredly cut from that "whole cloth" of rugged individualism, dogged hard work, honesty, and luck which typifies our image of the self-made man. Uncle Sid had the advantage of a large family, closely knit and held together by his mother, whereas Dad left home at the age of thirteen, motherless. However it may be accounted for, the competitive spirit within each man flourished until death. Sid Richardson, an East Texas farm boy, pursued his interests in cattle ranching, horse raising, and the petroleum industry, and succeeded in achieving fame, fortune, and friendships with the leaders of his time.

My father, son of a blacksmith, left his native Crafton and walked barefoot to Bowie, thus beginning his long and successful career. He first waited tables in a boarding house, then progressed to selling chickens and bread at the railroad station. Dad was first and foremost a salesman, and pursued this bent all over the West and Northwest, selling enlarged art reproductions and frames. He later entered the advertising field in California before returning to Fort Worth. It was this which led him to the newspaper business, and its later involvements in radio and TV. Both men were utter patriots and complete realists, possessing a fierce pride in their humble beginnings. Each had a love of the

9

land, and a sense of his roots in it, that could well be defined in our modern term "territorial imperative." By whatever label, their belonging to this land of Texas undoubtedly nourished those two valiant spirits and hearts to fight against often insurmountable odds and continue undismayed to seek their fortunes.

My share in their friendship began in the early 1940s. Dad was no longer married, and the two bachelors were constant companions. During my college vacations, there was hardly a night when Uncle Sid was not at our dinner table. These were war years, and both men were working long hours with oil production and the war effort. Uncle Sid had begun collecting pictures in these years, while Dad's collection had come to a standstill. Had my brother not been a prisoner of war during three years—absorbing all of my father's thoughts—there could well have been some ardent vying between them for works by Frederic Remington and Charles M. Russell. Both men were buyers and keepers, and there is only one instance of an exchange. After much badgering by Dad, Uncle Sid finally agreed in 1947 to sell him Charles M. Russell's *In Without Knocking*, which was the companion piece to *Smoke of a .45*, already owned by Dad. It should be noted that both men purchased works of art only for personal pleasure. When Dad acquired *A Dash for the Timber* in 1945, Uncle Sid protested loudly that never again would he buy another Remington because that "damn Amon Carter had run the prices up so high." However, untrue to his boast, Uncle Sid purchased the remainder of his Remingtons in the mid-forties and early fifties. After my brother's safe return, Dad plunged into collecting again with all the old fervor and delight. The years 1952–53 saw the acquisition of practically all the bronzes in his collection, with the addition of two paintings in the last year of his life.

Frederic Remington wrote in the *Denver Republican* in 1900, "Everything in the West is life." So he painted, and so he modeled. No slogan could have touched more deeply the hearts and souls of men like Amon Carter and Sid Richardson. The American West as "celebrated" by Frederic Remington reached to the marrow of their bones, by different pathways. Uncle Sid was a shrewd observer of people, a cattleman, and an extremely knowledgeable lover of horseflesh. His collection of the works of Remington reveals, on close observation, examples of especially detailed portraiture and character studies. Men and horses populate the canvases. It is very apparent why *A Taint in the Wind* was his favorite, for here is all the mystique of the West, as well as the heroic relationship between man and nature. This painting hung over the mantel in his apartment and was always lighted.

Canvases by Remington dating after 1895, when he came under the influence of the Impressionists, drew a great response from the two collectors, for these paintings evoked feeling and stirred imagination through the use of a broader palette and more vigorous brushwork than had appeared in his earlier works. Though the documentary and anecdotal qualities were appealing, the spirit of the later works touched a chord with these men. They found in these paintings the answers to a need of the spirit, and they seemed to derive from these canvases the lifting out of oneself that others find in literature. Conversations about the paintings were centered on how well the painter knew his subject matter, not aesthetic judgments of line and form as such. The Carter collection excels in a broad range of subjects, and a large number of the paintings deal with Remington's awareness of man in his environment. The landscape is especially apparent in Dad's pictures. Though I find it hard to remember whether or not he actually had a favorite painting, *His First Lesson* was always hanging in an obvious place. This was his first purchase of a work by Frederic Remington, and still today strikes the note of the pioneer spirit of the American West, its disciplines, and the inherent quality of freedom and opportunity taken in proper perspective and reasoned orderliness.

Since we live in an age of the antihero, it seems appropriate to close with the thought that the only hero image

of any kind remaining is the cowboy; he still manages to captivate the imagination and some deep stirring within the spirit of modern man, though he is no longer the cowboy of Remington's day. Certainly Dad and Uncle Sid shared this reaction to a symbol of their times. In addition, they could be called romantic realists, for their pursuit of life was a romance of the highest order in the Western American saga. Both men were individual humanists to whom permissiveness, substituted for liberty, would be nauseating and totally unacceptable. They were prepared, when necessary, to sacrifice self-interest to the common good while retaining independence of thought and capacity for initiative.

My father's will, in the section pertaining to the establishment of the Carter Museum, says: "It is my hope that my friend Sid W. Richardson will contribute to said museum his collection of Western Art, and I direct that if he does that, all objects of art received from him be suitably inscribed to show their source." Whatever may be the final disposition of the Richardson collection, this book records the lives and friendship of two men through their shared love of works of art. It is not inappropriate to hope that it can serve to inspire other men, who may have exalted individuality to a point where the public weal is imperiled, to reinstitute the heroic as a replacement for the commonplace and mediocre which characterize our age.

RUTH CARTER JOHNSON
Fort Worth

INTRODUCTION: *Frederic Remington, 1861–1909*

IN THE LATE SUMMER of 1881, a strapping, sandy-haired young dude from upstate New York wandered onto the frontiers of the Montana Territory. His name was Frederic Remington, and he brought with him more than the ordinary schoolboy's enthusiasms for Meriwether Lewis and William Clark, Washington Irving, Josiah Gregg, and George Catlin, whose tracks he followed. Winding his way west on train and horseback, he rode for the first time through the grand open country of his dreams. Yet the further he rode the more he realized that something was wrong.

Evening overtook me one night in Montana, and I by good luck made the camp-fire of an old wagon freighter who shared his bacon and coffee with me. I was nineteen years of age and he was a very old man. Over the pipes he developed that he was born in Western New York and had gone West at an early age. His West was Iowa. Thence, during his long life he had followed the receding frontiers, always further and further West. "And now," said he, "there is no more West. In a few years the railroad will come along the Yellowstone and a poor man can not make a living at all."

The old man had closed my very entrancing book almost at the first chapter. I knew the railroad was coming—I saw men already swarming into the land. I knew the derby hat, the smoking chimneys, the cord-binder, and the thirty day note were upon us in a restless surge. I knew the wild riders and the vacant land were about to vanish forever, and the more I considered the subject the bigger the Forever loomed.

Without knowing exactly how to do it, I began to try to record some facts around me, and the more I looked the more the panorama unfolded.

To this unfolding of the American frontier saga Remington devoted the remaining twenty-eight years of his life. Of the many writers and artists who have glorified the Western experience none has been more singularly devoted, more overwhelmingly prolific, or more enduring than he. For millions of Americans and Europeans, his name has become synonymous with the West.

Frederic Remington was born on October 4, 1861, in Canton, a small but thriving town in upper New York. His father, Seth Pierpont Remington, known as "Pierre" to family and friends, was a staunch Republican journalist, who several years before Remington's birth had founded the

St. Lawrence Plaindealer as a means of venting his political sentiments. Frederic's mother was Clara Sackrider Remington, daughter of a prominent local family. The Remingtons christened their son Frederic Sackrider.

Though retired as a major, Pierre was known thereafter by his family and community as "colonel." For about a year after the war, the Remingtons lived in Bloomington, Illinois. Pierre edited the *Pantagraph* of that city. Then they moved back to Canton where Pierre, in 1867, repurchased the *St. Lawrence Plaindealer* and returned to his newspaper and local politics. In 1869, and once again in 1870, disastrous fires swept the main street of Canton, successively destroying the two printing shops owned by Colonel Remington. It was not long after the ashes had cooled that Remington's father initiated a crusade for a better fire department. The community joined the Colonel's campaign for improved equipment and protection, and Fred became the mascot. Although the new apparatus was not horse drawn, the men prided themselves on the swiftness and efficiency of their teamwork.

The Colonel continued to advance the cause of the Republican party. As a reward President Grant appointed him to a choice position as United States Collector of the Port of Ogdensburg, New York, in 1870. This meant that the family moved from Canton about twenty miles north to the banks of the St. Lawrence River. Though forced to sell the *Plaindealer*, the Colonel was still imbued with journalistic zeal and divided his time between government duties and editing the *Ogdensburg Journal*.

Believing that his son would profit by more formal education than was provided by the local school system, the Colonel enrolled Fred at age fourteen in the Vermont Episcopal Institute in Burlington.

In the autumn of 1876, a bashful and sturdy 180-pound Remington presented himself at the Highland Military Academy in Worcester, Massachusetts. Here Bud Remington, as he came to be called, spent the next two years. Like all cadets, he was forced to memorize the fundamental elements of such tomes as Upton's *Infantry Tactics*, but he spent his free time either committing youthful pranks or discussing the merits of his sketches with a fellow cadet, Julian Wilder. It was now that his artistic inclinations took their first form. Wilder possessed a modest facility for draftsmanship which Fred admired. Even more influential was one of Julian's friends, Scott Turner, who lived in Orlando, Maine. Scott had taken some art classes and proved his ability with pen and ink in an illustrated letter to Wilder. Remington saw the correspondence and quickly availed himself of the opportunity to exchange ideas and drawings with his newly found hero.

Awkward pen sketches accompanied Remington's letters to Turner. He pictured Cossacks on horseback, bearded scouts, and even a historical scene of "Signor Barandani in California" (probably Juan Bandini, who took a leading role in fomenting California's revolt against Mexican rule in the 1830s). Although naively shaded and ill-proportioned, the figures in these youthful artistic efforts exuded vitality, aggressiveness, and a developed sense of humor. These fancies of Remington's pen reflected the young artist's mind as it swirled with visions of Indians, cow punchers, and desperadoes. Fred seemed well suited for cadet life. His breezy way and happy, generous disposition brought him many rewarding friendships. His artistic prowess attracted the attention of his peers. "We soon found that he had a talent for drawing," wrote one of his fellow cadets, "which made him in demand at all gatherings of the cadets, who delighted in his caricatures of the cadet officers and the teachers."

By the spring of 1878 Remington and his family were considering an appropriate career for him to pursue and a proper college for him to attend. On May 27, Remington wrote his uncle Horace Sackrider, "I am going to try and get into Cornell College this coming June and if I succeed will be a Journalist. I mean to study for an artist anyhow, whether I ever make a success of it or not." Whatever happened to this plan is unknown. When autumn came, Frederic Remington was enrolled in the School of Fine Arts at Yale, most likely because Cornell's curriculum included neither art nor journalism.

Remington's first year of study was devoted to the principles and elements of art along with studio courses in drawing and perspective. John Henry Niemeyer, his instructor in drawing, had come to Yale as a professor in 1871, just two years after the art school was founded. Trained at the École des Beaux-Arts under Jean-Léon Gérôme and L. M. F. Jacquesson de la Chevreuse, Niemeyer never forgot that energy and integrity of line are the basis of all art. He was considered a great teacher by many, and by some, "unsurpassed in the entire country. On the walls of the room in which he gave instruction he placed a quotation from Ingres, 'Drawing is the probity of art.'"

Remington's life had its bright sides too. Less than three months after his arrival at Yale, the young artist published his first illustration in one of the several college newspapers, the *Yale Courant*. The sketch pictured an injured football lineman recuperating in his room, his right foot elevated and his desk top covered with liniment bottles. It was, in reality, a self-portrait. The picture illustrated one of a series of articles entitled "College Riff-Raff." In the caption Remington assures an inquiring friend that "a fellow must get used to the Rugby rules, you know.— The Doctor says I'll be all right by Thanksgiving, and that's all I care for now."

At the end of the 1879 season Remington went home for the Christmas holidays. The family had always been close, and such occasions were cheerfully celebrated, but this year the gaiety was muted. Remington's father had become gravely ill. On February 18 he died.

After deliberation Fred decided to quit Yale. He left partly because of disenchantment with the training received under Weir and Niemeyer and partly because of financial and family considerations. Remington's guardianship was granted to his uncle Lamartin Z. Remington, known as Mart, and he moved to his uncle's home in Albany. Mart was vehemently "opposed to having any men artists in the family and . . . desired to have him carry on the family tradition of writer-politician. . . ." With Mart's influence Fred became executive clerk in the office of New York Governor Alonzo B. Cornell on March 12, 1880. He later changed jobs, taking a clerical position briefly in the State Insurance Department and then transferring to a clerkship in the Department of Public Instruction of which his uncle was chief clerk.

On a visit to Canton in the early fall of 1879, Remington met Eva Caten, a local beauty from Gloversville, New York. They fell in love, and before long Fred was braving her father's doorstep to ask for Eva's hand in marriage. Consent was withheld. The rejected suitor, seeing the refusal as implied adjudication of his limited future prospects, decided to go west to seek his fortune. It was a land he had dreamed and read of for years, and there would be no better chance to see it than now. The *St. Lawrence Plaindealer* announced on August 10, 1881, that "Fred Remington, son of the late Col. S. P. Remington, expects to start on Wednesday of this week for Montana. We understand he intends to make trial of life on a ranche."

Remington came home without riches. No gold dust or ranch deeds lined his pockets, but the promised land had not been selfish either. It presented Fred with an image worthy of his artistic potential, one with which he could truly identify. The West, its people, its history, and its spirit were to serve as the foundation of his art. The door was open.

Throughout his travels, Fred had made numerous sketches. When he returned to Albany, his portfolio bulged with drawings, his mind with new ambition. "I have an appointment to go to New York soon," he wrote his uncle Horace Sackrider in October, ". . . to see George William Curtis of *Harper's Weekly* in order to see if that Co. will publish some work of mine. It would be a good scheme if I could get something in there."

The interview was a success. One of Remington's drawings caught Curtis's eye. The editor purchased it and turned it over to William A. Rogers, an experienced illustrator who had spent some time in the West. To Remington's delight, the picture, though redrawn, appeared as a full-page illustration in *Harper's Weekly*. He had made

his debut. Rogers signed it, crediting Remington with the original sketch. Remington was always grateful for Rogers's assistance. "It was you," he told Rogers years later, "who introduced me to the public. That was my first appearance and I was mighty glad I fell into the hands of an artist who knew a cowboy saddle and a Western horse."

On October 4, 1882, Remington's twenty-first birthday brought him control of his patrimony. He was in correspondence with Robert Camp, one of his cronies from Yale. Camp had moved to eastern Kansas, established a sheep ranch, and gloried in the outdoor life and the freedom of self-employment. In letters to Remington he pointed out that while a cattle ranch called for a substantial investment, sheep ranching could be undertaken with modest capital. He suggested that Remington might want to go into business for himself.

By late February, Remington had left his job and was on his way to a new life in the West. Initially, Kansas depressed him; no doubt the prairie in early March was not the most encouraging sight. As spring advanced, however, he recovered his usual exuberance and optimism. He slowly learned the business by watching Camp's operation. He bought a ranch near Peabody, Kansas, which began as a quarter section but soon doubled in size. He hired help, had some of the ranch buildings remodeled for sheep, and ultimately bought stock and horses of his own.

In late September Uncle Mart, prodded by an interest in Remington's ambitions, arrived to view the sheep ranch in operation. Together they celebrated Remington's twenty-second birthday. The proud rancher was eager to show how work had progressed, and Mart was favorably impressed. Unfortunately, the elder's review ended in tragedy. One October day they rode the twelve miles to Peabody and on the return trip were overtaken by an unexpected cloudburst. Remington was young, strong, and toughened to the rigors of the outdoors, but the drenching gave Uncle Mart a severe cold. He was still sick when he returned home to Albany and died soon thereafter.

Evidently Remington departed from his Peabody ranch around the first of the year, 1884, and moved his residence to Kansas City, Missouri. There he spent the next two years, but not without first retracing his steps to New York State, where he at last took Eva as his wife. On October 1, the day after the wedding, Remington and Missie, as he called her thereafter, caught a train back to Kansas City. A modest house in Pendleton Heights became their first home.

Kansas City in the mid-1880s was no longer a frontier town; it was a flourishing urban center. According to the *Kansas City Times*, real-estate sales in the first eight months of 1885 alone amounted to $9,000,000, and the city was considered the largest cattle market in the West. The boulevards were thronged with carriages of all descriptions, and the city bustled with activity. Remington could not resist the chance to partake of the town's economic opportunity and invested part of his remaining inheritance in a saloon. S. E. Ellis, the bartender, recalled that although Remington "used to spend a good deal of time in the saloon and poolroom of Bishop & Christie . . . it was a long time before I learned that he was one of the proprietors. He was a sort of silent partner, who had some money invested in the business, but no active management."

Remington passed much of his time in the pursuit of leisure activities and sports. He particularly enjoyed boxing and horseback riding, although he did not neglect his art. "He was never contented unless he had a brush or pencil in his hand," recalled Nellie Hough, a close friend of the Remingtons in Kansas City. "I have never seen any one so in love with his occupation as was Remington. His portfolio fairly bulged with his sketches, and that too at the age of twenty-three."

It was fortunate that Remington had this artistic facility on which to rely. In the spring of 1885, the saloon moved quarters, and through some legal manipulation the silent partner lost his investment. Family finances grew desperate. Missie decided to return to Gloversville, allowing Remington to travel once more to collect material for pre-

sentation to the Eastern publishers. He had already sold his second illustration to *Harper's Weekly*, called *Ejecting an Oklahoma Boomer*. Although the sketch had to be redrawn by another artist, Thure de Thulstrup, Henry Harper recalled that the crudeness of Remington's early work was overshadowed by "the ring of new and live material."

Before long Remington rejoined his wife in New York. They gathered up their belongings in Canton and Gloversville and took up residence on South Ninth Street in Brooklyn. From there he made the rounds of various editorial offices, intent on peddling his artistic work as illustrations.

At first, he must have met resistance. Spurred by initial rejections by art editors, Remington decided to freshen his work by attending classes at the Art Students League of New York. The league had been the hub of development in the American school of illustration for over a decade before Remington arrived in March of 1886. Young artists as well as established professionals attended sessions there; even Winslow Homer was observed working in one of the classes in the 1890s.

Remington evidently enrolled in three classes—painting, life drawing, and sketching. His instructor in painting was J. Alden Weir, younger brother of his Yale professor and later an important figure in the American Impressionist movement. From Weir and his other teachers and fellow students, Remington picked up numerous pointers. The opportunity to acquaint himself with other artists and illustrators served also to advance him into the ranks of the professional illustrator. But Remington was notoriously impatient when it came to schooling. Anxious to forge ahead with his own ideas, he could not abide instruction for long and quit the league at the end of the session in May.

Within a few weeks, Remington was on his way back to the West. Probably on an assignment from *Harper's Weekly*, he traveled directly to St. Louis and thence west through Colorado, New Mexico, Arizona, and as far south as Hermosillo, Mexico. He went in search of Geronimo,

and even though he and the renegade never met face to face, Remington came away steeped in the history and scenery of the Southwest. He summarized his feelings about the trip at the end of his traveling journal that summer. "Let anyone who wonders why the troops do not catch Geronimo but travel through a part of Arizona and Sonora and then he will wonder that they even try. Let him see the desert wastes of sand devoid of even grass, bristling with cactus . . . let the sun pour down white hot upon the blistering sand about his feet and it will be plainer. Let him see a part of those jagged mountains . . . and he can then imagine the whole for of course no one man has seen all the defiles & peaks of The Sierra Madres, as they rise like blue into the blue above and sink in cañons dark and black. . . ."

Not wanting to rely solely on *Harper's Weekly* for support, on his return to New York he sought out the offices of other magazines. Success followed closely. By November of 1886 two of his drawings were featured in *St. Nicholas*, a magazine for young people which employed the best writers and artists of the time. In December, *Outing* published several drawings, initiating a string of commissions which continued for the next two years.

Outing's editor, Poultney Bigelow, had been a friend of Remington's at Yale. Remington's first appearance at Bigelow's office was cause for jubilant reunion. For Bigelow it was not only good to see an old friend but also exciting to scan such cogent, vigorous work. The longer Bigelow perused Remington's portfolio, the more delighted he became with the prospects of a cooperative venture. "Here was the real thing, the unspoiled native genius dealing with Mexican ponies, cowboys, cactus, lariats and sombreros. No stage heroes these, no carefully pomaded hair and neatly tied cravats; these were the men of the real rodeo, parched in alkali dust, blinking out from barely opened eyelids under the furious rays of an Arizona sun." Bigelow promptly purchased the entire portfolio.

Comparable reactions and success in the next few months set the standard for Remington's development. His

style improved slowly, but progressively. It took time before the hearty authenticity of his work could be combined with consistent technical excellence, and if his drawings and watercolors lacked refinement, their very roughness was regarded as evidence of the artist's sympathy with his material.

By November, 1886, the Remingtons had moved into a boarding house at 165 Ross Street in Brooklyn. He began to look beyond the horizon of New York magazines for patrons. In a letter to the *Illustrated Graphic News* of Chicago, dated November 2, Remington wrote: "By this mail I send a . . . series of sketches of the 'horse show' as per arrangement with Mr. Grandin—your agent. They are nearly all sketches taken on the spot, very quick and somewhat rough to be sure."

Nor was illustration Remington's sole aim. He realized that professional recognition required exhibition of his work as well. The National Academy of Design and the American Water Color Society were the most prestigious outlets for New York artists, and by early 1887 Remington had entered works in major exhibitions of both organizations, thus setting a pattern which he followed for fifteen years.

These works were done in watercolor. Like most illustrators, Remington had begun to draw for reproduction with pen and ink, but soon found that for him this medium held limited potential for expression. "The pen was never natural with me," he admitted in later years. "I worked with it in the early days only to get away from the infernal wood engravers."

Even so, his early works in pen and ink were fresh and vivid. It was these that attracted Theodore Roosevelt. In 1888, Roosevelt furnished *The Century Magazine* with a series of articles recounting his early life of ranching and hunting in the West. He pressed to have Remington as his illustrator. The ensuing collaboration of author and artist spawned a lasting friendship between the two New Yorkers who had benefited from similar experiences in the West as a result of youthful wanderlust.

In his capacity as an illustrator Remington continued his practice of traveling west with camera and sketchbook. He was in western Canada in the summer of 1887, where he visited provincial outposts as far west as Calgary. In 1888, commissioned by *Century* to collect illustrations and notes, he made a full swing from Kansas City through Colorado, New Mexico, Arizona, Texas, and the Indian Territory. In Arizona the artist accompanied the Tenth Cavalry on a two-week tour from Fort Grant through the San Carlos Reservation. Priding himself on his stamina and resolve, he nonetheless looked the part of the perfect dude in his sun helmet, puttees, and khakis. The expedition among the Apache was strenuous, dusty, and hot, but he took well to the military life, enjoying the test of man against the elements. When it was over, he had determined that "soldiers, like other men, find more hard work than glory in their profession."

Moving on, he passed through Fort Worth on his way to Oklahoma. He wrote Missie from Henrietta, Texas, revealing his weariness with the routine of the artist-correspondent. The letter is dated July 1, 1888; he had already been on the road a month. "Here I am at last—leave in the morning by stage for Fort Sill. . . . The mosquitoes like to have eaten me up—there is not a square inch on my body that is not bitten—and oh oh oh how hot it is here—I have sweat and sweat my clothes full. . . . I am dirty and look like the devil and feel worse. . . . Well all this is very discouraging but it's an artist's life. I have no idea how long this thing will take for these Indians are scattered all over the earth but I 'touch and go.' . . . I came to do the wild tribes and I do it."

Before returning to New York in early August, Remington had wandered among the Pueblo and Navajo of New Mexico, the Apache of Arizona, and the Cheyenne, Kiowa, Wichita, and Comanche of Oklahoma. His survey had provided a reserve of material to be used as illustrations, preliminary studies for paintings, and ideas for stories which he now began to work up for *Century*. What he had not captured with his pencil and sketch pad, he had noted

in his journal or caught on film. He now set to the task of refining these field notes and studies for publication and exhibition.

Remington's patrons left him little time for rest. *Harper's Weekly, Harper's Monthly, Century,* and *Scribner's Magazine* demanded all he could supply. By 1889 he had won recognition as an author and was acknowledged to be among the foremost men in American illustration. His contemporaries E. A. Abbey, Howard Pyle, A. B. Frost, E. W. Kemble, Arthur I. Keller, W. T. Smedley, and Charles Dana Gibson counted him a close associate and peer. Thulstrup, Zogbaum, and William A. Rogers, who had each redrawn some of Remington's work for illustration a few years before, now found him secure in the profession and technically on a par with themselves. By the end of the decade he had attained eminence as a professional illustrator, and was one of a select and prestigious group of men who made their era what Oliver Larkin has called "the golden age of American illustration."

In the 1870s a technical advance in the process, a switch from "black-line" to "white-line" wood engraving, occurred. In the earlier "black-line" engraving, forms were defined by areas of wood in high relief that carried ink. The new style took into account the desire of many artists to render tonal differences. It did away with strict definition of form by adding white flecks, dots, or lines in areas of tonal gradation. This was a great advantage, and the commercial shops which perfected the process attracted artists who otherwise refused to have their work illustrated because of the loss of fidelity.

Other developments came in the eighties with the introduction of photographically processed blocks and half-tone printing. In praise of *Harper's* implementation of process blocks, Remington wrote the art editor, Frederick B. Shell, in January of 1890, about that week's double-page illustration. "It has all the qualities of the original. It is one of those things which make an illustrator's life worth living. These engravers are all right when they do . . . good work but they need a good deal of special dispensation to

purge their sins—process is the coming thing—the purpose of reproduction is the point and if a reproduction cost $25 or $300 it does not matter—the fittest will survive."

All the illustrators profited by such advancements in technique. However, it was Remington's vigorous style and firsthand knowledge of the West that brought him into popular demand. His name had become synonymous with the image he portrayed; Frederic Remington and the West were united in the public mind. Editors and authors sought his counsel. If they needed an opinion on some detail of trans-Mississippi history, or a description of a cow puncher's habits or an Indian's trappings, they consulted Remington; if it was a matter of illustration of such subjects, they logically turned to him. By the end of the decade he had worked in association with ten of the most popularly recognized magazines and periodicals. Over four hundred of his pictures had appeared as magazine illustrations, and his art had been reproduced in book form, too. Elizabeth B. Custer's *Tenting on the Plains* included plates by Remington, as did Theodore Roosevelt's *Ranch Life and the Hunting-Trail.* Remington had spent the summer of 1889 in Mexico working up visual material to illustrate Thomas Janvier's *The Aztec Treasure House* and assorted articles on Mexican life. The same year he entered into negotiations with Houghton Mifflin of Boston to fill a major commission by illustrating their new edition of Longfellow's *Song of Hiawatha.* All this was accomplished by 1890, only three years after he had entered the profession on a full-time basis.

Such success had Remington achieved that artists, too, began to seek his advice. For Maynard Dixon, who inquired how he might best prepare himself for a career in illustration, Remington had the following words of advice: "Most every artist needs 'schooling.' I had very little—it is best to have it. Be always true to your self—to the way and the things you see in nature—if you imitate any other man ever so little you are *'gone.'*

"Study good pictures—do not imitate them. . . . See much and observe the things in nature which captivate your

fancy and above all draw—draw draw—& always from nature. Do not try to make pictures when you are studying—do the thing—simply and just as you see it. . . .

"Another thing—never cheapen yourself—you do not know it but to be a successful illustrator is to be fully as much of a man as to be a successful painter. . . ."

This last comment to Dixon provides an important insight. For the majority of Americans, Remington included, the boundaries between fine art and illustration were minimal. The acceptance of illustration as "high" art in America was accounted for by the "egalitarian nature of our society, with its lack of fixed traditions and its constant demands for an art that can be understood by the majority." Though Remington dreamed of becoming an accepted painter, he never questioned his own integrity or purpose as an illustrator. It was a reputable profession, and he knew it.

For Remington, nonetheless, the progression from illustrator to painter was both logical and fortuitous. He could have found no fuller preparation for his later work as a painter than he did as a "black-and-white" man. Royal Cortissoz noted that Remington's illustrating "trained him in the swift notation of the moment which lies somehow at the very heart of wild Western life." Also, since the illustrator's pencil must be used rapidly when the artist is in the field, truth generally prevails over picturemaking. Subtle nuances of shading, perspective, and composition must be sacrificed for more elemental considerations. There was no time for deliberation on beauty or decoration. Only truth mattered. As Cortissoz said, it "is not that he failed to draw beautifully, which is precisely what he failed to do, but that he got into a way of drawing skilfully [sic] and cleverly, so that he put his subject accurately before you and made you feel its special tang." This, allied with the breadth of Remington's personal experiences in the West and his own pragmatic individualism, gave his work a sense of candor and straightforwardness that became the trademark of his art.

In November of 1888, Remington wrote an old Yale classmate, Eliot Grant Fitch, summarizing his career to that date and suggesting a new emphasis on painting as a complement to his work in illustration. "I tried 'rousting about' in the West but when I struck hard-pan I found that I . . . was rubbing against natural laws and so I came East and entered Art. I have had a very encouraging success both as an illustrator and a painter. My time is so well taken by the publishers that I have had little time to paint in colors but I manage to exhibit two or three paintings a year in the National Academy of Design."

By this time Remington had in fact established a noteworthy exhibition record. At the 1888 spring show of the National Academy of Design, Remington submitted an oil, *Return of a Blackfoot War Party*. The striking composition of a ragged band of Blackfoot warriors leading two grim captives home from war won instant success. The critic George Sheldon reviewed the painting: "Mr. Remington recites what he has seen, but his splendid reputation as an illustrator for the magazines has failed to satisfy the ambition of an artist who bids fair to become equally established as a professional painter."

He had started the 1888 season off with the dynamic study in character and action, the watercolor *Arrest of a Blackfeet Murderer*, which hung in the annual exhibition of the American Water Color Society. *Harper's Weekly* thought so highly of the painting that they illustrated it in two separate issues and noted its importance: "Mr. Frederic Remington, the artist . . . has caught with singular felicity the rush and endurance of horses at full speed. . . . Visitors to the late exhibition of water-colors at the Academy of Design will remember this picture in colors hanging in the corridor. There is a moral concealed in the scene which the observer may possibly overlook if it is not mentioned. The only accessories to the grim scene are skulls of buffaloes, the chief support of Indians of this type. Their food has been slaughtered mercilessly by . . . the whites, and the Blackfeet, unwilling and in most cases unable to settle down as farmers and citizens, owing to their inherited na-

ture and the absence of those traits which permit white men to thrive in regions swept bare of game, are forced to plunder or starve."

In reality it was as a documentarian rather than a moralist that Remington gained notice for his early paintings. Presenting himself as the visual record keeper of a waning era, Remington veiled his imagery in historic and contemporary facts. The ravaged Indian, the misunderstood soldier, the disappearing cowboy, the bygone trapper and explorer were presented for what Remington thought them to be. The moralizing came as a natural result of the situation; it was not consciously applied by the artist. In fact, his objectivity was scorned by many who wished a more sympathetic approach—a more compassionate viewpoint. The novelist Hamlin Garland, for one, decried Remington's treatment of the Indian and trapper. "Remington . . . carried to the study of these hunters all the contempt, all the conventional notions of a hard and rather prosaic illustrator. He never got the wilderness point of view. His white hunters were all ragged, bearded, narrow between the eyes, and his men stringy, gross of feature and cruel." Garland looked for a muted view, Remington for reality. "Best of all the secrets that I suspect his admirers of not knowing or thinking about as much as they should," wrote Remington's close friend Julian Ralph, "—Remington always paints and draws the truth." Yet even in his early works, his was a candor enriched with a tinge of the romantic.

Remington had selected an exotic theme, the final act in the drama of the Far West, but he chose to portray this romantic theme in the terms of a realist, allowing few compromises with grace, beauty, or sympathy. As a Romantic Realist, then, he found a place in American art, and his stature as a painter grew apace with the advancement of his technical facility.

Like Winslow Homer and Thomas Eakins, Remington sought to express those qualities unique to the American experience. Eakins implored his students at the Pennsylvania Academy of the Fine Arts "to study their own coun-

try and to portray its life and types." Each had his own province: Eakins, the city and its people; Homer, the sea and Maine fishermen; and Remington, the West and its diverse human elements.

Because of the particular subjects and area Remington chose to render, he was confronted with technical problems that his fellow artists never faced. Probably the raw, burning light of the Western plains proved most challenging to him. "The sun . . . in the arid country . . . does more things than blister your nose," he wrote in 1898. "It is the despair of the painter as it colors the minarets of the Bad Lands."

The depiction of Western spaces also tested Remington's skill. It was impossible for the Eastern mind to visualize the clarity and openness of the broad vistas that Remington viewed on his trips across the prairies. Albert Bierstadt and Thomas Moran had given the public eye a romantic image of the Western landscapes; Remington's paintings, with their lack of atmospheric perspective, seemed to evince a naive color sense rather than a faithful accounting. His brush remained true to what his eye saw—his colors were simple and strong, his distances clear. Writing many years later, Robert Henri concurred with Remington's approach: "I think most pictures of the Southwest are to a great extent false because the painters get blind to whiteness, make pale pictures where the real color of New Mexico is deep and strong."

Yet these matters of light, color, and spatial handling served as secondary tools in Remington's early work. He was a narrative painter, and in his stories the human figure was primary. His interest lay in people and the part they played in the flow of history. Turning to the frontier where native expressions of individuality blossomed, he recorded these individuals in paint with freshness, humor, and a sense of independence.

Few of Remington's nineteenth-century paintings show the human figure secondary to the landscape. He once wrote, "My art requires me to go down . . . the road where the human beings are . . . , in the landscape which to me

is overpowered by their presence." As in Homer's paintings of this period, Remington's characters dominated their natural surroundings. When Remington insisted, "keep close to nature," he insisted on viewing man's proper place in the overall scheme and on faithful observation of human character and anatomy.

Remington's understanding of the human figure was indispensable in his art. In order to picture an Indian, whether Sioux or Aztec, he felt the artist must be prepared to render human anatomy in paint. Although his training at Yale and the Art Students League of New York had provided the fundamentals, much of his ability was picked up along the way. With time and practice, he became facile and was able to place the human frame into almost any attitude he wished.

In most of Remington's compositions, there was an associated figure—the horse. His ability to paint this animal brought his widest public recognition. He wished his epitaph to read, "He knew the horse," and though it was never chiseled on his headstone, the truth of the statement is no less certain. For years he worked with horses and studied the conformation of each breed. He even wrote on the subject. In his first article for *The Century Magazine*, Remington discussed the distinguishing characteristics of the various types of horses found in the West. Yet his paintings and drawings far surpassed prose: his pictures brought his words to life.

As much as he loved horses and understood their place as a subject in art, Remington was not an animal painter in the true sense. He rarely allowed horses, or other animals, to stand alone as they did in the paintings of Rosa Bonheur or Peter Moran, his contemporaries. Invariably Remington placed the horse in juxtaposition to man. Never did he make the horse a symbol of man, and never did he paint the horse with human characteristics, a common failing of many animal painters. Remington regarded the horse as inherently graceful and its movements, even in slow gaits, as suggestive of speed, agility, and strength.

For Remington, the horse and action were synony-mous. While the artist pictured many steeds at rest, he is best known for the portrayal of horses at full gallop, a subject which recurred in his art throughout his career. In his concern for correct delineation of horses on the run, Remington is said to have been influenced by the photographs of Eadweard Muybridge. No positive proof exists that the two men ever associated, but Muybridge's studies of running horses were popular by the early 1880s, and his and Dr. J. D. B. Stillman's book, *The Horse in Motion*, reached the market in 1882. It is likely that Remington saw Muybridge's photographs in some form before fully embarking on his art career and was influenced by them. Some students of the question have even confused the identity of the two men. A writer in the *Christian Herald* credited Remington with having "some snapshots taken of horses in full canter" to prove that his rendition of horses was correct.

Muybridge's findings wrought significant changes in painting. Artists of such diverse styles as the Frenchmen Ernest Meissonier and Edgar Degas credited his influence. Thomas Eakins explored stop-action photography and its uses in painting. Dr. Stillman, Muybridge's associate, had observed in 1882, "It becomes now a curious and not unimportant question to discuss whether or not artists should abandon their old methods of representing the galloping horse and show him in some of his active positions."

Fortunately Remington was not bound by tradition. He gave so little credence to his academic training that he could take either path, and he chose reality. Ultimately, it was Remington, of all the American artists, who explored the photographic potential of horses in motion to its fullest.

Remington employed photographs and photography on his own, especially in field work, where he collected material for illustrations. He supplemented his sketchbook with a Kodak and on occasion relied on film entirely. "I got lots of ideas but no sketches as my camera was not loaded," he wrote in his traveling diary on one occasion.

By the early 1890s, however, he found his reliance on photography less and less pronounced. Writing to a Mrs.

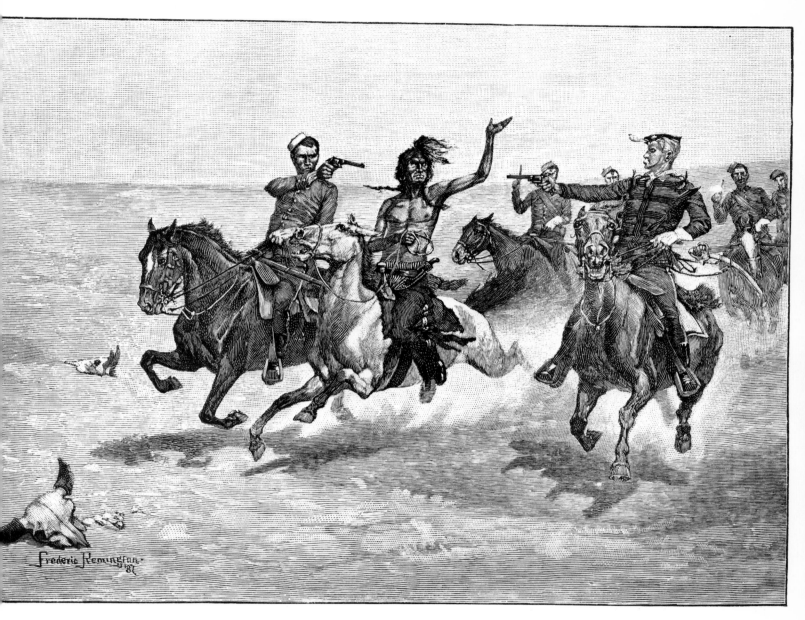

2. *Arrest of a Blackfeet Murderer,* from *Harper's Weekly,* XXXII (March 31, 1888), 233

Sage in 1892, he outlined his thoughts on the role of photography in his art. "As to instantaneous photography—I could write a large library about it and its relation to art. I often use photographs in illustrating for Harpers Weekly but almost never in magazine work—for the reasons that first—I often have M.S. [manuscript] from points and scenes with which I am not familiar. . . . And the best reason why I use them so little is that I can beat a Kodac [sic]—that is get more action and better action because Kodacs have no brains—no discrimination. If Kodac would make an artist's reputation for·'action'—they are so cheap that the world would have many such [as myself] so distinguished but unfortunately or fortunately that is not so. . . . The artist must know more than the Kodac. . . ."

If Remington was loath to admit dependence on photography in the depiction of action, he must have had some other reason for using the camera. This, no doubt, involved his concern for the accurate recording of details, particularly evident in paintings executed during the first decade of his career. In the course of time he realized the necessity for selectivity. "To know the essential details from unessential details is the study of all arts," he wrote in 1898. "Details there must be; they are the small things that make the big things."

Through the 1890s, Remington's style of painting, like that of his writing, remained distinctively narrative and overtly masculine. He searched always for the simple spirit in America. He wanted no reminders of effete Europe, no interference from women, and no pandering to what he considered the flitterings of international tastes and morals. The popularity of his paintings showed that the public acknowledged the direction of his art.

Remington continued to enter works in the major exhibitions in the New York area. His outstanding year was probably 1889, when his monumental canvas *A Dash for the Timber* was hung in the annual exhibition of the National Academy of Design. The stirring scene of frontier survival brought wide critical acclaim and public recognition.

It was also in 1889 that Remington was awarded a silver medal at the Paris Universal Exposition for his oil *A Lull in the Fight*. The exhibition committee divided the American entries into two sections, distinguishing the work of Americans residing in Europe from the work of those who had chosen to paint at home. Among the entries from native artists, Remington's choice of subject was unique. A Comanche battle scene from the Llano Estacado, 1861, captured the fancy of the European audience, who demanded representative American material. John G. Brown, president of the American Water Color Society, proclaimed: "I believe . . . that American artists . . . should paint the things of interest they see around them, and pay no attention to those who call them commonplace. . . ." For Remington this came naturally. The judges who selected entries from the United States also followed a new trend toward recognition of American subjects and styles. Albert Bierstadt's painting of apotheosis, *The Last of the Buffalo*, was rejected by the selection committee as being too reminiscent of German techniques, even though the subject was truly American.

A Lull in the Fight was not the only picture that Remington sent to Paris that year. At the insistence of Henry Harper he also submitted four black-and-whites. Remington, with his five paintings, was as well represented as any of the more than one hundred American artists who contributed.

The news of the silver medal reached Remington and Missie in time for them to take a vacation with light hearts. Early in July they went to Canton, where Remington used his uncle Horace Sackrider's barn as a studio. The *Plaindealer* reported that "almost any morning will find him at work in his studio on State Street, surrounded by horses and attendants." Local boys served as models. Remington, exhilarated by a recent trip to Mexico and weekend jaunts to the Adirondacks, worked through much of his vacation to fill his fall orders for *Harper's Monthly* and *Century*.

The prodigious amount of his work and the number of prestigious assignments given him by the magazines had

brought Remington prosperity. In 1890 he and Missie moved out of the city, or Gotham, as Remington called it, and took a spacious house in New Rochelle. He named his new home Endion, an Algonquin word meaning "a place where I live." There he had a stable and a pleasant view of Long Island Sound and the surrounding Westchester countryside. As always, Remington maintained a rigorous work schedule. He rose at six, breakfasted at seven, painted from eight until three or four in the afternoon, and then exercised by taking cross-country rides on horseback or extended walks.

Remington's library doubled as a studio, and like most others of the nineteenth century, it was profusely filled with the artist's props. For Remington, of course, this meant Indian paraphernalia and cowboy trappings rather than classical busts. His attic bulged with ethnological material, cavalry accouterments, and assorted Western garb, from which he drew freely to clothe his models. The accuracy of his work depended on the authenticity of costume, and he made it a point to dress his characters properly. As Julian Ralph described the room, "The trophies of his many visits and errands to the West hang all about the walls and litter the floors delightfully. Axes, clubs, saddles, spears, bows and arrows, shields, queer water-tight baskets, quaint rude rugs, chaparrajos, moccasins, head-dresses, miniature canoes, gorgeous examples of beadwork, lariats, and hundreds of sorts of curios from the desert and wilderness complete a collection that has been a mine of profit and a well-spring of pleasure to him."

Remington's stamina and vigor were rejuvenated by periodic breaks when he returned to the field for new visual material. In the 1890s these trips were frequent, sometimes numbering as many as three or four each year. "If I sat around the house all the time I couldn't do it [so much work]. . . . I travel a third or half of my time. I can't work steadily more than two or three months. I must go somewhere and see something new. Then when I see what I want I think it over and kind of get my idea of what I am going to do. Then the rest is nothing."

In 1890, for example, he journeyed west at least three times. Summer found him in Alberta, Canada, where he viewed the sun dance of the Blackfeet. In October and again in December he went to the Pine Ridge Agency to accompany General Miles in pursuit of the visionary followers of Wovoka and the ghost dance. Here an observant young lieutenant in Miles's service, Alvin H. Sydenham, noted Remington's presence in the troop and recorded his impressions of the artist in his diary. Remington's ample proportions and odd attire caught Sydenham's eye. He weighed over two hundred pounds and wore a great brown canvas hunting coat with bulging pockets, a little round hat, tight black riding breeches, Prussian boots, and English spurs. "As he ambled toward camp there was abundant opportunity to study his figure and physiognomy. His gait was an easy waddle that conveyed a general idea of comfortable indifference to appearances and abundant leisure. But his face, although hidden for the time behind the smoking remainder of an ample cigar, was his most reassuring and fetching feature. Fair complexion, blue eyes, light hair, smooth face—would probably have been his facial description if he were badly wanted any place by telegraph. A big, good-natured, overgrown boy—a fellow you could not fail to like the first time you saw him—that was the way he appeared to us."

When he returned to New Rochelle, Remington began writing an essay on the Indian problem and its possible solution. His ideas, though not particularly broad-minded, were as imaginative as those formulated by the Washington bureaucrats. In an article, "Indians as Irregular Cavalry," he pointed to the fact that the reservation Indians had lost their identity and sense of purpose. Why not, he wrote, enlist them in the cavalry? Here they could rediscover their individual integrity and, through standard military regimentation, be invested with a sense of order and responsibility.

Yet there was a mystery about the Indian which Remington could never fathom, no matter how intense his study, no matter how frequent his observations. "The one

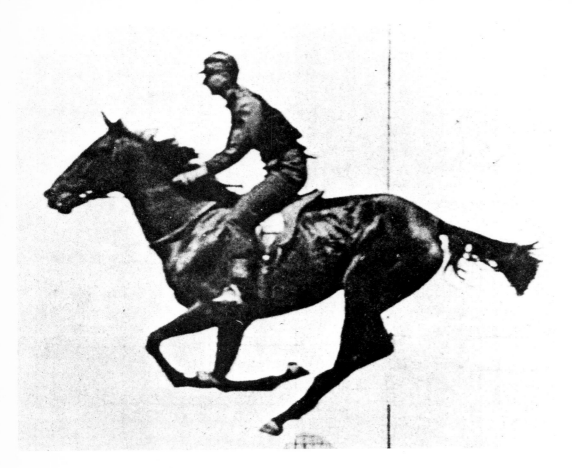

3. Cantering horse from Eadweard Muybridge, *Animal Locomotion* (n.p.: privately printed, 1887), plate 631, frame 10

thing about our aborigines which interests me most is their peculiar method of thought. With all due deference to much scientific investigation which has been lavished upon them, I believe that no white man can ever penetrate the mystery of their mind or explain the reason of their acts." It was this enigmatic quality which lured Remington toward the Indian image, not any underlying empathy with them as a people. Thus, as much as the artist and his critics emphasized the realistic foundation of his interpretation, Remington, in admitting his inability to fathom the true spirit of one of his central characters, forfeited objectivity to emotional speculation. A romantic interpretation inevitably resulted.

This was true also of Remington's handling of the soldier and the cowboy as pivotal subjects in his work, but for a different reason. In this case, the artist showed abounding empathy for the army's "yellowlegs" who weathered the trials of plains life and for the cow punchers whose characteristic individualism was deep-rooted in the American experience. These were types he could and did come

to know. He ultimately identified with them, and once this fusion was effected, emotional involvement replaced reason.

With such themes, Remington rose to success. In January of 1891, the writer Julian Ralph observed that Remington had "made a distinct impression upon the world of art . . . within five years." His oil, *Arrival of a Courier*, illustrating an episode in General George Crook's Indian campaign, brought Remington his first official academic sanction when it was exhibited in the annual spring show of the National Academy of Design. By June the academy elected him an associate member, "rather a notable distinction," announced *Harper's Weekly*, "since MR. REMINGTON is still under thirty years of age, and it is only six years ago that he was first introduced to the public through his maiden sketch for this paper." Though his friends thought Remington deserved full membership, the initials A. N. A. (Associate National Academician) after his name honored him greatly. Without deferring to academic standards, he had won official sanction, though his brush-

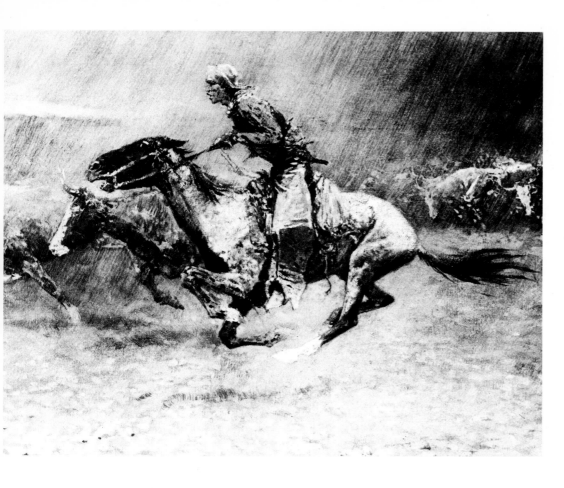

4. *Stampeded by Lightning* (detail). 1908.
Oil on canvas. 26½ x 39½". Courtesy of
The Thomas Gilcrease Institute of
American History and Art, Tulsa, Oklahoma

work was, according to one critic, "as unconventional as one of his own subjects taken from the frontier."

Remington topped off the year by entering a large canvas in the academy's autumn exhibition. It was called *Right Front into Line—Come On!* Record of the painting has since been lost, but it must have been an impressive work—it was listed at $5,000.

Such prices tempted Remington to paint solely for exhibition, but illustrating still fascinated him. With his commissions spiraling in scope and prestige, he saw no need to relinquish his firm position for the uncertain life of a painter. In January of 1892 he began work on illustrations for a new edition of Francis Parkman's *The Oregon Trail.* Parkman delighted in the thought that Remington would put his ideas into paint and wrote Remington: "I have long admired your rendering of western life, as superior to that of any other artist. You have seen so much and observed so closely that you have no rival in this department."

Parkman suggested that Remington examine the works of the German artist Karl Bodmer before he began his studies for *The Oregon Trail.* Bodmer "paints the Indian exactly as S. [Quincy Adams Shaw] and I saw them," wrote Parkman, "before any touch of civilization had changed them in costume or otherwise." Remington knew nothing of Bodmer but, following Parkman's advice, went to the Astor Library to study the illustrations in Maximilian, Prince von Wied-Neuwied, *Reise in das innere Nord-Amerika.* On January 9, he wrote Parkman his impressions and conclusions: "Bodner [*sic*] drew much better than Catlin and in fact was able to render what he saw to a very good account. He was tredemendiously [*sic*] painstaking, and for refference [*sic*] and scientific purposes he is much better—even better than a modern man who would give you more of his heart than he did of his head. . . . To revert to my purpose—I desire to symbolize the period of the Oregon Trail. . . ." According to his own statement, Remington saw no application for the empiricism of Bodmer's vision; he refused the role of fact finder, preferring to fashion a romantic illusion of what that era of his-

tory signified in his own mind. He realized that he was an artist after the fact and that dependence on an artist like Bodmer would undermine the credibility of his Western image.

Unlike most American artists of his day, Remington was too much interested in the potential imagery of his own continent to seek international travel or study. But Henry Harper had other ideas. Having experienced success with a number of articles on Germany and Russia, the publisher encouraged Remington to sail for Europe chaperoned by his friend Poultney Bigelow. Although Bigelow knew that "for provincial braggadocio not even a Californian could match Frederic Remington," he was convinced European exposure would broaden the artist's horizon. Remington submitted to his friend's cajoling, essentially because the adventure promised a canoe trip down the Volga and a chance to observe foreign militia.

Two cruising canoes, fitted with sails and stowed with tents and camping equipment, were shipped to St. Petersburg, the intended point of embarkation for the river trip. In late May, 1892, Remington boarded a steamer for London, where he was to join Bigelow and sail for Russia. "This was a fatal embarkation," wrote Remington years later. Although they were well armed with the necessary documents of travel, the journey into Russia proved ill-fated from the start. They had picked a time when Russian-American relations were tense. Through no fault of their own, they were evicted, and Remington wrote Julian Ralph from Germany that: "Bigelow and I have been chased all over Russia and finally fired bodily out of the country—we left St. Petersburg and instead of crossing at the R. R. point we stopped at KOWNO [Kaunas] and took a steamer down the Neman and then a Jew with a funny cart. These Russians are a frightful lot of barbarians and their police espionage is something you cannot imagine. We dodged the police telegrams and got off with our notes and sketches—the canoes are in Russia and God knows whether we will ever get them. . . ."

Unwilling to scrap the project, the two friends stayed in Europe about a month, hoping for affirmative word from the Russians. This never came, but Remington took full advantage of the novel scenery. His brush and pencil were seldom still. He and Bigelow visited the Kaiser's stud farm, Trakehnen, and touched down in North Africa and Paris, eventually routing homeward through England. In Paris he availed himself of the museums and galleries, coming away "with a general feeling of dissapointment [sic] although," he wrote, "I have learned much." In London he felt more at home. Here the language was no barrier, and he even savored a taste of the American West by visiting Buffalo Bill's show. He wrote home to *Harper's Weekly*, "One should no longer ride the deserts of Texas or the rugged uplands of Wyoming to see the Indians and pioneers, but should go to London. It is quite unnecessary," he added, "to brave the fleas and the police of the Czar to see the Cossack. . . ."

January 6, 1893, marked Remington's initial bid for recognition as a professional painter. His first one-man show opened at the galleries of the American Art Association and culminated in an auction a week later. For the event Remington selected about one hundred paintings, including *A Lull in the Fight*, which had hung in the 1889 Paris International Exposition, and *The Last Stand*, a large and impressive depiction of Custer's finale.

The sale was not the success he had wished. "Mr. Remington's preeminence as an artist of the far West was readily recognized in the prices paid for his illustrations," commented one critic, "while some of his paintings failed to reach the expected figure." The pictures netted Remington only $7,299, though they were received enthusiastically "before an audience in size and quality most complimentary to the artist and his works. . . ." *A Lull in the Fight* was sold to the Boston collector H. S. Bloodgood. The canvas *The Last Stand* was withdrawn when bidding lagged below what was considered a suitable figure.

So unsatisfactory was the outcome of this auction that Remington did not venture into the art market again for almost three years. When he finally decided to chance it

a second time in the autumn of 1895, he did so with flair but even less success. He annouced in a letter to Owen Wister, "'I open' as the theatrical folks say on Nov. 14. American Art Association-6-E. 23rd and sell everything but 'the old lady' on the night of Nov. 19—I am going to send you a bunch of my cards and ask you to mail them to Phila. folks where they may do me some good."

Wister attended the auction on the last night, being counted among the many purchasers. But again, as in the 1893 sale, it was essentially Remington's illustrations which attracted buyers, not the paintings he considered especially worthy of artistic consideration. One paper reported, "Many people were present at the sale of the works of Frederic Remington, at the American Art Galleries, on Tuesday night. Anxiety to secure black-and-white sketches by this popular man made bidding lively, and $5,800 was realized for some hundred-odd works."

Remington's spirits were dampened. His motivation to support himself as a painter dwindled, not to be rekindled until after the turn of the century. Meanwhile, he had discovered a replacement for painting—sculpture.

There was quite a stir in the small art colony of New Rochelle in the spring of 1895 when Frederic W. Ruckstull, a sculptor friend of the playwright Augustus Thomas, obtained the commission for the equestrian statue of General John Frederick Hartranft that was to be erected in front of the Capitol at Harrisburg, Pennsylvania. Ruckstull was persuaded to work up the preliminary model in a tent pitched behind Thomas's house.

Remington's interest and curiosity were instantly aroused. An admirer of good sculpture, he harbored special fondness for the work of Antoine Barye, the French animalier. Remington had never before watched a piece of sculpture come to life and observed Ruckstull's project with consuming interest. The two artists had little in common stylistically, Ruckstull being essentially an allegorical sculptor who cloaked his figures in classical conventions. Despite the dichotomy of their viewpoints, Remington was impressed with the potential of Ruckstull's medium, admitting later that he had long been impelled by "a natural desire to say something in the round. . . ."

Both Ruckstull and Thomas encouraged Remington to try his hand at clay. One day about this time Thomas visited Remington's studio and watched him draw a shoot-out scene in a Western saloon. Remington was having difficulty with one of the central figures. "That hulking figure in the foreground . . . obstructed other detail that he wished to show. Remington immediately dusted off the charcoal outline, and instead drew his gunman in the background shooting down the room. I said: 'Fred, you're not a draftsman; you're a sculptor. You saw all round that fellow, and could have put him anywhere you wanted him. They call that the sculptor's degree of vision.'"

Remington only laughed at the idea. Nevertheless, Ruckstull soon afterwards sent him a set of tools and a supply of modeling clay. The feel of "mud" was a revelation, and he worked the summer through on the model of his first bronze, *The Bronco Buster*. It cost him much effort and time, but skill in the medium came easily to him. He wrote Owen Wister: "I have got a receipt for being *Great*—everyone might not be able to use this receipt, but I can. D—— your *'glide along'* songs—they die in the ear—your Virginian will be eaten up by time—all paper is pulp now. My oils will all get old mastery—that is, they will look like pale molases [*sic*] in time—my water colors will fade—but I am to endure in bronze—even rust does not touch.—I am modeling—I find I do well—I am doing a cow boy on a bucking broncho and I am going to rattle down through all the ages, unless some Anarchist invades the old mansion and knocks it off the shelf." When the model was completed in the early autumn, Remington took it to the Henry-Bonnard foundry, where it was reproduced in bronze. Shortly before his thirty-fourth birthday, in October of 1895, he proudly copyrighted the finished piece.

The public applauded this new direction in Remington's art. Before the month ended the critic Arthur Hoeber wrote in *Harper's Weekly* that Remington had "struck his

gait." Hoeber pointed out that in sculpture Remington had found "for the first time ample opportunity to search for the forms and masses that have always so appealed to him, to obtain which in other mediums he found himself hampered and restrained." All that Remington strove for in his painting came to life in *The Bronco Buster*. Excitement, realism, fluid motion, and perceptive handling of equine anatomy, all the traits of Remington at his best, were summed up in this bronze. In addition, he found his theme was as effectively expressed in bronze as it had been in paint. "To those who delight in things purely American," wrote William A. Coffin, "not as trees, fields and skies are American, but as scenes of life and manners are, Mr. Remington's 'Bronco Buster' will give much satisfaction." Here was a true glorification of the American hero—the cowboy image brought to life in Remington's modeling and held forever in bronze.

Business prospered. The winter of 1896 found him consulting an architect, O. W. Degen, about adding a studio to his house and improving the stable. The studio was built as a wing, forty feet long with a high ceiling, large skylight, and massive brick fireplace. A set of double doors at one end of the room was large enough to admit a team of horses, though whether Remington actually painted mounts in the studio is debatable.

Remington chose animation and detailed realism over the sentimental idealism of Daniel Chester French or the symbolic rhetoric of Augustus Saint-Gaudens. His works paralleled the spirit of Gutzon Borglum's, though he was never quite able to match Borglum in expressing fluidity of form in motion. In his effort to portray the rigors of frontier existence, Remington's tense forms, highly articulated surface textures, and unbridled action remained in perfect sympathy with the overall Western theme.

The Spanish-American War interrupted Remington's sculptural interlude. For months magazines had been reporting on the unrest and violence in Cuba; in December of 1896, William Randolph Hearst, proprietor of the *New York Journal*, decided to get into the act. Cuba had been rebelling against Spanish rule for some years, but in these months under the energetic leadership of General Máximo Gómez y Báez the insurrection spread over the entire island and took on the proportions of a national calamity. What properties the guerrillas did not destroy to keep from the Spaniards, the Spaniards ravaged to deprive the guerrillas.

Hearst persuaded Richard Harding Davis and Remington to go to Cuba to report on the scene, promising to publish a book on their exploits. They were to travel in Hearst's yacht, the *Vamoose*, to a place on the Cuban coast assigned for a rendezvous with Gómez. But because of foul weather and shortage of crew, the reporter and the artist were forced to take an ordinary steamer to Havana, where they were isolated with the Spanish forces of occupation and never met the insurgents.

Nonetheless, they witnessed enough atrocities to provide themselves with stories and pictures and Hearst with some headlines. Remington returned to New York after about three weeks, convinced that American intervention was mandatory. The book *Cuba in Wartime*, written by Davis and illustrated by Remington, served as a cooperative effort to further this cause.

On a February morning of 1898 while Remington sat in his library putting the final touches on his *Sundown Laflare* stories, the Western Union agent telephoned Remington's friend Augustus Thomas that the battleship *Maine* had been blown up in Havana harbor. Thomas immediately phoned Remington, whose only thanks was to roar "Ring off!" as he rushed to put in a call to *Harper's*. This certainly would mean war, and he was not going to miss it.

"War, storm at sea and mountain scenery are bigger than any expression little man has ever developed," Remington had written in 1895. As a theme, war had already played a significant role in his paintings. The Cuban conflict proved a test for him personally as well as artistically. He found that the war artist, like the correspondent, must "stalk through the middle distance, seeing the fight . . . and the wounded; lying down by a dead body mayhap, when the bullets come quickly; he will share no

glory; he had only the responsibility of seeing clearly what he must tell; and he must keep his nerve."

Remington kept his nerve, but his health was not so stable. He was in the field, on the left flank, during the charge up San Juan Hill, and though his bulky torso was hidden in the shelter of a ditch for most of the engagement, he witnessed the capture of the fort through a blaze of rifle fire. The day following the San Juan charge Remington tried to struggle to the front once more. Suffering from fever and the oppressive heat, he staggered back to headquarters and asked that arrangements be made for his return to the United States.

While this raw confrontation with the horrors of war did not change Remington overnight into a pacifist, it softened his blatant advocation of war. In Cuba, as in Russia, Remington had ventured outside his familiar domain; the results were elucidating but ephemeral. The source of his inspiration was still the West. When summer came again to the Rocky Mountains, Remington boarded a train and was on his way. In September, back in New Rochelle, he scribbled an enthusiastic note to Wister: "Just back from 2 months in Montana and Wyoming—trying to paint at the impossible—had a good time—as Miss Columbia said to Uncle Sam 'That was my War'—that old cleaning up of the West—that is the war I am going to put in the rest of my time at."

As the nineteenth century came to a close, so did a chapter in Remington's career. In 1900 Yale conferred an honorary Bachelor of Fine Arts degree on Remington, thus increasing his prestige as an artist. He began to realign his priorities, to choose different patrons, to adjust his style of painting, and to look with a different eye at the aura of the West. Since the character of the region had changed, both the artist and his audience needed a new perspective to view it properly.

In his reports of an autumn trip to southern Colorado in 1900, the artist's outward motivation appeared to be the same as always. He commented to a reporter of the *Denver Republican*: "Western subjects for art? Why, I don't consider that there is any place in the world that offers the subjects that the West offers. Everything in the West is life, and you want life in art. There is a freedom about the West that is inspiring: it is still comparatively new, invigorating. The field to me is almost inexhaustible, although I've been painting and drawing Western life for a great many years.

"My present trip is sort of a finishing touch to my Western education and is taken wholly on my own responsibility."

His letters home suggested a quite different appraisal of the situation. Two weeks out of Denver he wrote Missie from Ignacio, Colorado: "Went over to Piedras—30 miles in Wagon.—Too cold to sketch. Came back here—have 111 color studies now—& two or three stories.—The Utes are too far on the road to civilization to be distinctive." He ended the letter with a telling note: "I am dead on to this color and trip will pay on that account alone—." The West as he had known it, a land of unique and distinct human types, had disappeared. Only the landscape remained unaltered; only the sunlight and the broad prairies and the gray sage told the same story as before.

He paused for a day or so at Espanola, New Mexico, to gather material on the Pueblo Indians but he found them too tame, as he had the Utes. Writing Missie from Santa Fe he complained, "I am either going to do the Pueblos or not and don't yet know. I think I won't. They don't appeal to me—too decorative—and too easily in reach of every tenderfoot.

"Shall never come west again.—It is all brick buildings—derby hats and blue overhauls—it spoils my early illusions—and they are *my* capital."

Though his threat to delete the West from his travels proved idle, it admitted to a disappointment reaching to the very foundation of Remington's art. He needed a new perspective, a new level of observation, realizing that the West of the twentieth century had changed drastically from that which he had grown to know and cherish. In consequence he began to turn to nature's constants, rather than the ever-changing face of humanity.

There was no abrupt transformation in Remington's style of painting; the process was gradual and only partially premeditated. But hints of a new direction slowly emerged. The once rigid outlines of his figures began to soften, blending into the surrounding landscape. In his early work man and nature had stood apart as separate entities in a cosmos where, so far as Remington was concerned, the human element predominated. Now, man's place was found in nature—a union had been effected.

An increasing tendency to romanticize the Western theme also became apparent. Less and less were his pictures literal transcriptions. They tended increasingly to elicit an emotional response from the viewer, enshrouding the subject with a mysterious, sublime quality evocative of romantic vision.

These new directions in Remington's art did not evolve entirely because of the demise of his West. Other forces came into play, one being the rise of Impressionism in America. Impressionism had made its debut in America in 1886, when the Paris dealer Durand-Ruel brought to New York a selection of three hundred canvases by Monet, Pissarro, Renoir, Manet, Degas, Sisley, Morisot, and others. Though many, including Remington, had considered the pieces in this premiere just so much crazy-quilt nonsense, the American reviewers in general "showed an uncommon comprehension and instead of laughing stupidly made an honest effort to understand."

By 1895 an American school of Impressionism had formed around a group of New York and Boston painters. They exhibited that year under the name Ten American Painters. Among the more important artists in this group, J. Alden Weir, John Twachtman, Childe Hassam, and Robert Reid were friends of Remington's. He attended their exhibitions, lauded their pioneering efforts, and lamented their lack of public and academic support. When asked in 1907 what artists had most influenced his painting he replied that "lately some of our American landscape artists — who are the best in the world — have worked their spell over me and have to some extent influenced me,

in so far as a figure painter can follow in their footsteps."

From the first years of the twentieth century Remington's paintings manifested Impressionist qualities. The atmosphere, instead of appearing clear and dry, now began to shimmer with sunlight and the reflections of the moon. The visual world of night, full of mystery and melancholy, nurtured Remington's imagination. He was soon devoting as much time to the study of nocturnal light and color as he had once spent on the depiction of prairie sunlight. According to Augustus Thomas, it was in search of these fascinating nighttime effects that Remington first realized his aspirations as a painter's painter. "It was an exhibition of Charles Rollo Peters' moonlights . . . that gave Remington his most serious wish to paint. The mystery of these efforts and their largeness were keyed to the mute though not inglorious poet in him. He came to see and to master the nuances of the moon's witchery in all her moods. It was interesting to follow his awakened and developing sense of color. Nature on that side made more and more appeal to him until in our Sunday-morning and weekday-evening tramps the tints of the sky and field and road almost totally dislodged the phantom soldiery from the hillsides."

Charles Rollo Peters was a California painter who devoted himself almost entirely to the study of night effects. Born in 1862, Peters studied abroad at the École des Beaux-Arts and the Académie Julian for seven years before returning to Monterey in 1895. Remington probably saw Peters's work when it was exhibited at the Union League Club in New York during the autumn of 1899 or at the MacBeth Galleries, where both artists displayed works in 1901. No doubt he saw some more of Peters's night scenes when he and Missie vacationed in California in 1901. Regardless of the date, the spark of this new style ignited into flame, a flame which burned throughout the remainder of Remington's career. In his late years about half of his finished works were nocturnals.

About the turn of the century Remington effected a change in his sculpture also. By 1898 he had had four bronzes cast: *The Bronco Buster, The Wounded Bunkie, The*

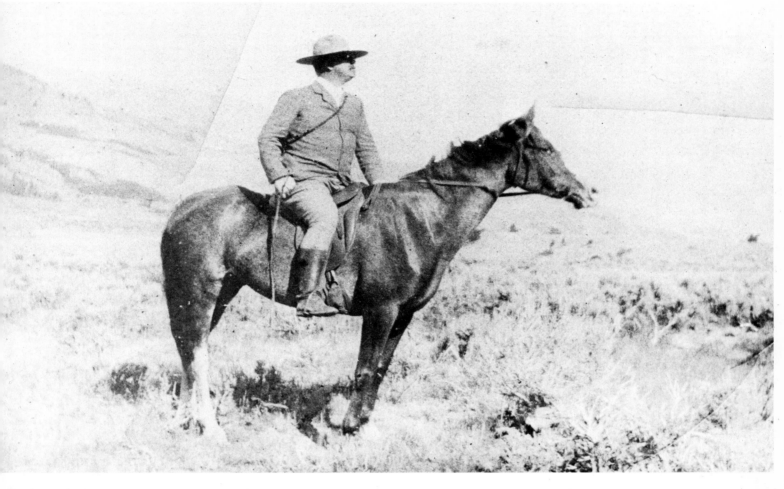

. Remington in the West, c. 1900. Joseph E. McCarrell Collection, Amon Carter Museum

Wicked Pony, and *The Scalp.* For the foundry work the artist had employed the Henry-Bonnard Bronze Company, with whom he worked successfully. In 1898 a tragic fire put the firm out of business, and Remington had to look elsewhere for his casting. The choice he made proved auspicious.

Remington turned to the Roman Bronze Works, a Long Island firm run by an enterprising Italian, Riccardo Bertelli. While the other American foundries utilized the traditional French sand-casting method to convert the artist's model into bronze, Bertelli introduced to the country the more versatile cire-perdue, or lost-wax, method. The new process was ideally suited to preserve all the spontaneity and texture of the original clay model and to allow considerably more variation in form and configuration. The artist could alter the details on each piece before it was cast, thus making each bronze unique. Remington reveled in the freedom and potential of the new method. Of his twenty-two bronzes, eighteen plus two new castings of *The Bronco Buster* and *The Scalp* were produced in this manner under Bertelli's guidance.

For Remington, the art of sculpture combined pleasure and hard work in equal measure. "Great fun," pronounced the artist as he toyed with the position and coil of the serpent in *The Rattlesnake.* "Just see what can be done with it—isn't it wonderful. You could work on this for days, changing and rechanging as you like—the only limit is your time and patience." Remington worked with determination and verve, sustaining a brisk pace and long hours. Sometime in 1902, laboring over his most famous sculptural piece, *Coming Through the Rye,* he wrote to

Owen Wister: "I go to the Roman Bronze Works—275 Green St. Greenport—Brooklyn—leaving here every morning at 8:20 a.m. to work out a four horse bronze and I reach this above oasis [Endion] at 6. P.M.—eat—smoke go to bed and day after day I am to do this until I die or complete this bronze. . . ."

When an opportunity for diversion came his way, he pursued that with equal vigor. "I have concluded that I don't drink enough—" he wrote with tongue in cheek to Julian Ralph; "I don't go fishing as often as I should and I now realize that Art was made for man and not man for Art."

To relieve his burden, in 1899 Remington purchased a small island on the St. Lawrence not far from Ogdensburg, where he had spent much of his childhood. He named the summer place Ingleneuk. He remodeled a roomy cottage and built a modest studio affording a view through a stand of birch and pine across the blue expanse to Canada. His days were full—painting and writing interspersed with canoeing, fishing, swimming, tennis, and repose. He grew to love Ingleneuk even more than the West, as he indicated in a letter to John Howard written one year in the early spring. "Oh I am itching to get up on that Island but its three long months yet. I look forward to it like a school boy. I want to get out on those rocks by my studio . . . in the early morning when the birds are singing and the sun a shining and hop in among the bass. When I die my Heaven is going to be something like that. Every fellow's imagination fixes up a Heaven to suit his tastes and I'de be mighty good and play this earthly game according to the rules if I could get a thousand Eons of something Just like that."

Early in May, 1903, the editor Robert C. Collier approached Remington with a proposition. He asked the artist to work exclusively for Collier's, promising to illustrate his works in full color and to publish twelve each year for four years under a contract that would guarantee Remington $1,000 per month. The subject matter was left to Remington's discretion. Since the pictures were to be reproduced as works of art rather than illustrations for prescribed articles, the artist could create in any vein he wished. In the November 21, 1903, issue of Collier's, a full-page announcement of the coming Christmas number stated that Remington had found the contract acceptable. It declared that the centerfold double-page picture would be "one of Frederic Remington's masterly paintings of western adventure, 'The Fight for the Water Hole.' This . . . will be lavishly reproduced in color, and marks the beginning of the exclusive publication in Collier's of all of Mr. Remington's work." Thus, his pictures gradually disappeared from other magazines.

Remington decided that the best way to handle the new commission was to produce groups of pictures thematically related. He began with the Louisiana Purchase series, a dozen paintings slated to run through 1904. It started with a bright, fluid oil, The Pioneers, which pictured four Indians watching curiously from a bluff as the bateaux of the first white fur traders passed before them up the Missouri River. Then Remington traced pictorially the developing stages in the history of the trans-Mississippi frontier.

Other series followed. The Great Explorers, a group of ten paintings, began in October of 1905 and ran through July of 1906. Next came a three-part series, the Tragedy of the Trees, a muckraking exhortation on the evils of the lumber industry in the Adirondacks, which bridged the years 1906 and 1907. The rest were individual paintings representing ideas that Remington had long wished to develop.

Transliteration of specific facts and details to canvas mattered far less to Remington now. The omission reduced neither the verity nor the quality of his work; it was merely a reflection of his broader viewpoint. Remington had grown in the knowledge that pictorial essence was not the sum of numerous details but rather the overall statement reduced to essentials. "Big art is a process of elimination," he remarked in 1903, "cut down and out—do your hardest work outside the picture, and let your audience take away something to think about—to imagine." Freed from the

Frederic Remington – del.

sketch with K Troop 10th Cav.

"The riderless horse."–

6. *The Riderless Horse*

The Geronimo campaign of 1885-86 was one of the most grueling and unrelenting of the military operations undertaken during the long history of Indian wars in the United States. A handful of resolute Apache, refusing to accept the sedentary life on the reservation, broke from the confines at San Carlos in May, 1885. There followed many months of savage military hide-and-seek in the course of which the marauding Chiricahua band was chased back and forth across the Mexican-Arizona boundary. Two generals, first George Crook, then Nelson Miles, ordered every available man into the field to hunt the elusive renegades.

Remington's 1886 trip west brought him into the midst of the bitter fray. In Tucson he had an opportunity to survey the situation in some detail. On June 9 he visited K Company of the Tenth Cavalry, where he received a cordial welcome from Lieutenant Powhatan H. Clarke. Clarke had recently been commended for great bravery in action and later became one of Remington's closest friends. Remington was allowed to accompany some of the sorties of K Company into the Santa Catalinas Mountains north of Tucson where he may have painted the watercolor *The Riderless Horse*. This picture was reproduced a couple of months later in the form of a rather spiritless wood engraving associated with a short descriptive essay on soldiering in the Southwest. The vitality of the watercolor suggests that Remington may have taken the idea from an on-the-spot sketch.

Sid W. Richardson Foundation Collection. 1886. Watercolor. 9 x 11⅞" (22.5 x 30.1 cm.)

7. *Remington's studio at Ingleneuk, Chippewa Bay, from Edwin Wildman, "Frederic Remington, the Man," Outing,* XLI (March, 1903), 713

bonds of the illustrator, Remington could consider picture-making rather than actualizations in paint.

In time, Remington even began to fault the idea of painting narratively. After visiting the 1906 exhibition of The Ten, he wrote an amusing letter to his friend J. Alden Weir about one of Weir's paintings, entitled *Hunting the Coon*. "Your coon hunt made a hit with me. . . . The whole thing is rich and distinguished but you must be careful—it is perilously near a story. Art must rise superior to human interest—not to speak of coons." Even in his most advanced compositions, Remington could not adopt art for art's sake. Yet he considered the tenets viable and was not above chiding his friend and mentor Weir for falling below the standards.

Always his own harshest critic, Remington also rejected many of his own efforts. On at least two occasions, in 1907 and 1908, he burned large numbers of canvases. Among those destroyed were nine of the Great Explorers series and all of the Tragedy of the Trees. But there had to be some failures as the illustrator's mark gradually disappeared and was replaced by that of the painter.

Roland Knoedler, among several American dealers, recognized the merit of Remington's step toward identification as a painter. Knoedler first appreciated the bronzes, exhibiting them in 1905, and ultimately replaced Tiffany as Remington's major outlet. He soon came to value the artist's paintings as well. Impressed by the vibrant colors, the muted nocturnals, the overall spontaneity and American character of Remington's work, Knoedler gave him one-man shows each December from 1906 until his death.

At first the critics commented with favor only when discussing Remington's moonlight studies. They saw no change in his handling of "the rather crude effects which he . . . found on the Western plains, and which he . . . exploited again and again." Some critics observed, too, that Remington's figures had lost strength as his palette became lighter. When they considered the nocturnals, Remington was given hope to continue. In 1907 one commentator wrote: "Mr. Remington has painted a number of

night scenes, and in these he has made a great stride forward. It is not simply that he has changed his key. Study of moonlights seems to have reacted upon the very grain of his art, so that all along the line, in drawing, in brush-work, in color, in atmosphere, he has achieved greater freedom and breadth."

By the time of Remington's last Knoedler showing in 1909, critics had come to accept the dazzling vibrance of his sunlit paintings as well. His was an Impressionist vocabulary made unique by the harsh Western landscape which served as his motif. One of the first to notice this was Royal Cortissoz, who reviewed the paintings at Knoedler's in 1909.

Under a burning sun he has worked out an impressionism of his own. Baked dusty plains lead in his pictures to bare, flat-topped hills, shading from yellow into violet beneath cloudless skies which hold no soft tints of pearl or rose, but are fiercely blue when they do not vibrate into tones of green. It is a grim if not actually blatant gamut of color with which he has frequently to deal, and it is not made any the more beguiling by the red hides of his horses or the bronze skins of his Indians. In past times he has made it shriek, and, even now, he finds it impossible to lend suavity to so high a key. But that, of course, is precisely what no one would ask him to do.

At last, and perhaps too late, the art world realized that Remington did not seek to beguile, only to picture the absolute qualities of the West. He was as close to Monet as any of the American Impressionists. Remington knew Monet's work, and though they differed diametrically in technique and subject, there was a strong theoretical affinity. Monet was one of the few influences that Remington openly acknowledged, firmly believing that all an artist "needs to see, study, and bring to his canvas is light. . . ."

The boldness Remington had lost in his work by elim-

inating hard outlines in the name of Impressionism he began to reinstate in these late years with vigorous brushwork. His oils, formerly lacking in painterliness, now showed the force of brush and pigment. This, combined with powerful treatment of light, produced heightened visual dynamics and, when resolved uniformly, gave him tremendous satisfaction as a painter. After completing the canvas *Cavalry Charge on the Southern Plains* he commented in his 1908 diary, "I have always wanted to be able to paint running horses so you could feel the details instead of seeing them." The energy and movement Remington had captured in his early works were multiplied.

Remington tried from time to time in these last years to express himself in pure landscape. Six of his canvases displayed at Knoedler's in 1909 were small, plein-air sketches. They were of "uncommon merit," wrote Cortissoz, suggesting "a talent that is always ripening, an artistic personality that is always pressing forward." Yet Remington fought against time to escape his stereotype. During an interview with Edwin Wildman, he complained, "people won't stand for my painting sunsets.... Got me pigeon-holed in their minds, you see; want horses, cowboys, out West things—won't believe me if I paint anything else." It was a popular misconception that Remington continued to take trips west to collect material. What embellishments he needed already hung on the walls of his studio. As he told Perriton Maxwell, "I go West now every year, but only to paint landscape—not to get material."

Remington had made efforts in his sculpture, too, to break away from the Western theme. His swirling bronze of 1904, *Polo*, and his impish *Paleolithic Man* of 1906 exemplified his search for other motifs beyond cowboys, Indians, and cavalry on the prairies. Yet his most popular pieces, like *The Bronco Buster*, *The Rattlesnake*, *The Mountain Man*, and *The Cheyenne*, were all part of this frontier imagery.

Remington had always approached sculpture from "the pictorial rather than the monumental side." But in March of 1907 he was awarded a commission for a heroic-size bronze of *Cowboy* to be erected in Fairmount Park in Philadelphia. The spirited work recalls his statement that "sculpture is the most perfect expression of action," though the figure was treated with a picturesque dignity unusual in Remington's work.

It is quite possible that if Remington had lived longer he would have been given an opportunity to produce another even more monumental sculpture. At a dinner in honor of W. F. Cody on May 12, 1909, Rodman Wanamaker proposed that a heroic Indian statue be erected at the mouth of New York harbor. The memorial to the "First Americans" was to confront all ships entering the port, "so that when the foreigner comes into this broad harbour," the artist Homer Davenport explained, "there his eyes will rest upon a fine group as big as or bigger than the Statue of Liberty, of Remington Indians welcoming him to America." It would have been a worthy tribute to the artist as well as to the Indian.

Remington's last house and studio were built in 1908 under his own supervision in Ridgefield, Connecticut. He had purchased the land about two years before. The plot was shown him by J. Alden Weir. In a letter to Childe Hassam, dated October 23, 1906, Weir wrote, "Fred Remington came here the other day with his wife looking for a place as New Rochelle is crowding them out.... I took him to Ridgefield which I thought at the time would suit him.... He has since written me he has bought thirteen acres and will build there."

Construction of the house began in the autumn of 1908 and proceeded through that winter and the following spring. "My new shack in Ridgefield is the finest building what ever was," he wrote Louis Shipman on March 18, 1909. "I have some dandy out buildings up and an appalling proposition to make a poor old Stony Lonesome Rubbed out hill in Connecticut sit up and bleed like Kansas but never mind I believe all I read in the fertilizer advertisements."

Through the summer the garden bore ample fruit, as did Remington's painting. His new surroundings lifted hi

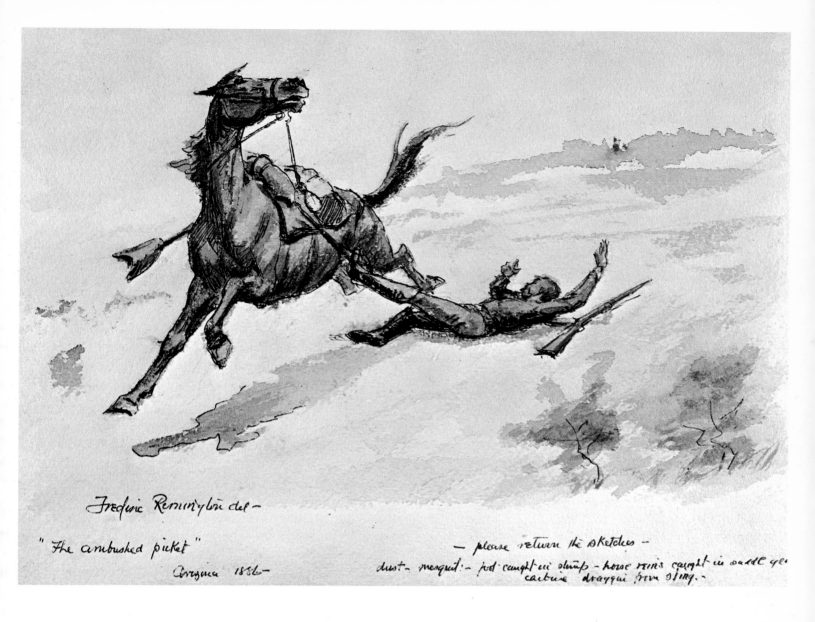

Frederic Remington del—

"The ambushed picket"
Arizona 1886—

— please return the sketches —
dust · mesquit · — foot caught in strap — horse reins caught in saddle gea[r]
carbine dragged from sling —

8. The Ambushed Picket

What was normally the uneventful, boring duty of the sentinel has ended here in tragedy. For most soldiers of the Apache campaign it would have been considered an ignoble death. This vedette probably never saw the enemy, never heard the crack of the rifle that knocked him from the saddle. Ambush was the Apache's most effective defense. Throughout the long years of hostilities they employed hit-and-run tactics with telling effect. In the late stages of the Chiricahua Revolt the Apache band was continually on the run and used such retaliatory devices as a means of confusing and delaying the cavalry's relentless pursuit.

Ideas for pictures which Remington gathered on his frequent Western trips provided visual material often not used until several years afterwards. This is true of the watercolor *The Ambushed Picket*, probably produced during or shortly after the artist's 1886 venture in search of Geronimo. It did not appear as an illustration in *Harper's Weekly* until three years later, although it was no doubt submitted to the magazine at about the same time as the other watercolor in the Richardson collection, *The Riderless Horse.*

Sid W. Richardson Foundation Collection. 1886. Watercolor.
9 x 11⅞″ (22.8 x 30.1 cm.)

spirits, and though he had had to sell Ingleneuk, the life of the country squire suited him. Poultney Bigelow visited him at Lorul Place, as he and Missie had come to call it, and wrote of Remington's enthusiasm: "He had created his ideal studio at Ridgefield . . . one so large that he could have a cavalry man mounted as his model. He talked of the future joyously—he felt on the threshold of a new world—he was coming into his own."

A new bronze, *The Stampede*, was begun. Through the autumn he put the finishing touches on the twenty-three canvases to be shown at Knoedler's in December. Critical response had been overwhelmingly favorable toward his 1908 exhibition, and he had written John Howard earlier that year: "My show made a great hit this winter. . . . I am no longer an illustrator." He now painted with renewed confidence and purpose.

On November 29 Remington's last show opened at Knoedler's. Gustav Kobbé noted enthusiastically that the artist had reached his goal. "Extremely interesting has been Mr. Remington's development from an illustrator into a painter. It has been slow, not because of any lack of ability, but because there always was such a demand for his illustrative work that he could not very well give it up or even relax from it sufficiently to devote the necessary time to painting as distinguished from illustrating. But the pictures, more than twenty in number, which he recently exhibited in the Knoedler galleries showed him as a painter. . . ." He had made his mark, but his time was done. Ten days after his show closed Remington was struck with severe abdominal pains. Since he had been frequently bothered by stomach problems in his later years, he thought nothing of this new attack. Finally, when the pain became unbearable, a doctor was called in. He diagnosed the ailment as appendicitis, and an appendectomy was performed. But to no avail. The artist died the day after Christmas, 1909.

Although he was only forty-eight years old, he left behind a Western legacy in paint and bronze which is as remarkable in its longevity as in its faithfulness. His pictorial record is seldom one of beauty or splendor, but it has remained a valid, candid, and vigorous statement directly from the heart of a man who was himself a citizen and student of the frontier. History had called on him to celebrate the American West, and Theodore Roosevelt's eulogy was prophetic: "The soldier, the cowboy and rancher, the Indian, the horse and the cattle of the plains, will live in his pictures, I verily believe, for all time."

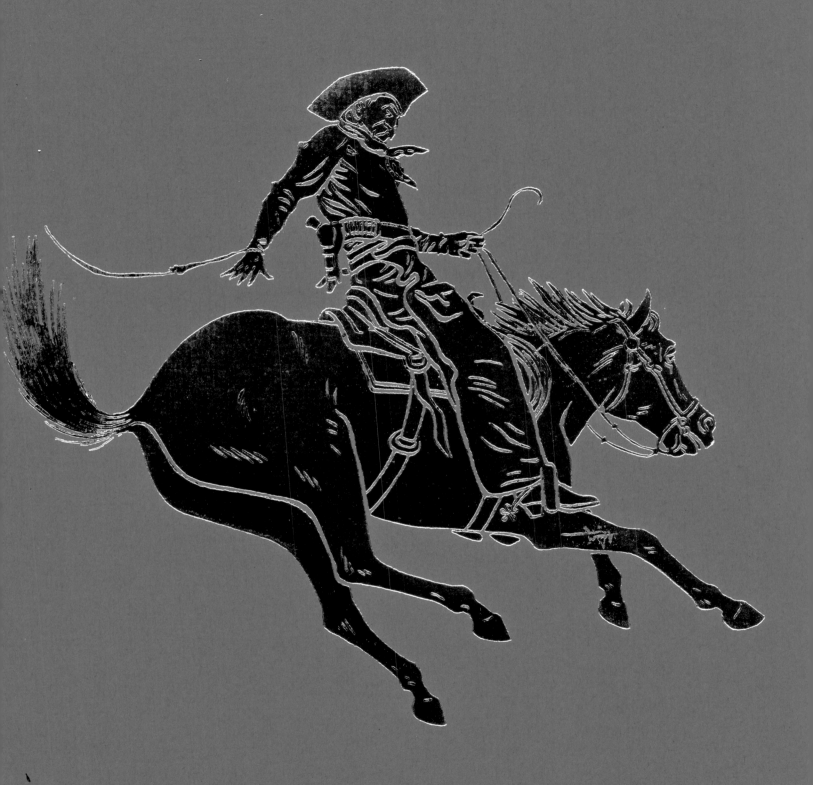

PAINTINGS AND DRAWINGS

9. Cow and Bull Elk

In February of 1888, *The Century Magazine* initiated a series of articles on the West written by Theodore Roosevelt. These short stories recounted Roosevelt's ranching and big-game hunting experiences and told of the characters, nefarious and otherwise, who frequented the Dakota Bad Lands which Roosevelt knew so well. *Cow and Bull Elk* was intended to illustrate the fifth story in the Roosevelt series, "The Ranchman's Rifle on Crag and Prairie," published in the June, 1888, issue of *The Century Magazine*. Remington's inscription below the composition indicates that the picture was scheduled as the third illustration for this article, but, probably because of space problems in layout, an engraved version of the painting was never printed.

Cow and Bull Elk is of interest because of its rarity as an unpublished work and because it exemplifies Remington's skill at delineating animal forms other than the horse. It was with such works as this that he influenced Carl Rungius.

1888. Tempera (black and white) on paper. Sheet 17¼ x 15¼" (43.9 x 38.9 cm.)

10. *An Indian Trapper*

In one of America's earliest and most lucrative commercial enterprises, fur trading, the Indian found himself in the advantageous position of being at the right place at the right time. Seeing the ready opportunity to secure his necessary provisions of guns, calico, tools, and occasional whiskey, the red man became a self-appointed middleman serving to bring the pelts from the wilderness to the trading posts where they could be transported to eastern and European manufacturing centers. In Canada, the Indian worked in harmony with the white man, whether along the St. Lawrence River with some unknown voyageur or in the great Northwest with some expert trader like George Simpson. A history of successful cooperation was especially true of the Hudson's Bay Company. As early as the 1820s, when it gained a monopoly over all of Canada's western domains, the company realized that a union of forces provided the only viable road to success in the fur business.

The Indian trapper depicted here is probably a Cree or Blackfoot. This hunter discovered in the Canadian Rockies a bonanza that broadened his own narrow conception of a hunting ground. Attached to the Hudson's Bay Company, he wears that firm's livery, a colorful striped blanket coat of English manufacture. This, and the brass-studded flintlock which he lays across his lap, came to him through trade. The bearskin leggings, the fur cap, and the beaded moccasins are of his own fabrication. For a saddle, he rode a pad of skins, "not unlike an air-cushion, cinched in place and provided with a pair of very short stirrups hung exactly in the middle. This dragged his heels to the rear, in the fashion of the old-time Sioux and gave him a very awkward seat.... His pony's back was always sore." In fact, the horse seems to have suffered as much from lack of nourishment as from the eccentric foibles of his rider. This might account for the apparent distortion of the mount's front quarter, although a number of critics protest that the figure is simply out of drawing. Nonetheless, the scrawny steed, his weathered rider, and the forbidding landscape have continued to enthrall viewers, for the painting has remained one of Remington's most frequently illustrated works.

1889. Oil on canvas. 49⅛ x 34¼″ (124.8 x 86.9 cm.)

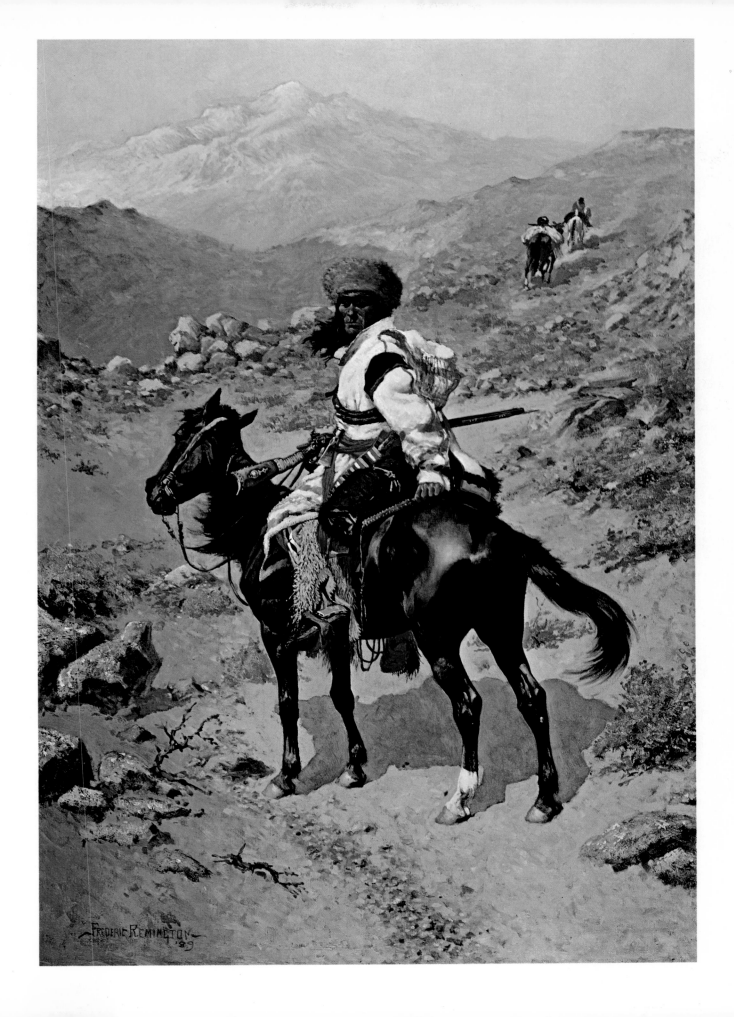

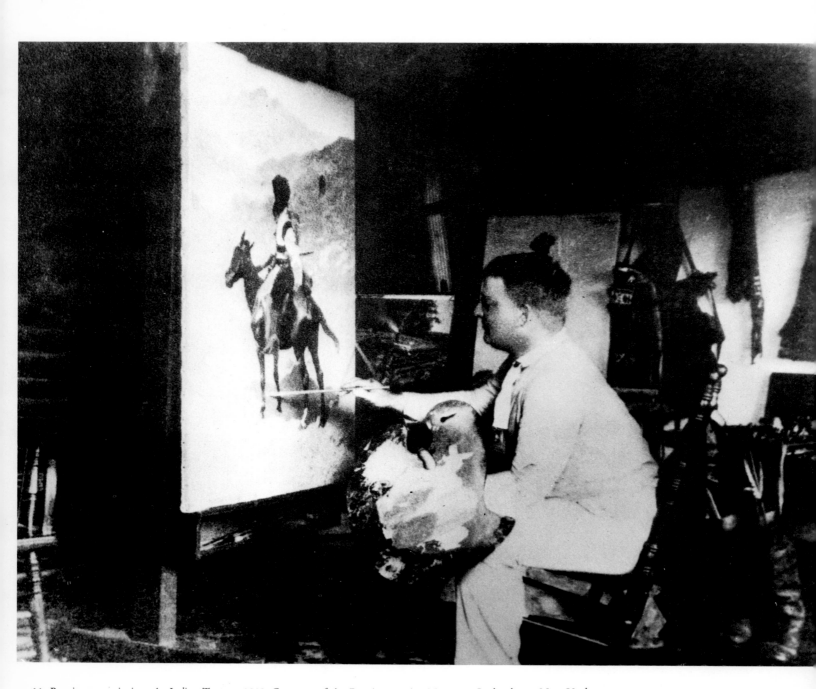

11. Remington painting *An Indian Trapper,* 1889, Courtesy of the Remington Art Museum, Ogdensburg, New York.

12. *A Dash for the Timber*
(overleaf)

Frontiersmen in the Arizona Territory led lives of perpetual risk. The extremes of climate, the harshness of terrain, and the abundance of venomous creatures made life miserable and sometimes short. Probably the greatest danger, however, came from the Apache whose domain the white man had invaded. Here a party of eight cowboys, or perhaps they are prospectors, beat a heavy retreat from an onslaught of vengeful Indians. Discharging their weapons over their shoulders, the bewildered riders plunge headlong toward a scanty stand of timber, a fundamental defensive tactic of frontier warfare.

In 1889, the same year Remington had been awarded a silver medal at the Paris Exposition, he entered *A Dash for the Timber,* one of his true masterpieces, in the autumn exhibition of the National Academy of Design. *A Dash for the Timber* had been commissioned earlier in the year by the capitalist and inventor E. C. Converse. The enthusiastic patron requested a monumental canvas depicting a life struggle on the frontier. Remington considered this first major commission an occasion to achieve a tour de force of realistic painting within the confines of his Western focus. Everything had to be right from the hats down to the boots, and a collection of authentic props became an essential prerequisite for the success of the painting. In April Remington had written his Arizona friend Powhatan H. Clarke: "I have a big order for a cowboy picture and I want a lot of 'chapperas' [chaparajos]—say two or three pairs—and if you will buy them of some of the cow-boys there and

ship them to me by express C.O.D. I will be your slave. I want *old ones*—and they should all be different in shape.... I have four pairs now and want some more and as soon as I can get them will begin the picture."

In December, Remington acknowledged the success of his new painting in another letter to Clarke. "My picture 'Dash for the Timber' in the Academy has got a *grand* puff in the papers.—they all had a good word to say—." On November 16, 1889, the *New York Herald* reported in an article entitled "The Autumn Exhibition a Display of Much Interest": "Frederic Remington's large and excellent work, 'A Dash for the Timber,' hangs in the center of the west wall of the south gallery. A small band of mounted frontiersmen are dashing toward the spectator, pursued by Indians in number. This work marks an advance on the part of one of the strongest of our young artists, who is one of the best illustrators we have. The drawing is true and strong, the figures of men and horses are in fine action, tearing along at full gallop, the sunshine effect is realistic and the color is good."

The *New York Times* of November 26, 1889, under the heading "Paintings at the Academy," acclaimed the popularity of the stirring frontier scene: "The picture at the Autumn Exhibition of the N.A.D. before which stands the largest number of people is Frederic Remington's 'Dash for the Timber.' " All of Remington's efforts had paid off.

1889. Oil on canvas. 48¼ x 84⅛" (122.5 x 213.5 cm.)

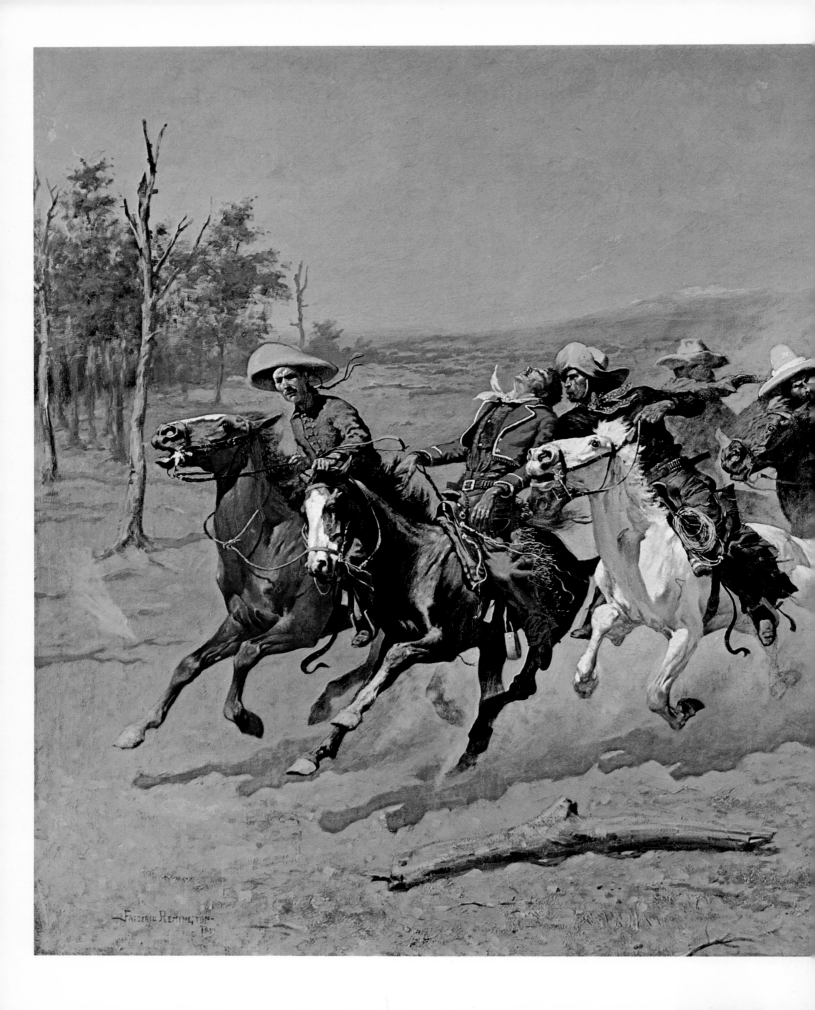

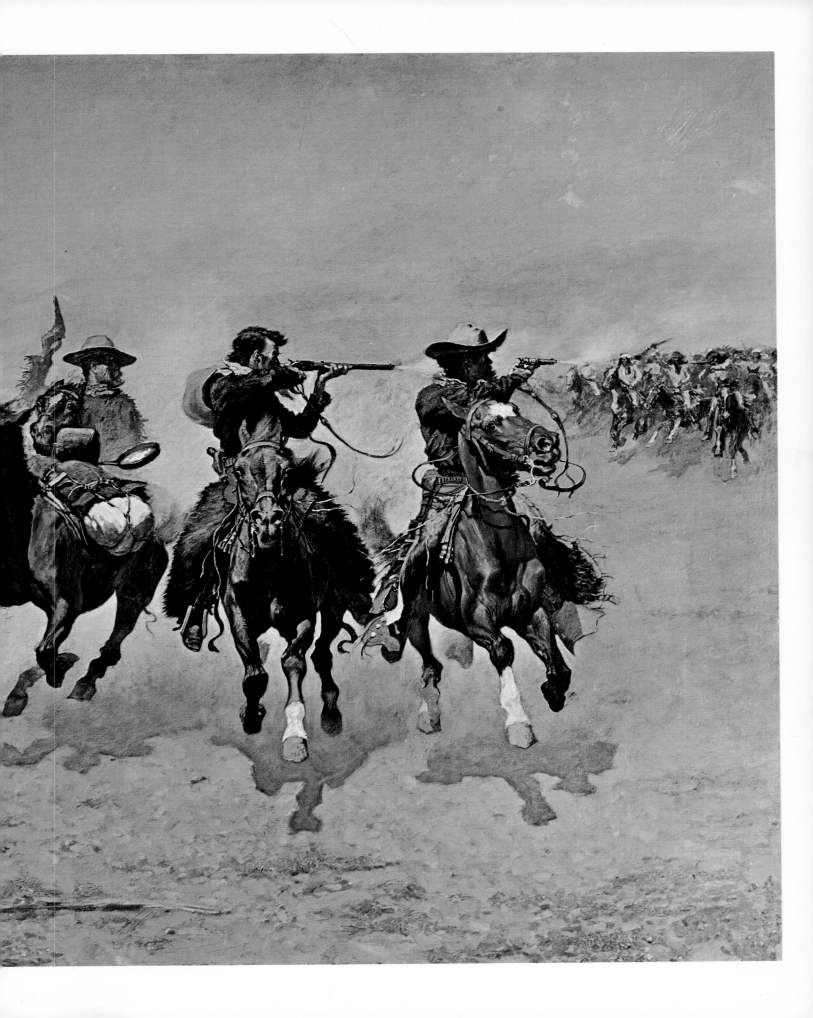

13. The Sentinel

In mid-January, 1889, Eva Remington sent a letter to Remington's uncle Horace Sackrider of Canton, New York. "About February 1st," she wrote, "Fred starts for a trip through Mexico and will be gone for two months. . . . He is going for Harper and will make a fine thing of it. Mr. Harper took him to Delmonico's to lunch yesterday and told him he was the greatest artist in America for him . . . [and] the House of Harper." Harper was sending Remington and Thomas A. Janvier south of the border to collect materials for a series of articles, "The Aztec Treasure House," to be written by Janvier, serialized in *Harper's Weekly,* and ultimately published in book form.

When the traveling artist found time free from the task of collecting illustrations, he viewed the diverse elements of Mexican life. Remington spent much of his time in Mexico City. Through the courtesy of the Mexican minister of war, he was allowed to tour various military establishments, where he sketched and photographed the colorful regiments of the regular army. He attended bullfights, visited some of the grand haciendas, and ventured out into the surrounding country towns. It was evidently on one of these side trips that Remington made the preliminary studies for the large oil *The Sentinel.*

Sid W. Richardson Foundation Collection. 1889. Oil on canvas. 34⅛ x 49¼" *(86.7 x 125 cm.)*

14. Cavalryman of the Line, Mexico, 1889

In 1889 Remington rode the rails to Mexico on a commission to gather visual material for an article about the Mexican army by Thomas Janvier. It was an ideal assignment. Soldiering had been one of Remington's loves since childhood; he was by nature drawn to the military element, and now to find himself rubbing shoulders with a foreign militia accoutered in unfamiliar fashion added a wonderfully exotic touch. The stables and barracks of the cavalry attracted him at once; there he could observe and sketch soldier and horse working together.

The Mexican *caballería* was esteemed internationally among savants of military affairs. Maurice Kingsley commented, "In mount, equipment, and smartness I question if a finer body of cavalry exists in any country. General Miles, I happen to know, was especially struck by their looks." Each cavalryman was armed with a .50-caliber Remington carbine and a saber, and was adorned in gray or blue fatigues, calf-high riding boots, and an oddly truncated cap or shako (called a kepí) strapped firmly atop his head. The horseflesh fit well within Janvier's description, "animals of native breed, as tough and as wiry as the men who ride them, and as capable of enduring enormous marches on a scant supply of water and food."

Remington no doubt intended the painting of the mounted cavalryman to be published in Janvier's account, but it was replaced by another picture of a similar subject entitled *Cavalry of the Line*. Whether the artist painted this on the spot or worked it up later from photographs and color notes remains a matter of conjecture. Either one would account for the rigidity of the composition, although the warm harmony of the colors brings a certain life to the picture, and the viewer can almost feel the heat of the Mexican sun as it is reflected by the white adobe walls of the stables in the background.

1889. Oil on canvas. 24⅛ x 20⅛" (61.3 x 50.9 cm.)

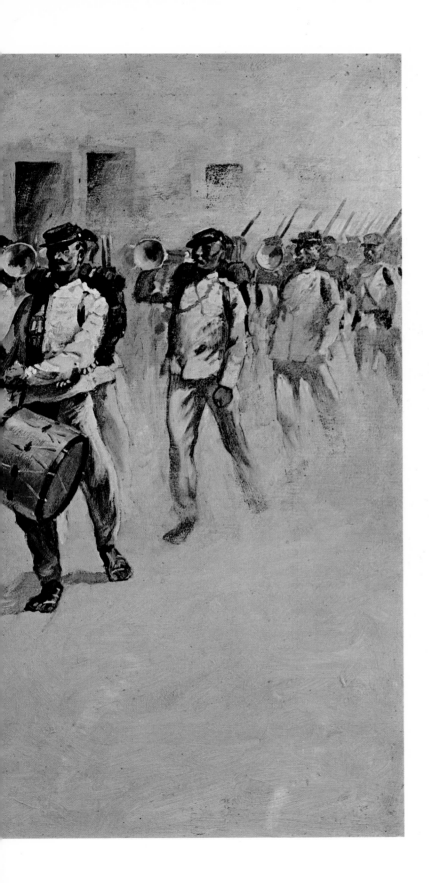

15. *Drum Corps, Mexican Army, 1889*

In the vanguard of a dust-choked troop of Mexican infantry soldiers marches a sixteen-man drum and bugle corps, musically setting the pace of footsteps in unison. It is probably siesta time, as no small, eager faces watch from the doorways while the noisy cavalcade in arms proceeds four abreast down the narrow street.

Remington either painted this picture or made sketches for it when he was on a traveling assignment to Mexico in 1889, collecting illustrations for Janvier's articles on bullfighting and the Mexican army. Although the picture is rather modest in size and impact, the artist has achieved in it a remarkable transformation. Here, Remington's natural ability to render motion becomes a musical, as well as a kinetic, statement. The figures in the foreground literally bend and sway with the cadence of the snares and the crisp blast of the horns.

c. 1889. Oil on wood. 18⅛ x 28⅛″ (45.8 x 71.3 cm.)

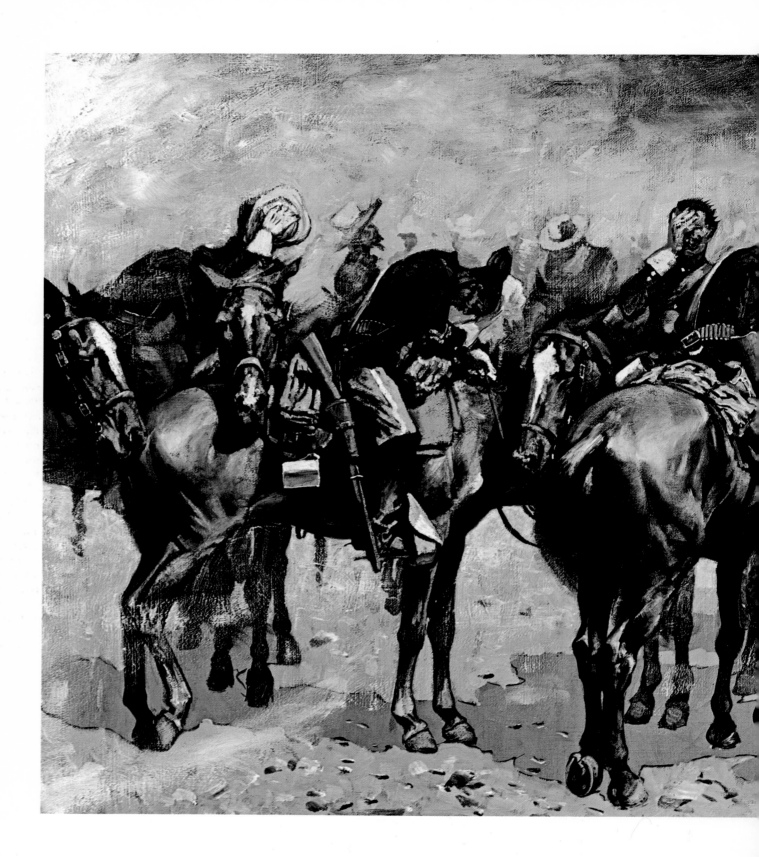

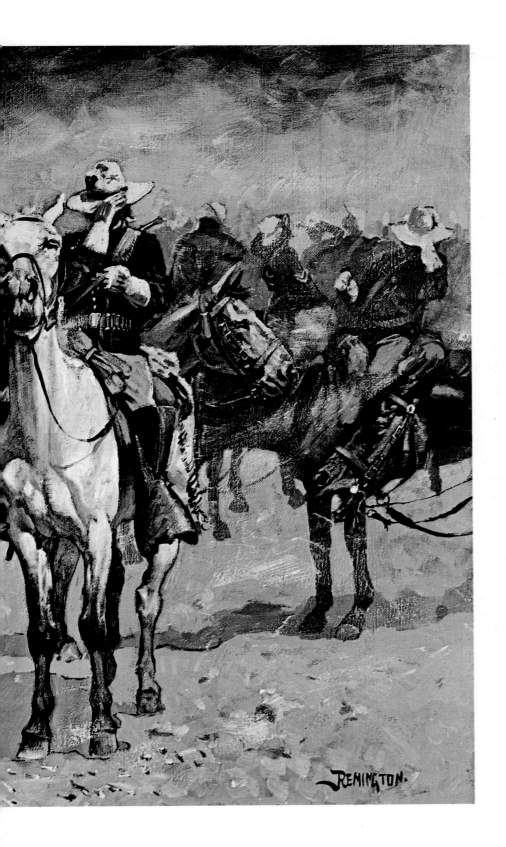

16. Cavalry in an Arizona Sandstorm

The desert can be a cruel province characterized by unbearable heat, bitter cold, harsh, forbidding terrain and, at best, meager means for sustenance. Probably one of the most merciless of the desert's elements is the sandstorm. One old soldier recalled such a dusty deluge from firsthand experience: "All in one moment the whole sky seemed to rush down upon us as if it were a big pepper-box with the lid off, and instantly all was dark as night, and I felt as if forty thousand ants were eating me up at once. You should have seen how the beasts whisked round to get their backs to it, and ducked their heads down! And how the men shut their eyes, and pulled their hats down over their faces, and covered their mouths with their hands! But it was no use trying to keep the dust out; it seemed to get inside one's very skin. When it cleared off we all looked as if we'd been bathing in brown sugar, and you might have raked a match on any part of my skin, and it would have lit right away!"

1889. Oil (black and white) on canvas. 22⅛ x 35¼″ (56.2 x 89.4 cm.)

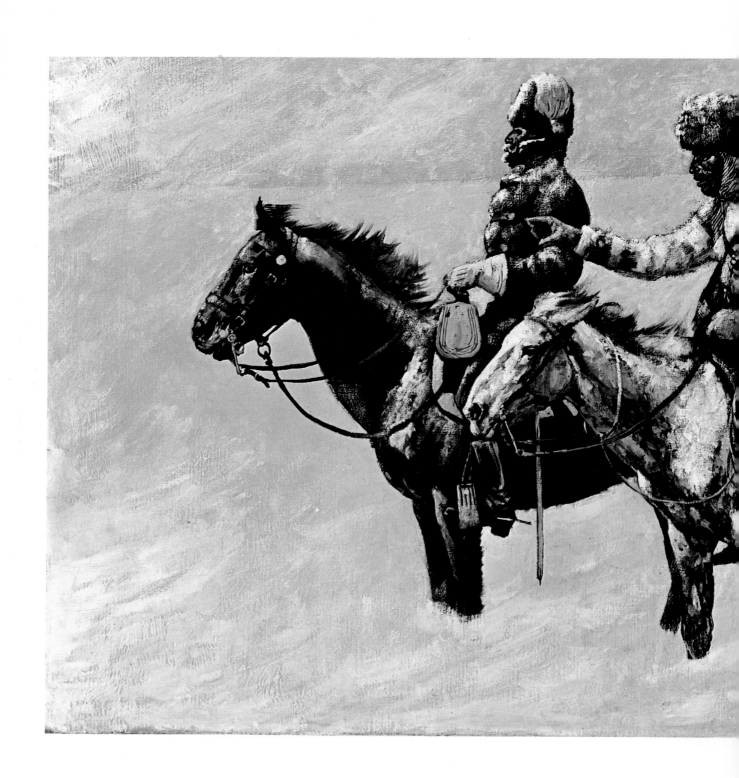

FREDERIC REMINGTON.

17. Canadian Mounted Police on a Winter Expedition

For the prairie provinces, the winter of 1889-90 was an especially severe one. Deep snow and sub-zero temperatures rendered travel hazardous, difficult, and often impossible. Under such conditions the dispensing of justice, the aiding of citizens, and even the stocking of police outposts went untended for prolonged periods. When a squad of men did venture out, they were likely to come face to face with a blizzard hurled down on them from the Arctic North or the Rockies. In such storms, the new emigrants and even trained men could lose their way and perish almost within earshot of their own dwellings. A native Indian scout became a necessary adjunct to any winter expedition because of his keen perception and thorough knowledge of the country.

The colorful summer gear of the mounted police, for which they were nicknamed the "Dandies of the Plains," was replaced by more practical attire when winter gales blew. Gone were the blue pillbox forage caps, the scarlet patrol jackets, and the steel-gray trousers with the double white stripe. The mounted police outfitted themselves in thick-haired buffalo coats, fur caps, heavy, long woolen stockings, moccasins, and warm mittens. Even the normal metal stirrups were exchanged for wooden ones that conducted less of the cold.

1890. Oil on canvas. 20⅛ x 32¼″ (51.1 x 81.8 cm.)

18. *A Cavalryman's Breakfast on the Plains*

There was little chance for respite in the long plains war between the Indian and the soldiers who pursued him so relentlessly on horseback. On campaign, the "yellow-legs" indulged in few luxuries. Coffee, bacon, and perhaps a biscuit or two were considered sufficient fare to carry a man through a day in the saddle.

Yet Remington imbued this scene with a sense of leisure and relaxation. The smoke rises lazily into a breathless sky, the soldiers stare patiently at the pot for the first signs of a boil, and the light suggests that dawn has passed a long time ago. There is little resemblance here to Remington's own experience on campaign in 1888. "In the early morning, as the night grows pale with coming light, the horse herd comes up from its night on the range at a good round trot, unconsciously keeping in the form of a column showing the impress of a military life on the entire equine nature. The Apache's chosen ground not being made for the echoes of a trumpet, no bugles blare; but the simple calls of the sergeant summon the men. 'Catch your horses,' comes the command amid the hurrying of many feet as the herd rounds up. The horses are caught and picketed, the breakfast eaten, the saddlebags rationed, because this is a warm trail and before the command 'Halt' is given, sleep will be more necessary than eating."

c. 1890. Oil on canvas. 22 x 32⅛" (55.9 x 81.5 cm.)

19. *Lieutenant S.C. Robertson, Chief of the Crow Scouts*

In the late autumn of 1890, Remington, at the request of *Harper's Weekly,* packed enough warm clothing for a couple of weeks and caught a train to Fort Keogh, Montana. The purpose of the trip was to accompany General Nelson Miles and a group of Indian commissioners to the Cheyenne Agency at Lame Deer, where they would attempt to persuade the Cheyenne to move off their land and take up residence on the neighboring Crow Reservation to the west. The commission ultimately failed in its task, but Remington was provided an opportunity to collect a variety of notes and sketches which he used for articles and illustrations soon thereafter.

The group traveled nearly two hundred and fifty miles on horseback between Fort Keogh and Fort Custer, which, according to Remington, was "not enough to make a man famous or lame, but enough for the time being."

Remington rode in the company of Lieutenant Casey from Fort Keogh. Casey had gained favor with the Indians and the cavalry by initiating a system of inducting Cheyenne braves into military service as scouts, thereby offering them a productive way of spending their time, a welcome sense of accomplishment, and a little cash to boot. This was not the first time Indians had been used by the army, but they were the first to become uniformed soldiers.

Lieutenant Samuel Churchill Robertson, stationed at Fort Custer on the Crow Reservation, was much impressed with Casey's accomplishments. Robertson had been in the cavalry since his graduation from West Point in 1879. Remington described Robertson as "another zealous young man with a fiery purpose to have the best scout corps on the crust of the earth." In Remington's opinion, what Casey and Robertson intended for the Indians was the best possible solution for the pauperization and purposelessness caused by reservation policies. "Casey and Robertson are the high priests of the new regime," Remington wrote an editor at *Harper's* when he submitted the watercolors for the article "Indians as Irregular Cavalry" in which Robertson's portrait appeared.

Because of the story and picture published in *Harper's Weekly,* Remington and Robertson became close friends. Before Robertson's premature death in 1893, he wrote an article for *Harper's* which Remington illustrated from photographs.

Robertson died exactly two months after his resignation was submitted. Remington and the Crows lost a friend and the army a meritorious officer.

1890. Watercolor on paper. Sheet size 18⅛ x 13⅛" (45.9 x 33.3 cm.)

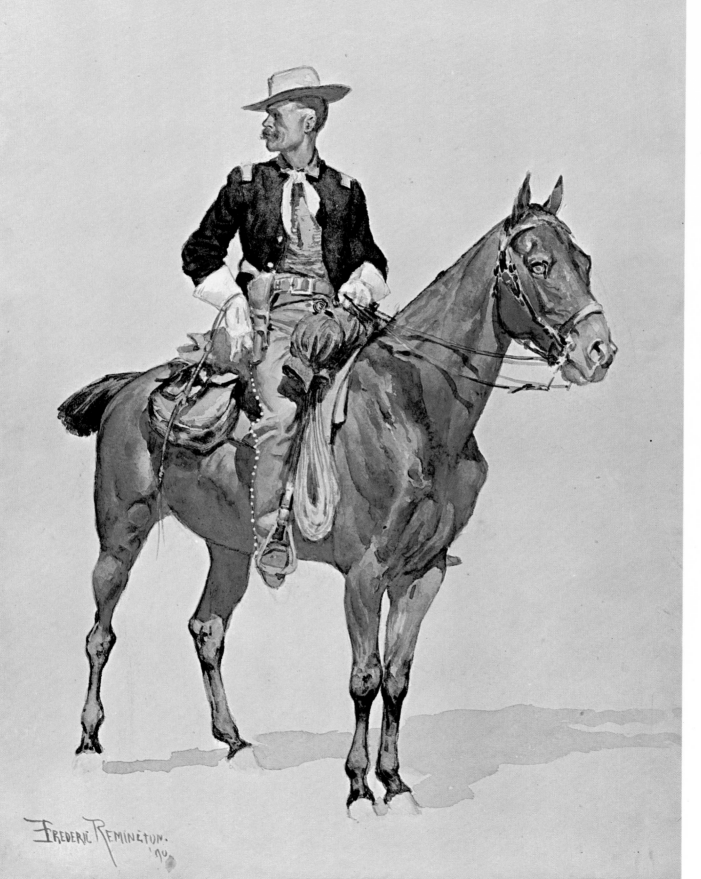

FREDERIC REMINGTON.
'90

20. A Vaquero

By 1890, Remington had gained sufficient reputation as an illustrator of horsemen to solicit a commission from the author Theodore Child to provide a couple of pictures for an article on the agricultural development of Chile. Child provided the artist with photographs, one of which Remington worked up into a black-and-white oil titled *A Vaquero*. Child wrote that "the 'vaquero' or cowboy, with his sheepskin leggings, his big spurs, and his inseparable cigarette, ties up his head in a silk handkerchief, pulls his hat over his eyes, and performs wonderful feats of horsemanship in rugged and pathless places."

It did not matter to Remington or Child that this was not a vaquero that they described in paint and print, but rather a Chilean *huaso*. Evidently, Child had not done sufficient research, nor had Remington been aware of the misnomer. Whatever the debate, Remington's painting stood as a masterful rendition of a Chilean horseman. The *huaso*, astride his surefooted mule, was silhouetted against the rugged Andean cordillera for which his mount was best suited. The straight-brimmed, rounded-crown hat which he wears was called a *sombrero de paño*, known in Spain as a *sombrero cordobés*. The leggings or *polainas* were of a variety popular from the 1850s, and the colorful *manta* or *poncho largo* is still worn today by Chilean *huasos* under the name of *chamanto*.

1890. Oil (black and white) on canvas. 28⅛ x 18¼" (71.3 x 46.3 cm.)

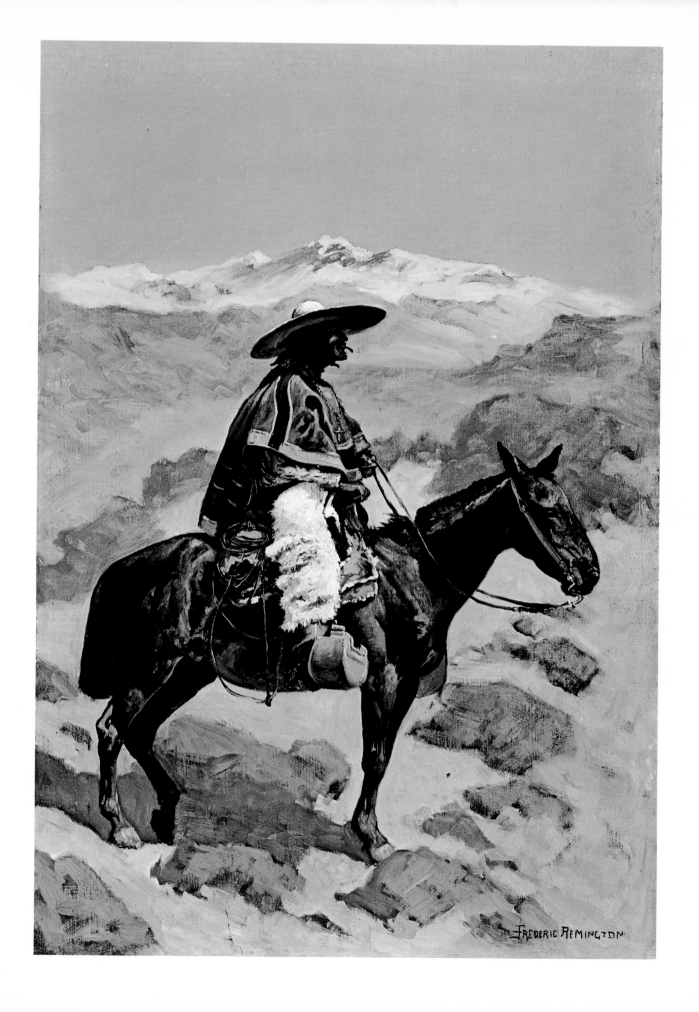

21. Durgy Rescuing the Girl

To the ranchers of Lucky Valley, William Durgy was known as Jonah. Though ambitious and resolute, he seemed strangely ill-fated. In an effort to increase the productivity of his acreage by systematically burning the prairies, he lost both his ranch and his wife in flames. On another occasion, he told his partners that he had compounded a new "sheep-dip," guaranteed effective against the ravages of scab. On Durgy's advice, two thousand fine ewes and wethers received treatment. The scabs were eliminated, but so were their hosts.

Of course, things had to get worse before they got better. After rescuing the sheriff's daughter from certain doom in the swollen waters of the Wild Cat River, he found himself in the middle of a complicated and potentially hazardous love match. The sheriff had recently been wounded in a shoot-out, and his daughter, unknown to her father, was in love with the villain. Before long, Durgy too became a suitor, and for once luck shifted to his side. The sheriff got his revenge, the daughter found an honest man, and Durgy's lonely bachelor days were over.

1891. Pen and ink wash drawing on paper. 18⅞ x 16½″ (47.8 x 41.7 cm.)

22. Register Rock, Idaho

Geological curiosities become the signposts for civilizations on the move. When the terrain is unfamiliar, natural landmarks guide travelers across uncharted reaches, serving as beacons in the wilderness. But as the paths become worn, so do the guideposts. They soon take on the etched identity of the people who pass and inevitably reflect the human failing to record that "Kilroy was here."

The roads across the Great American Desert were replete with such markers. Scotts Bluff, Chimney Rock, Castle Rock, Inscription Rock, Devil's Gate, and the Spanish Peaks represent a mere sampling of the hundreds of prominent points which directed the flow of Western traffic. Register Rock in Idaho served the Oregon Trail, and Remington's depiction of it embodies the whole story of Western migration. The bewildered Indian gazes in wonderment at the scribbled initials of an intruding civilization. The cow skulls tell of the journey's hardships for animals that did not complete the journey to greener pastures. This site was the resting spot for many wagon trains; here they spent the night and cooked a meal which may well have consisted of their own oxen.

1891. Oil on canvas. 17⅛ x 27¾" (43.4 x 70.4 cm.)

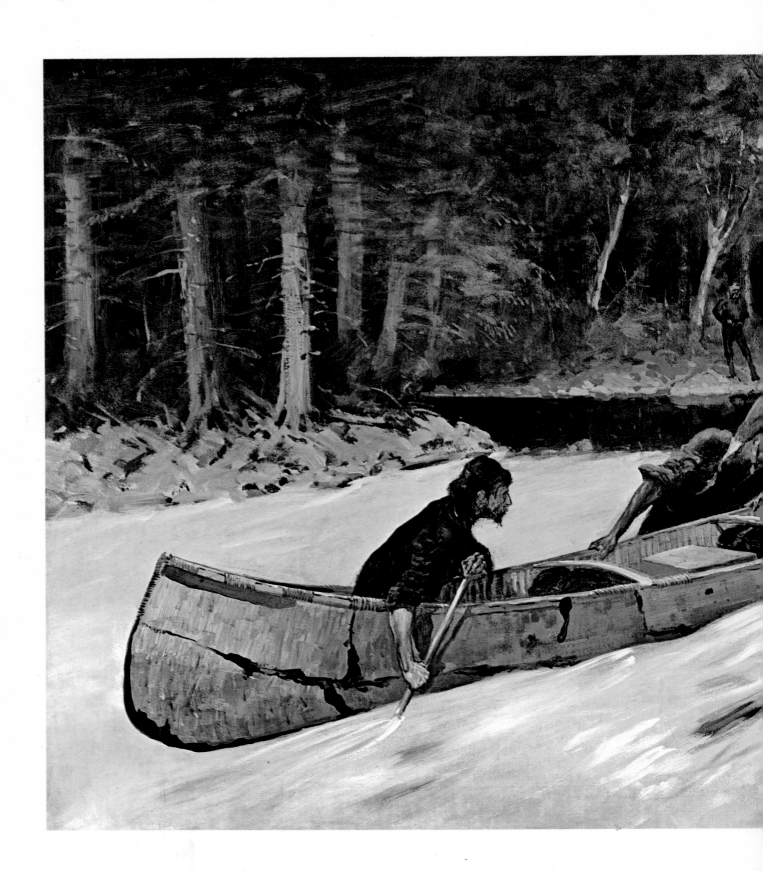

23. *In a Stiff Current*

The rivers of the Canadian north served as thoroughfares along which the voyageurs and the coureurs du bois moved the precious commodities of the Hudson's Bay Company. Furs and supplies were trafficked in and out of the wilderness along these watery channels. When the channels narrowed and the current grew so swift that paddles were useless, the alternative to going backwards was getting out to push *(décharger)*. This, in any case, was better than portaging.

Both Remington and Julian Ralph were fascinated by the voyageur and his hearty nature, his love of the free life and the wilds, his ability to live in complete harmony with the Indians. These intrepid backwoodsmen became a central motif in the works of both the artist and the writer. When Ralph wrote a story for *Harper's New Monthly Magazine,* "Talking Musquash" [muskrat], it was logical that he would call on Remington for the illustrations. This black-and-white oil served Ralph well.

Sid W. Richardson Foundation Collection. 1892. Oil (black and white) on canvas. 24 x 36″ (61 x 91.4 cm.)

25. Vignette from Henry Wadsworth Longfellow, *The Song of Hiawatha* (Boston: Houghton, Mifflin, 1891), p. [229]

24. *End of the Trail*

For a number of years there has been debate regarding the authenticity of this painting. Some students of Remington have argued that because of its painterliness and the existence of a human skeleton in the foreground it seems out of character with the artist's known work. Others claim it is quite in accordance with Remington's later Impressionist bent and illustrative of his inherent reverence for and fascination with the hardships of the wilderness. Upon close examination the picture reveals more than one of Frederic Remington's qualities.

In many details the painting corresponds to a small vignette of a backwoods cabin which appeared in *The Song of Hiawatha* (plate 25). When Remington was granted the sizable commission to illustrate Longfellow's momentous work, he was enamored of the Adirondacks and held a particularly fond place in his heart for Cranberry Lake, on whose banks were, no doubt, scattered disheveled cabins of this sort, part of a long history of the first white men who braved its lonely shores.

c. 1892. Oil on wood panel. 28 x 18⅛ " (71.1 x 45.9 cm.)

26. The Puncher

This painting was a pure characterization of the puncher, Remington's pictorial embodiment of the frontier type. All of the common attributes are here: rugged individualism, candid self-approval, and willingness to face the horizon of another day. Remington very much wanted this portrait to be archetypal, because it was dedicated to another devotee of American caricature, Howard Pyle. It was painted expressly for his friend and associate, and the story behind its inception is best told by Pyle's biographer, Charles D. Abbott:

> In November, 1894, in illustration to an article by Thomas Janvier, appeared a most dramatic picture, "Pirates Used to Do That to Their Captains Now and Then." It came to the attention of Frederic Remington, in whom Howard Pyle had found a congenial fellow artist. Remington immediately took a decided fancy to this picture and wanted it. An exchange of work was suggested. " 'Too good—too good,' " writes Remington on January 15, 1895. "The pirate captain dead on the sand. If I get that I will worship you, it, and once more take stock in humanity. As for what you will get—anything I have. I have nothing which is good in oil—sold out and have done nothing but potboil of late. The best thing I have is a big wash drawing now being reproduced for the market in actual size (retail price $10) a bucking horse, going like the sweep of an angel's wing. I shall probably not paint until spring, but whatever you see of mine which suits your fancy, is yours."

Sid W. Richardson Foundation Collection. 1895. Oil on canvas. 24 x 20¼" (60.1 x 51.3 cm.)

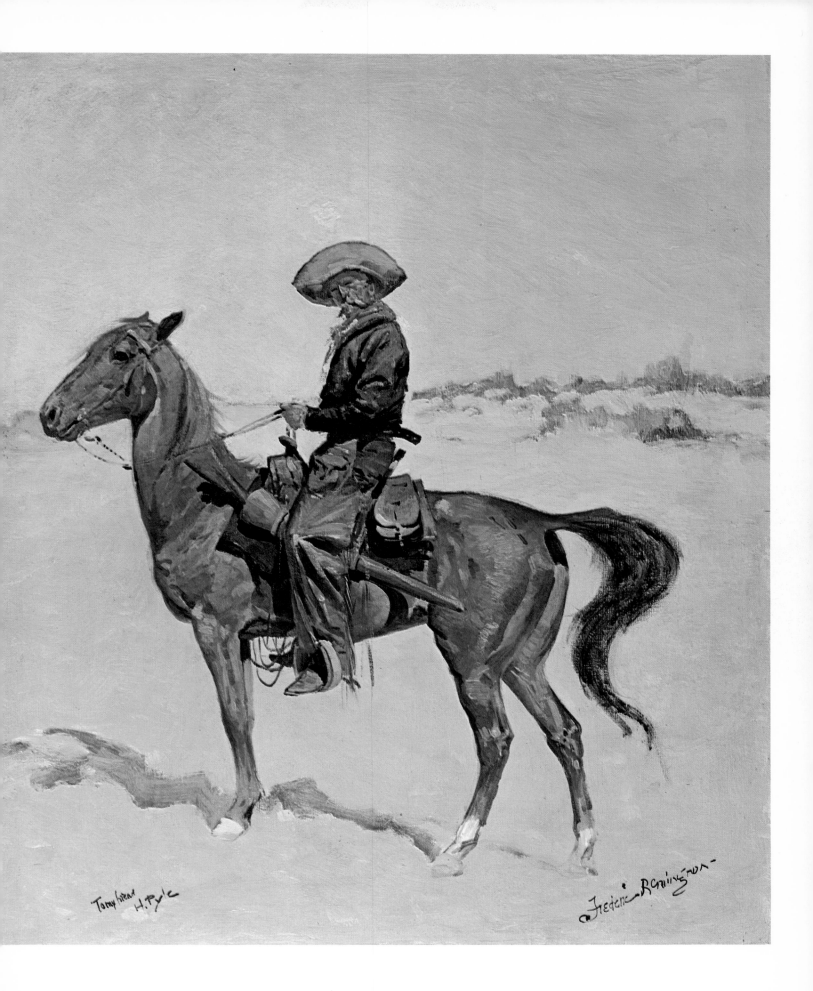

Tom friend
H. Pyle

Frederic Remington

27. The Fall of the Cowboy

By the end of the Civil War, a number of enterprising Texans concluded that ready profits could be made from the thousands of scraggly wild longhorns which roamed the wide valleys and mesquite-covered hills. These astute entrepreneurs hired the first cowboys to round up the beeves and push them north to the railheads of Kansas and Missouri. Their success stirred the nation almost overnight. The bellowing herds, branding-iron fires, cow towns, and punchers covered the prairie, disproving the long-held fable of the "Great American Desert." By 1880 the Western plains became a virtual cattle kingdom, and from the new Eldorado emerged a legendary figure—partly sired by the boom and partly its own progenitor—the cowboy.

But overstocking of the range caused the cowboy, practical as he was, to experience only a brief career. His heyday ended with the close of the open range, where "range lines" rather than fences separated one ranch from another. Owen Wister, writing of the puncher in 1895, was already aware that the golden age of the American cowboy had come to an end.

> And what has become of them? . . . Except where he lingers in the mountains of New Mexico he has been dispersed. Three things swept him away—the exhausting of the virgin pastures, the coming of the wire fence, and Mr. Armour of Chicago, who set the price to suit himself. But all this may be summed up in the word Progress. When the bankrupt cowpuncher felt Progress dispersing him, he seized whatever plank floated nearest him in the wreck. He went to town for a job; he got a position on the railroad; he set up a saloon; he married, and fenced in a little farm. . . . In these capacities you will find him to-day. The ex-cowboy who set himself to some new way of wage-earning is all over the West, and his old courage and frankness still stick to him, but his peculiar independence is of necessity dimmed.

In the somber oil which Remington painted as an illustration for Wister's article on the cowboy, the melancholy associated with the demise of a once picturesque American figure is captured with empathy and reverence.

1895. Oil on canvas. 25 x 35⅛" (63.3 x 89.3 cm.)

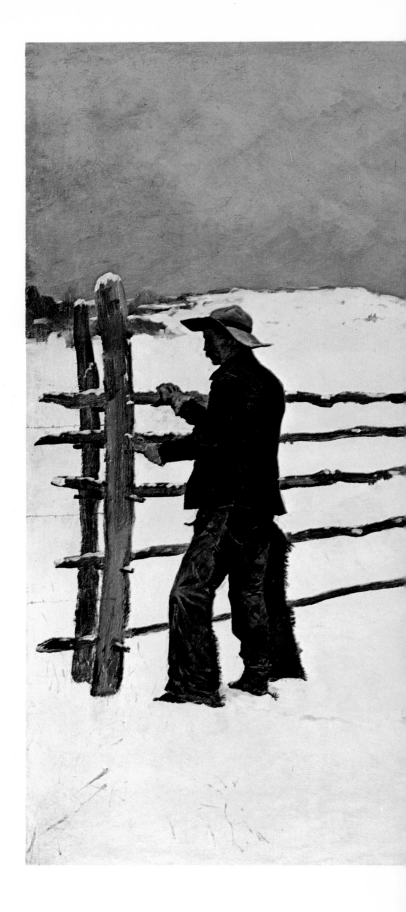

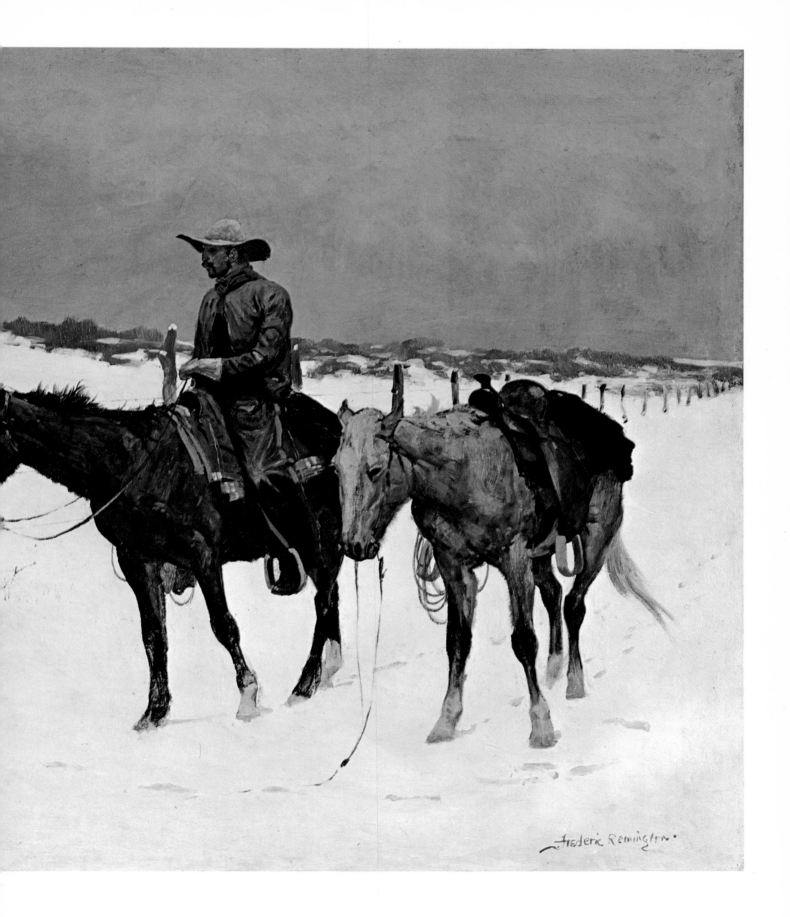

28. His Last Stand

For Remington and his Western cronies, bear-hunting served a dual function. First, it was sport—man pitted against the most ferocious of all beasts. Secondly, and more importantly, the hunt was undertaken to rid ranchers of a costly predator who threatened the well-being of their stock. On the bear-chase that Remington joined at the Montague Stevens Ranch in northwestern New Mexico in 1895, the local villain, a huge grizzly, cost the proprietor, "roughly estimating, about $416 a year to support, since that about covers the cattle he kills."

The composition of mounted men and dogs surrounding a bear is one used often by Remington. A picture, *At Bay,* was illustrated in Remington's story "Bear-Chasing in the Rocky Mountains," and another,

At Last, in *Done in the Open.* Owen Wister wrote a poem for this latter version:

Three years he fooled us, smooth and slick,
From Spittin' Cat to Dewlap Creek;
Both sides the river he would spree
From Dutchy's to Bar-Circle-Zee.
We chased him most to break our backs,
And found just nothin' save his tracks.
Up, down, acrost, he ate his fill
O' steers and heifers, too, until
Down by Dinwiddie's cañon rim
We handed our respects to him.

Sid W. Richardson Foundation Collection. 1895. Oil on canvas. 25⅜ x 29⅜" (64.4 x 74.7 cm.)

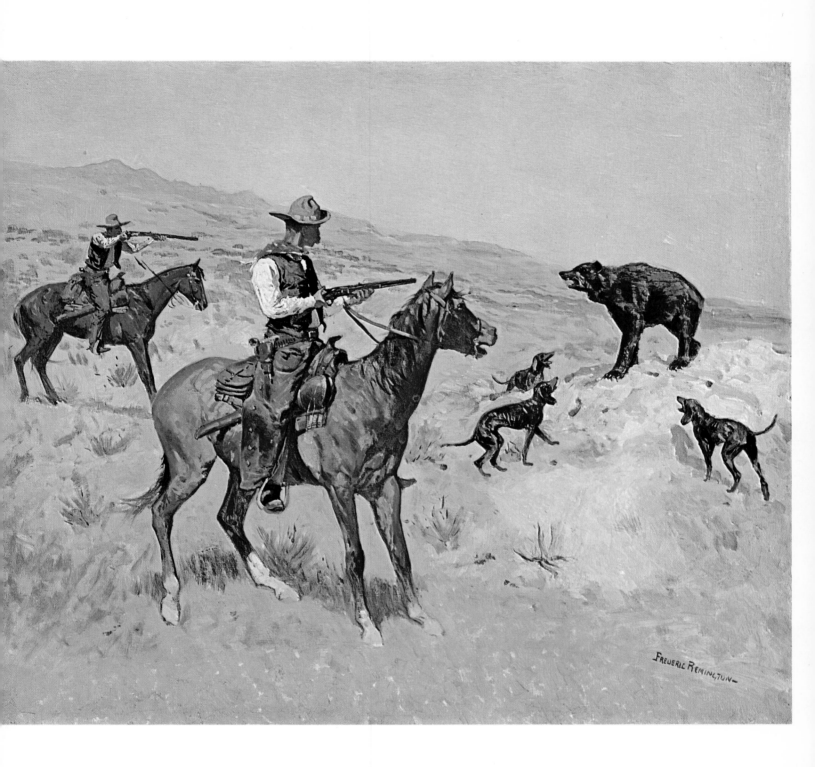

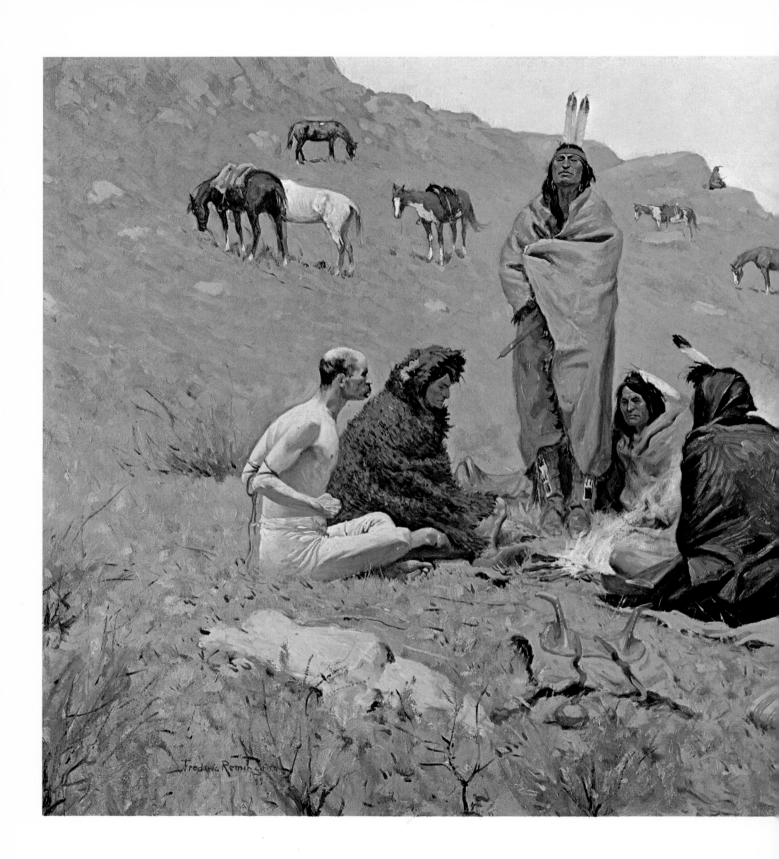

29. Captured

Few soldiers captured by their enemy during the Indian wars lived to see home again. In one way or another they came to their end; it was only a matter of time. The trooper depicted here is already suffering from the cruelty of his foe. Stripped of his garments and bound with rawhide, he is forced to sit away from the fire while his captors blanket themselves against a chill wind. He knows death is certain, and he is painfully aware, too, that the last hours of his life will pass slowly, if not torturedly.

Sid W. Richardson Foundation Collection. 1899. Oil on canvas. 27⅛ x 40⅛″ (69 x 101.8 cm.)

30. Her Calf (overleaf)

The buffalo was the basic unit of the Plains Indian economy. From the shaggy monarch of the prairies came food, clothing, shelter, and even fuel. So dependent on the buffalo was the Indian that the beast became the central object in his religious, political, and social life. Where the buffalo roamed, the Indian did likewise, and when the two met, the hunt was on.

Pursuing the buffalo required the cooperative efforts of the whole tribe, the men killing and the women and children butchering. The surround was the most common method of subduing the prey. Hunters would circle the herd at a good distance and then close in until their scent was picked up and the herd began to rumble in one direction or another. The strategy involved keeping the beasts moving in a circle, systematically eliminating those on the periphery. When the stampeding force invariably broke through the line of men and horses, success depended on the riders' skill and the horses' endurance.

In this picture, a confused calf has broken from the pack, followed by its anxious mother. Tender veal was an especially savory item for the Indian, who ate much of the fresh kill on the spot without cooking. The calfskins, too, were highly prized. No doubt this mother and child served some family a lavish meal before sundown. The jackrabbit probably got away.

1897. Pen and ink wash drawing on paper. 21¼ x 38¼″ (54.0 x 97.2 cm.)

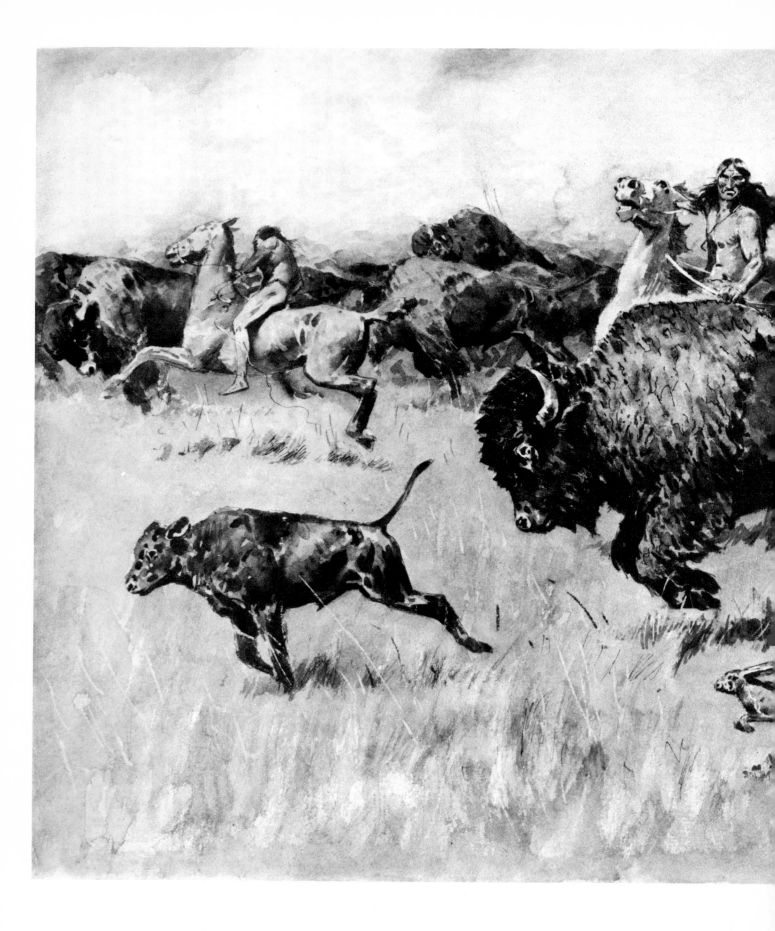

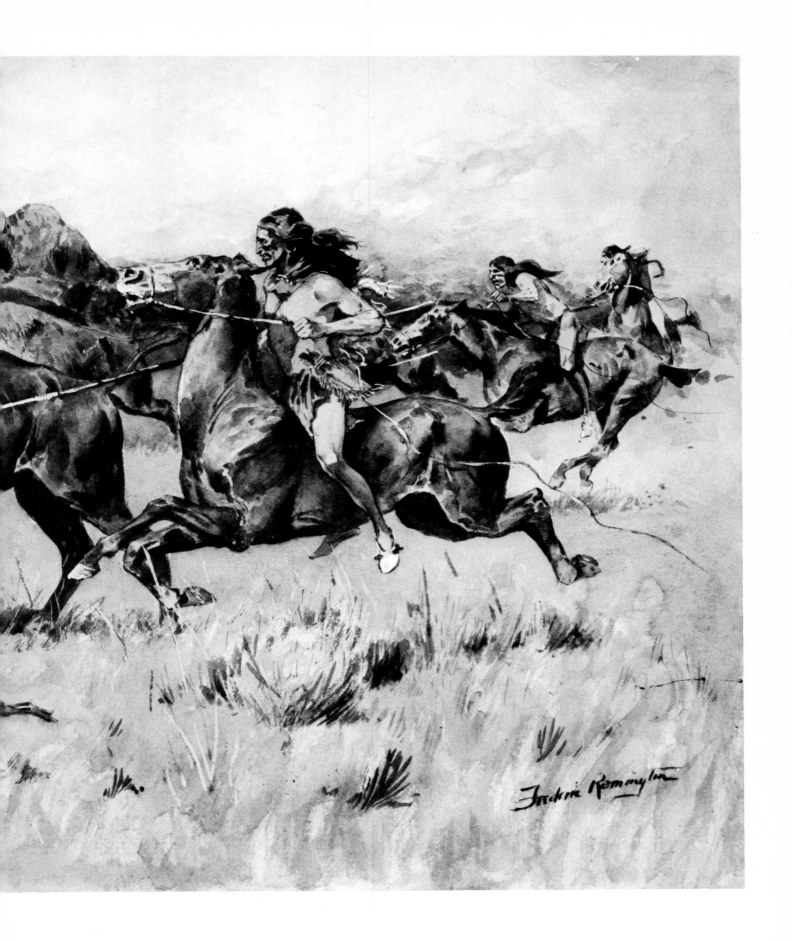

31. "The Right of the Road"– A Hazardous Rencounter on a Rocky Mountain Trail

Few fads have caught on in America with as much enthusiasm as the sport of bicycling in the final decade of the nineteenth century. Two-wheelers, four-wheelers, tricycles, and tandems were such a craze that by 1895 as many as 300 separate manufacturers were turning out varieties of bicycles for every age, size, and pocketbook. Getting a wheel offered a return to nature, a healthy respite, and an opportunity to ride, perhaps in a somewhat wobbly style at first, among the elite. Cycling clubs proliferated, and the monthlies, weeklies, and medical journals were filled with articles on the wonderful world of wheels.

Even Remington forsook his horse in these days and took to handlebars and pneumatic tires. He wrote Poultney Bigelow, himself a two-wheel enthusiast, in 1897: "I am riding bike–it's great fun. Everyone in America is riding bike. It makes the grease come out of a fellow and is the greatest thing to produce a thirst for beer–besides, any one can desecrate the sabbath on a bike and be forgiven by the other U. S. As.–who all do the same. In that respect it is like going to Hell–everyone is there whom I like."

Cycling was not only the amusement of a few lazy laps around the park. Overland touring became a popular pastime requiring stamina and, in those days, a considerable measure of courage. Hazards presented themselves at every turn, and, as Remington illustrated in *The Right of the Road,* the dangers were not limited to pedalers alone.

1900. Oil (black and white) on canvas. 27¼ x 40¼" (69.3 x 102.3 cm.)

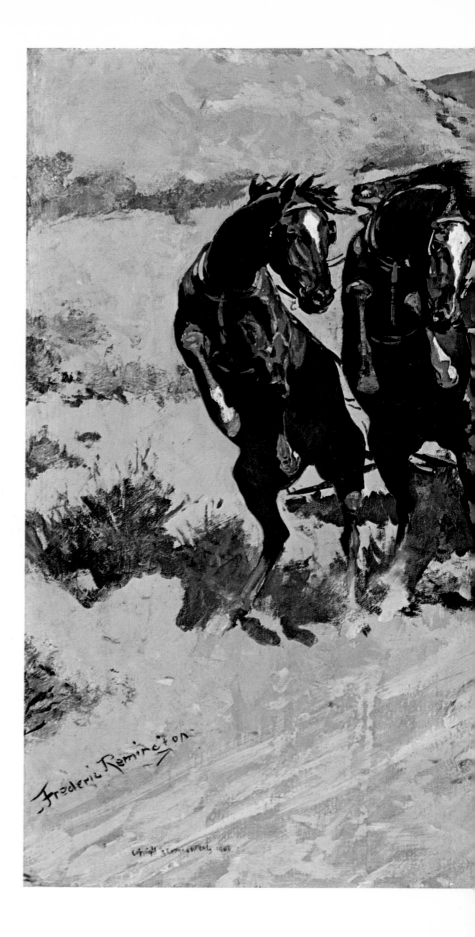

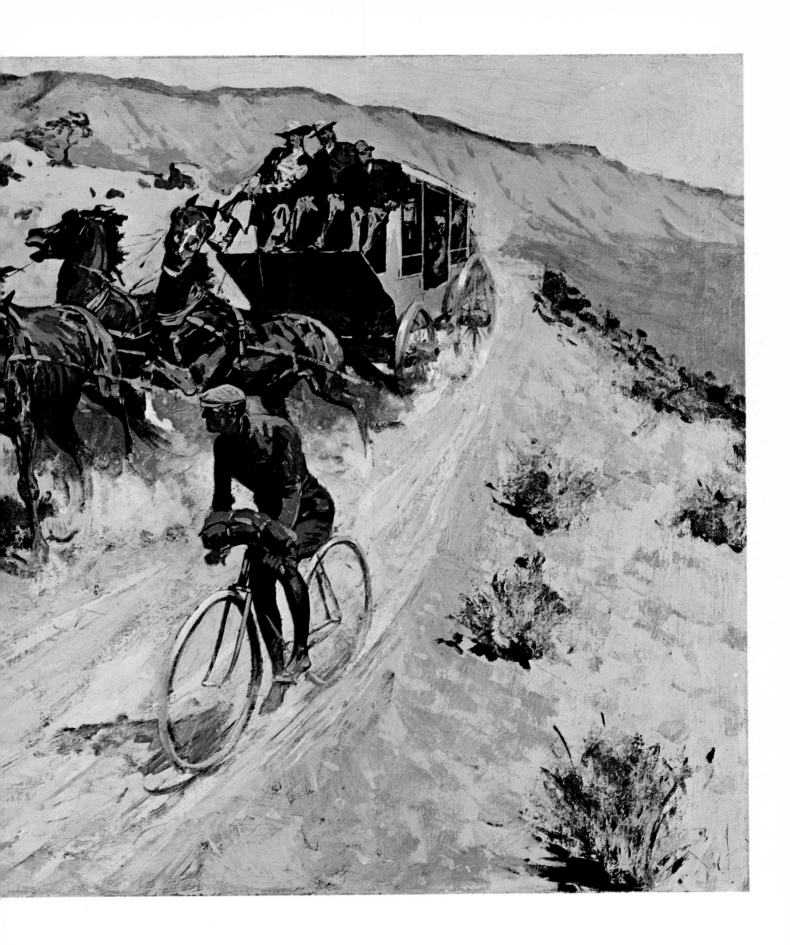

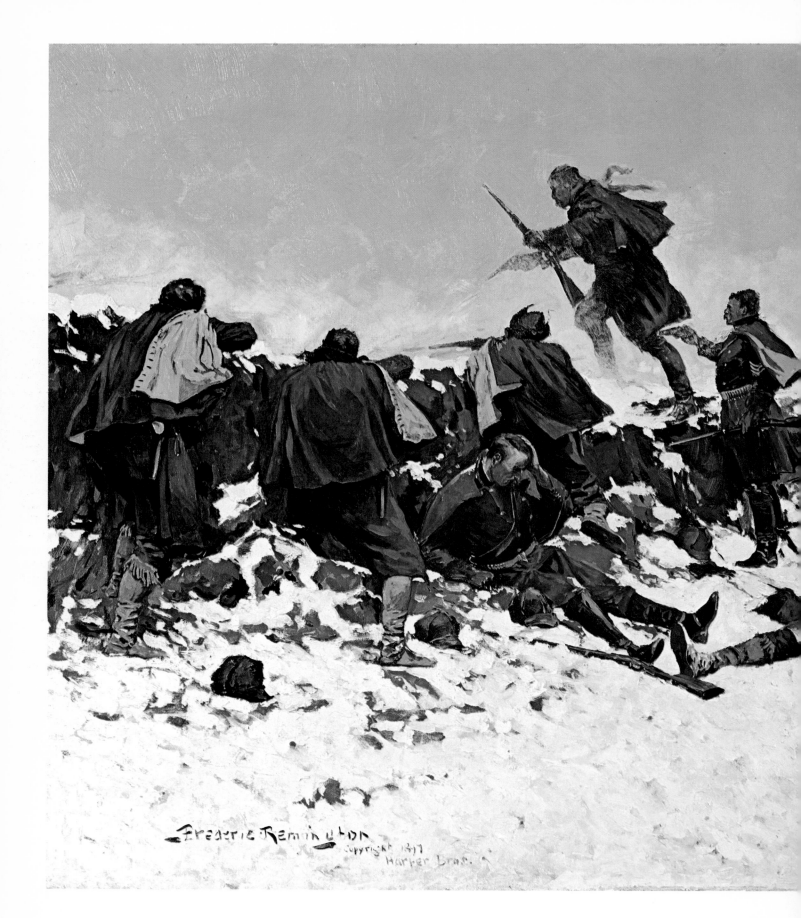

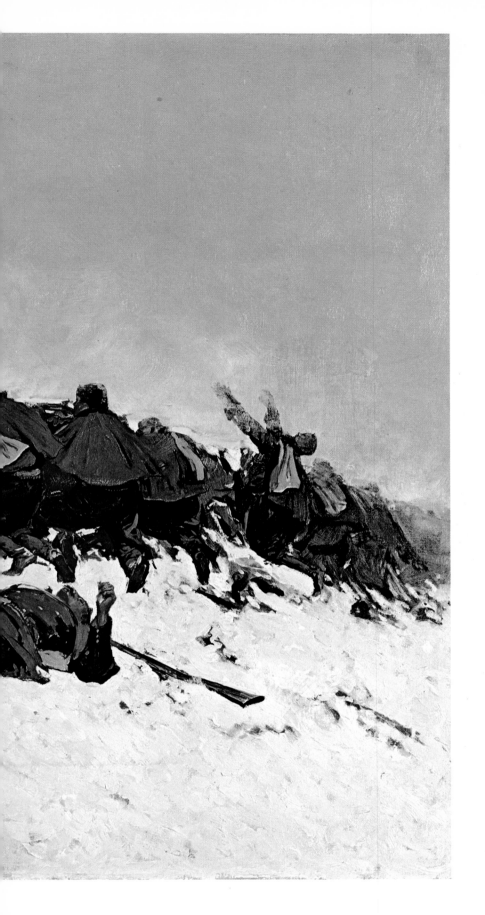

32. Through the Smoke Sprang the Daring Young Soldier

On a cold, gray November morning in 1876, General R. S. Mackenzie with a force of about eleven hundred thundered into Dull Knife's camp of Northern Cheyenne on Crazy Woman's Fork of the Powder River. So brutally were the Cheyenne defeated that, although many escaped to spend the remaining part of the winter with the Sioux of Crazy Horse's village, Dull Knife surrendered his people and himself to the federal troops the following spring.

The Northern Cheyenne endured about a year of hunger and ague before deciding to return to their own land. In October of 1878 two main bands struck the homeward trail. They were continually harassed by the soldiers, but pressed on with determination.

But peace was not their lot. They were taken into custody and garrisoned at Fort Robinson. During the next three months the Cheyenne were given freedom to move about the fort and even hunt in the surrounding hills with the proviso that they were all accounted for at suppertime each night. Not many weeks passed before one of the Indians took advantage of the situation and did not return to the post. This automatically cast an aura of distrust over the entire band, and the military command cut off rations to the Indians in hopes of forcing their return south. Dull Knife refused to concede; he saw death as preferable to the long journey back to Indian Territory.

On the snowy afternoon of January 9, 1879, Little Shield, one of the soldier chiefs, beckoned the weakened, desperate group of proud men, women, and children around him and spoke: "Now, dress up and put on your best clothing. We will all die together. . . . We will never go out and give up to these people to be taken back to the country we ran away from. We have given up our horses and our arms, and everything that we have, and now they are starving us to death. We have been without food and fire for seven days; we may as well die here as be taken back south and die there." And die they did. With five rifles and eleven pistols the band of about one hundred and fifty broke from the barracks that night. By daybreak the next day the soldiers had brought in over fifty stiffened bodies. They were unloaded from the wagons like logs. Before the pursuit was over, about half the Cheyenne perished, a few succeeded in escaping, and the rest were returned either to the south or to the Pine Ridge Agency.

1897. Oil on canvas. 27¼ x 40⅛″ (69.2 x 101.9 cm.)

33. The Cow Puncher

Remington's works, which embodied the spirit of Western types, were disseminated widely. While the original paintings and drawings were seen by only a small audience, reproductions reached thousands of Americans either in book form or as prints. As such, his work provided the public with an inexpensive, yet unique, pictorial record of Western history and life.

The painting *The Cow Puncher* is a notable example of the broad distribution of Remington's pictures. *Collier's* published this black-and-white oil originally as a frontispiece in its issue for September 14, 1901. The magazine's circulation in that year alone was 300,000, and the picture drew special attention because of an accompanying poem by Owen Wister:

No more he rides; yon waif of might;
His was the song the eagle sings;
Strong as the eagle's his delight,
For like his rope, his heart had wings.

The critic Perriton Maxwell, in an article on Remington in which *The Cow Puncher* was illustrated, praised Remington for his realism. "Remington more than any other man that wields brush and pencil is godfather of the whole race of pictured cowpunchers. . . . For a quarter-century this delineator of the West in its wildest and woolliest aspects has insisted on the reality of the cowboy. . . . "

Sid W. Richardson Foundation Collection. 1901. Oil on canvas. 28⅞ x 19″ (73.5 x 48.3 cm.)

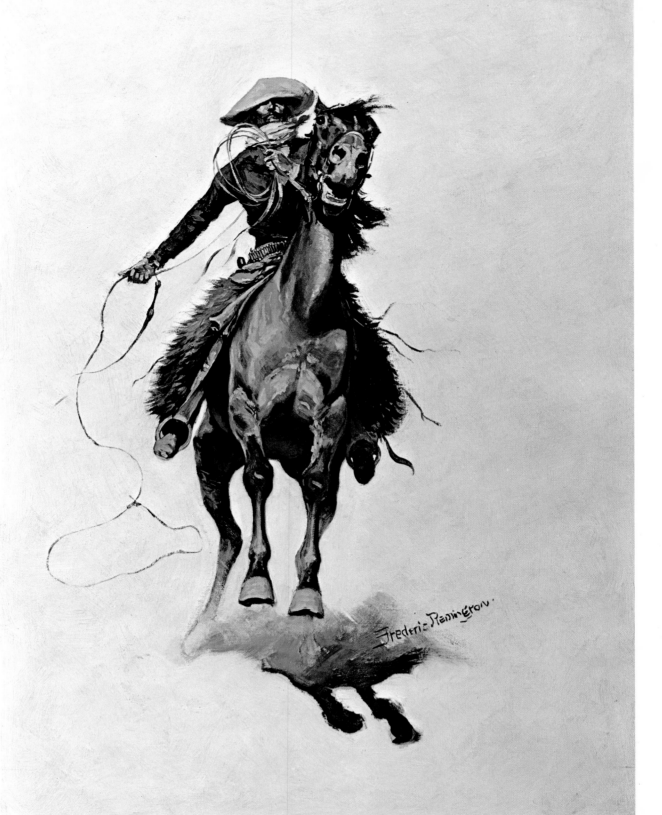

34. A Sioux Chief

In 1901, with the encouragement of the publisher R. H. Russell, Remington produced eight pastel drawings which were published as a portfolio of color lithographs under the title *A Bunch of Buckskins*. Shortly after the publication reached the market, Remington wrote Wister, who had written the introduction for the set of prints. "I think the pastels will be all right—did they send you the portfolio? When the shoppies put them in their windows passing fire engines will stop & hook onto the adjoining hydrant." It was an extremely popular set. The few original pastels which it reproduced provide an opportunity to view Remington's facile handling of this medium.

Sid W. Richardson Foundation Collection. 1901. Pastel on art board. 31⅞ x 22⅞" (81 x 58.1 cm.)

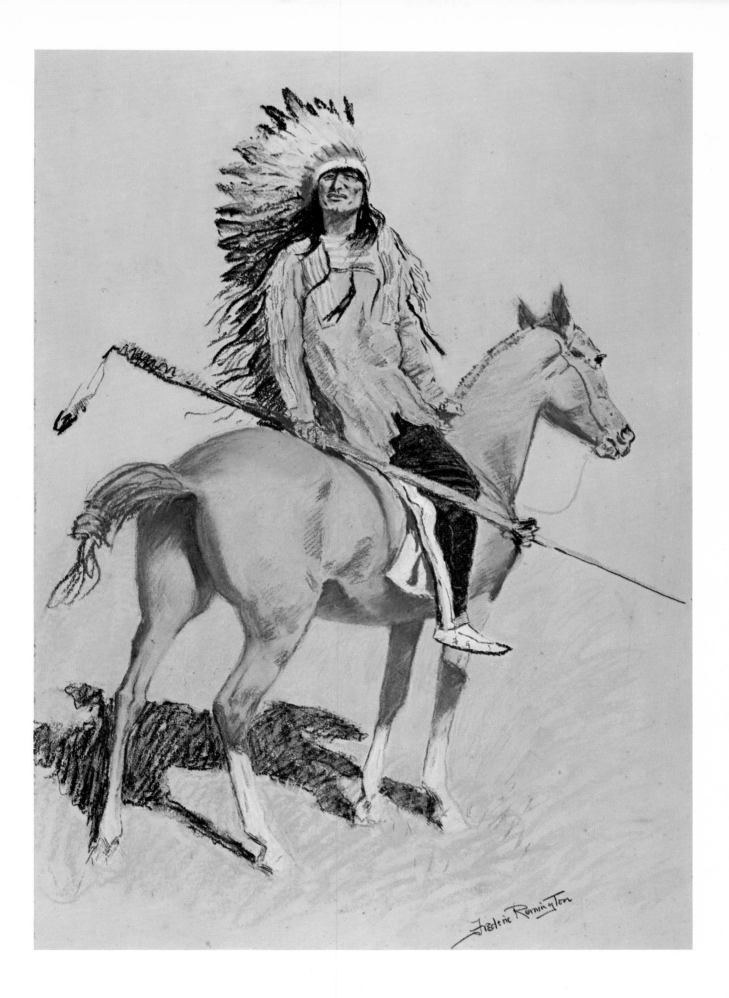

35. Infantry Soldier

This pastel drawing of an infantry soldier was used on the cover of Remington's book *Done in the Open* (1903). One of the purposes in compiling this bound portfolio of drawings and paintings was for the artist to set straight the American public's conception of their men in uniform. Owen Wister, who wrote the introduction, pointed out Remington's unique contribution toward popular understanding of the military. "How very different an impression of our American soldiers of to-day has the work of Frederic Remington given us! How well we all know the look of Remington's sergeant, the look of Remington's private! How our eye has been educated by Remington to perceive and note the differences between the trooper and the infantry soldier! For Remington with his piercing and yet imaginative eye has taken the likeness of the modern American soldier and stamped it upon our minds with a blow as clean-cut as is the impression of the American Eagle upon our coins in the Mint. Like the Mint, he has made these soldiers of ours universal currency, a precious and historic possession."

1901. Pastel on paper. 29 x 15⅞" (73.7 x 40.4 cm.)

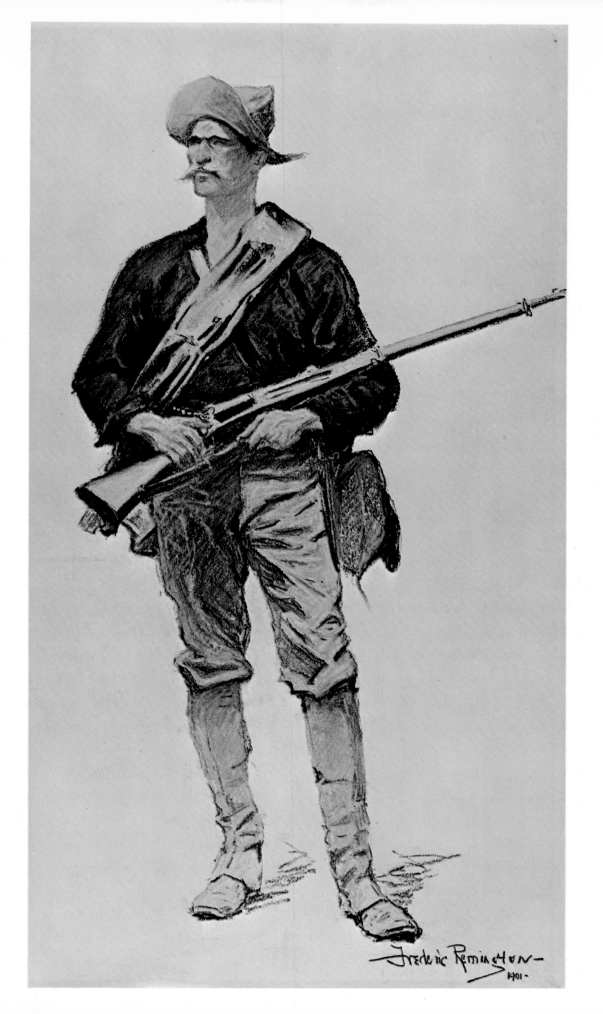

36. The Hold-Up

The Hold-Up was painted by Remington to illustrate
Richard Harding Davis's amusing tale of Ranson's folly.
Young Lieutenant Ranson, bored with his plight as a
garrison officer for a small, languid Indian post in
Central Kansas, longed for the action he had known
during the Philippine campaigns of the Spanish-Ameri-
can War. The West, he openly contended, was nothing
more than exile, and he threatened either to resign his
commission or to take some drastic measure to relieve
the tedium.

One evening, having decided to test the second
alternative, Ranson challenged two fellow officers to a
fifty-dollar bet. Wagering that he could successfully
mimic a local bandit known as the Red Rider, Ranson
donned a cape and mask. He assured his fellow officers
that there was really nothing dangerous about this
business of highway robbery. To prove his point, he
took up a large pair of scissors, rather than a six-shooter,
and rode off to intercept the incoming stage. The ruse
turned out a success even though the charlatan brigand
took nothing. Allowing that the cargo and personal
belongings were unworthy of his nefarious potential,
Ranson threw back his head in feigned disgust and rode
off into the dark. He took no jewels, but he did win the
bet.

Ultimately Ranson's plot was exposed when the real
Red Rider showed up. But Ranson was undaunted. He
cleverly won the hand of the post trader's lovely
daughter, whereupon they left the not-so-wild West
behind.

1902. Oil on canvas. 27½ x 40⅛″ (69.7 x 101.8 cm.)

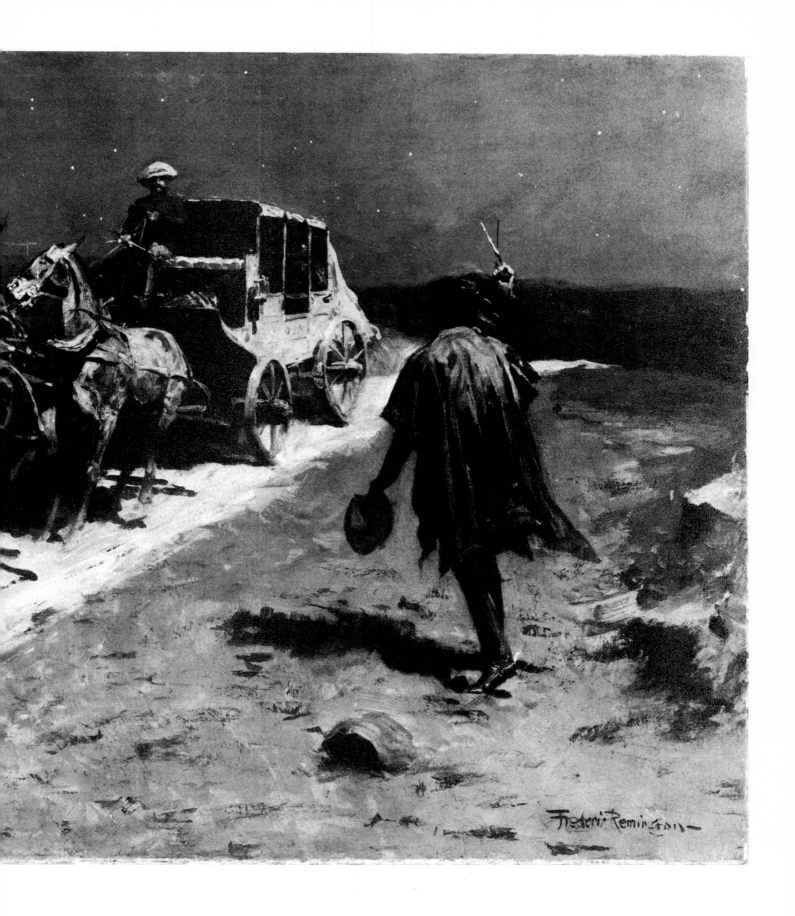

37. The Old Stage Coach of the Plains

The Butterfield Overland Mail was a true revolution on wheels. Leaving Tipton, Missouri, the western terminus for train travel, the Overland "road" followed a southerly loop to San Antonio and El Paso, where it turned northwest to Fort Yuma, Los Angeles, and San Francisco. The Concord Coaches, named after their site of manufacture in Concord, New Hampshire, swayed across the plains, averaging over 125 miles a day on the dusty 2,812-mile traverse. The drivers, many of whom came from New York state, were described by one of the first passengers on the Overland Mail as being, "on the whole, fine and with few exceptions experienced men. Several are a little reckless and too anxious to make fast time; but as a general thing, they are courteous." The horses were a sturdy lot, trained to "perform the laborious run with apparent pleasure and delight." The teams varied in size according to the size of the load and the character of the coach, with the typical count numbering four, five, or six. In the perilous Indian country between Fort Belknap, Texas, and Fort Yuma, California, the Overland employed mules as replacements for horses. The coaches rolled night and day, stopping only to change teams or drivers and occasionally to provide the passengers with the common fare of beans, bacon, bread, and that brown liquid Westerners had the temerity to call coffee. Digesting the unsavory meal while being bounced out of one's seat was a difficult task, while sleeping on the coach challenged even the most somnolent.

In 1901, the writer Emerson Hough was beginning to find his place in American letters. His interest in the American experience led him to write a series of articles for *The Century Magazine* on the settlement of the West. Hough's perceptive treatment of the history of the Western movement dealt in large measure with transportation facilities as they developed beyond the Mississippi. Remington was asked to illustrate Hough's documentary account, and the commission inspired one of the artist's most successful early nocturnal paintings, *The Old Stage Coach of the Plains*. Here Remington was able to capture the jostle of the rambling stage, the suspense of a night's ride through dangerous Indian country, and the beautifully subdued illumination of a clear moonlight night. The silhouetted figures of the driver and armed guard top the vertical composition and add an air of mystery as do the ghost-like riders who sit beside the driver in the box.

1901. Oil on canvas. 40¼ x 27¼" (102.0 x 69.0 cm.)

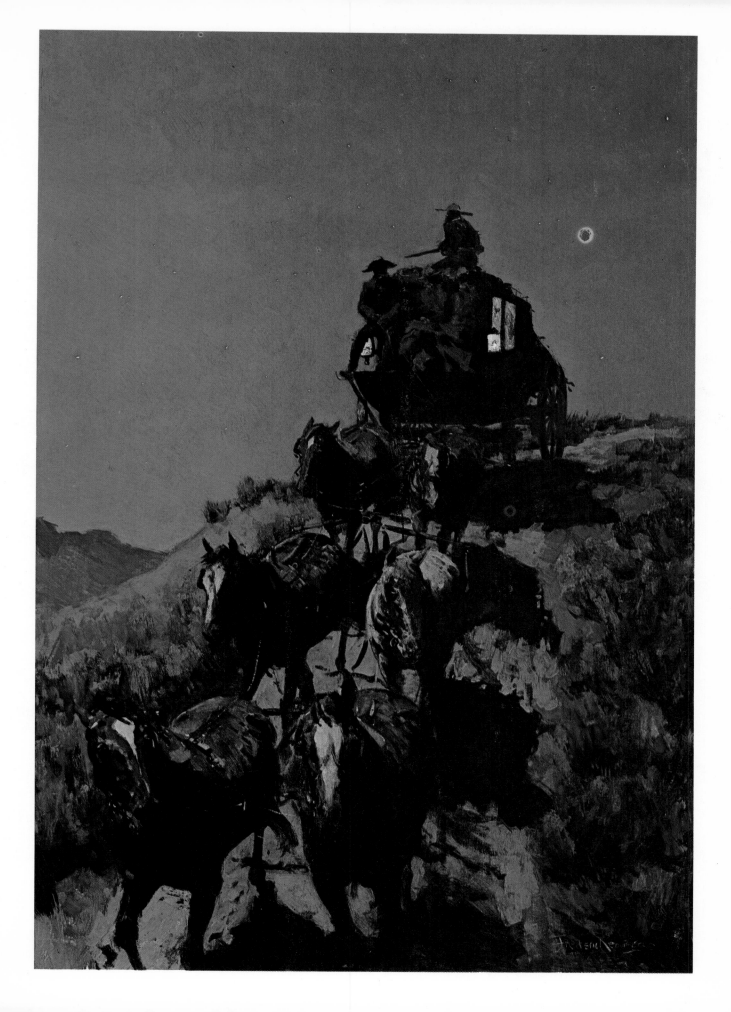

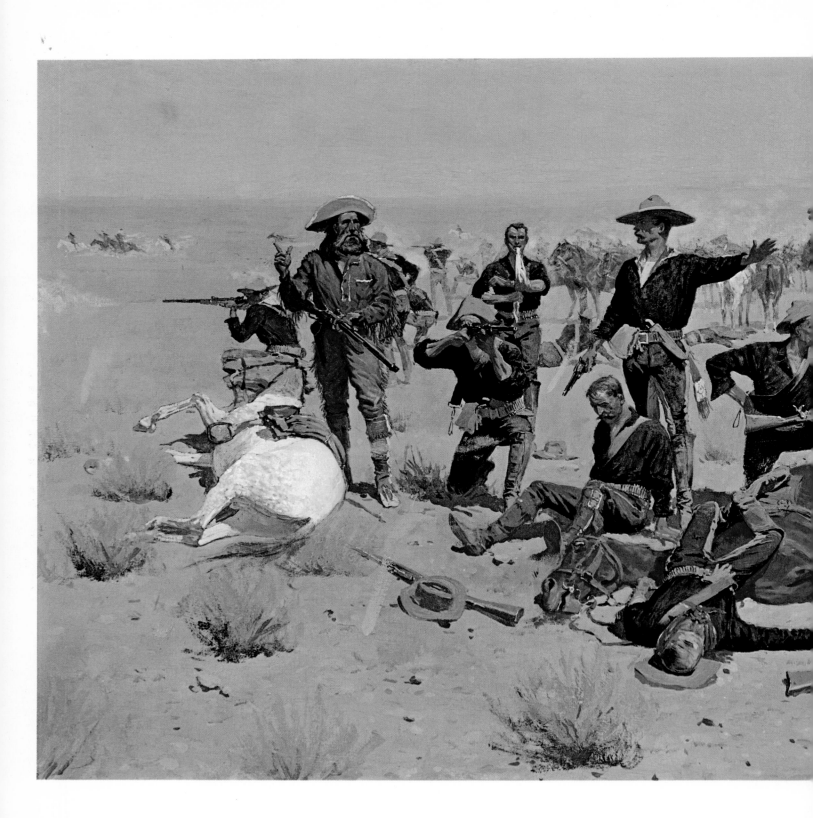

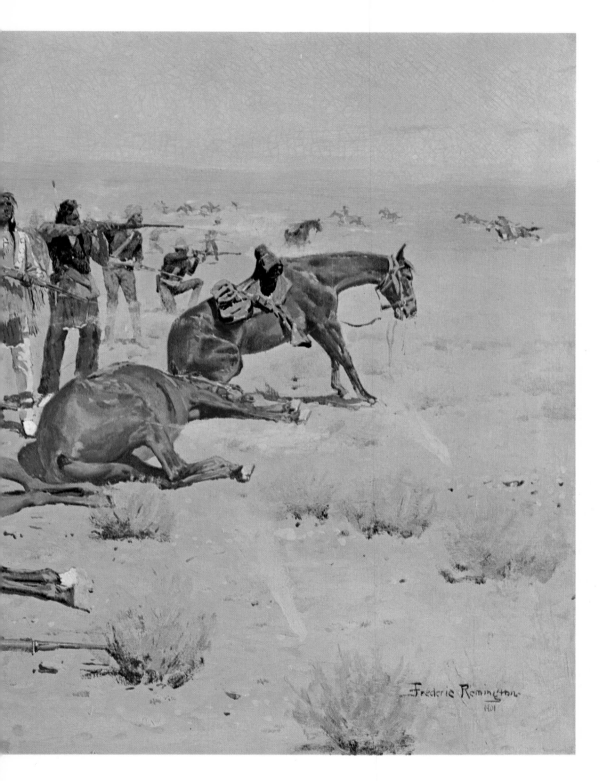

38. Rounded-Up

Getting caught in the middle of a circling band of Sioux was a quick way to end a military career. It meant either falling in a volley of lead or surrendering to the grim fate of torture. One other approach, when defeat seemed inevitable, was to reckon up courage and hold out for a parley. If the perimetric foes fell for the ploy, nothing was lost. With luck, the bearded scout or his two Crow friends could talk the survivors out of the fix, all still wearing their original hair pieces.

Sid W. Richardson Foundation Collection. 1901. Oil on canvas. 25¼ x 48¼″ (64.0 x 122.5 cm.)

39. The Cowboy

Running wild horses out of the foothills brought employment to many punchers whose nominal livelihood had ended with the demise of the great cattle companies. The cowboy took to the job with typical gusto and was the first to admit it was better than pushing "woollies" or sitting idle all day cussing the homesteaders, or "honyonkers," as he called them. So, although his days were numbered, the cowboy still filled them with hard riding.

Remington had a vested interest in this colorful character as legend and type, and though lamenting his downfall, he willingly documented his galloping plummet from the prairies into the pages of history. "With me," wrote Remington in 1895, "cowboys are what gems and porcelains are to others."

The artist used this painting as one of four illustrations in a pictorial essay on "Western Types" published by *Scribner's Magazine* in October, 1902. The caption, which was probably written by Remington himself, described the scene in the following words: "No longer strange, and becoming conventional, the cow-boy is merely trying to get mountain-bred ponies to go where he wants them to go. Knowing the 'Irish Pig' of their nature, he has to be fast and insistent; all of which represents a type of riding and pony 'footing' easier to delineate than to perform."

1902. Oil on canvas. 40¼ x 27⅜" (102.0 x 69.6 cm.)

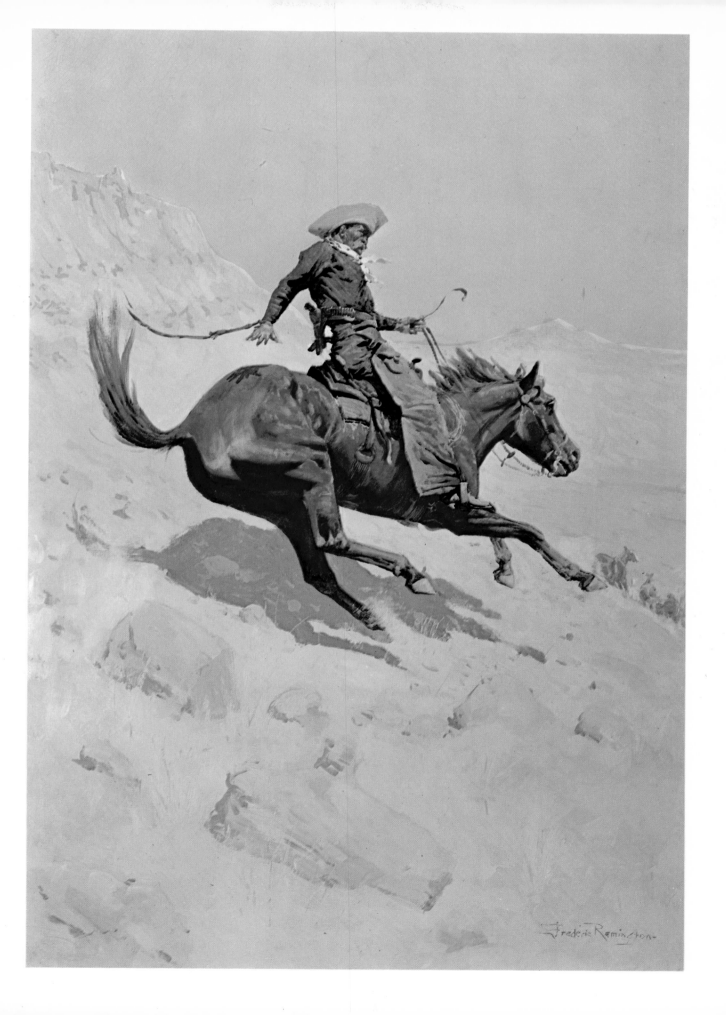

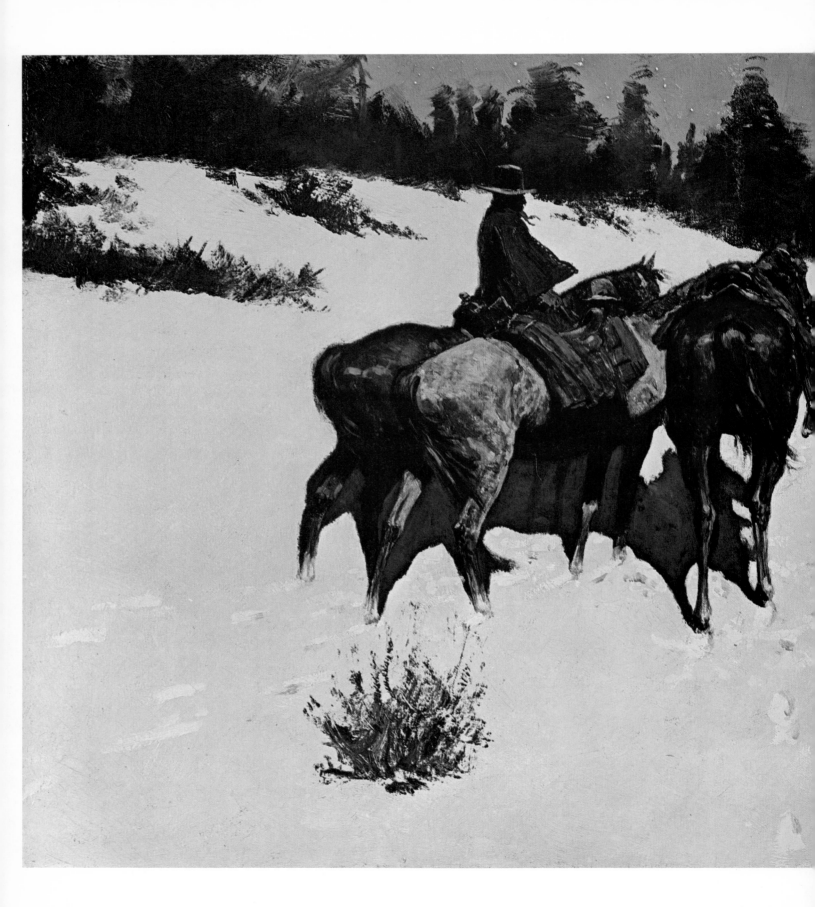

40. A Reconnaissance

The hours after dark quite often proved the most opportune time for the cavalry to track its elusive enemy, the Indian. The officer in charge of a small reconnaissance party has dismounted along with his scout and climbed to the crest of a hill from which they search the wooded area before them in the hope of spotting a clue, perhaps the flicker of a campfire or a slight column of smoke, which will lead them to their foe. Tonight, nature is on their side. The full moon lights their way, and the fresh snow has muffled their approaching footsteps. But what they seek and what they see must be left to the viewer's imagination.

This canvas is a fairly early example of Remington's attempts at nocturnal painting. Even so, he has masterfully captured the feeling of the ghostly landscape frozen in silence and bluish moonlight. One can almost feel the chill breeze which flutters at the horses' tails and lifts the cape of the mounted soldier.

1902. Oil on canvas. 27¼ x 40⅛" (69.1 x 101.7 cm.)

41. His First Lesson

With a raw bronc the lessons are taken one at a time. The first and most important step is getting the neophyte used to the feel of a hackamore and saddle. This involves roping the beast, haltering him, and securing his right rear leg up so he can't bolt or run. Then one must slap the saddle on his back and wait for him to simmer down. If it happens to be a "Mexican cow saddle," which, according to Remington, is "a double-barrelled affair . . . [that] will eat a hole in a horse's skin and a pair of leather breeches at the same time," the instruction may take some time. But in the end, should the lesson prove successful, as it no doubt will, the surprised young bay may someday make a fine cow pony for the cowhand who is now his teacher.

The title for the painting *His First Lesson* was more prophetic than the picture itself would suggest. Aside from being an initiation for the horse, and perhaps the rider as well, it also represented a new plateau in Remington's art. It was the first Remington painting which *Collier's* published in color. Shortly thereafter Remington signed a contract with the magazine in which he agreed to furnish them a dozen comparable paintings each year in return for a $12,000 salary. The picture was first, too, from another standpoint. It represented Amon G. Carter's initial venture into the collecting of Remington's works.

1903. Oil on canvas. 27¼ x 40″ (69.2 x 101.8 cm.)

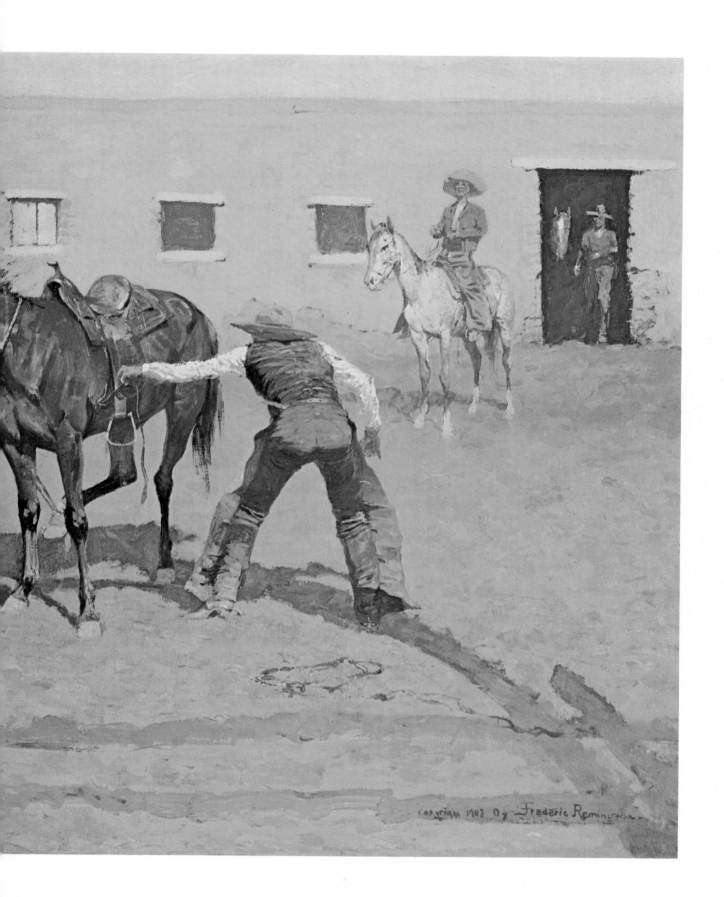

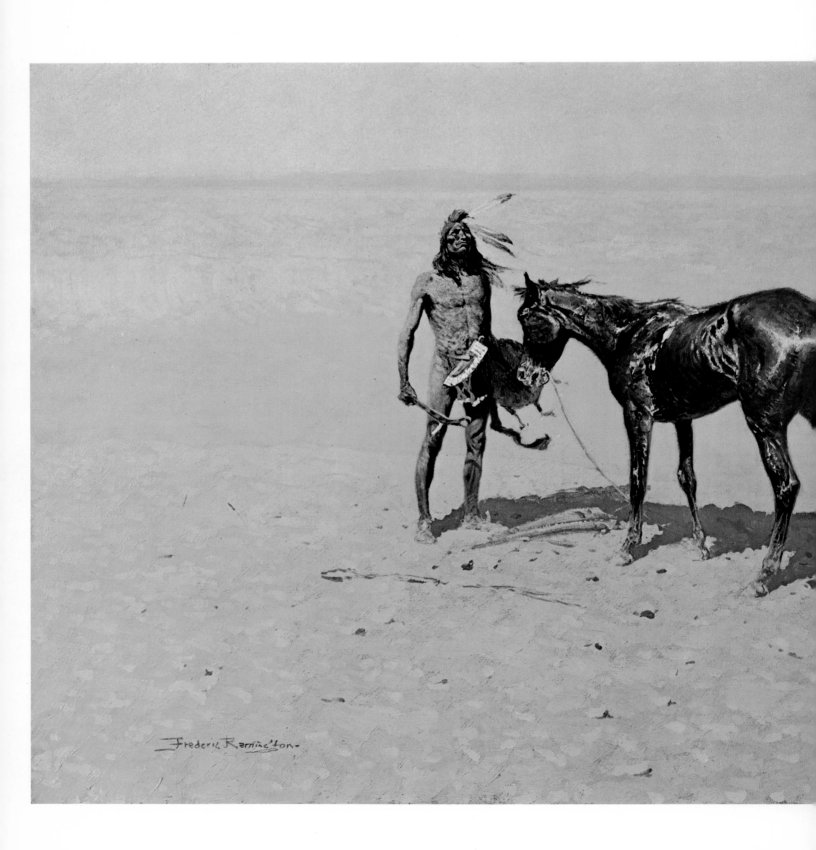

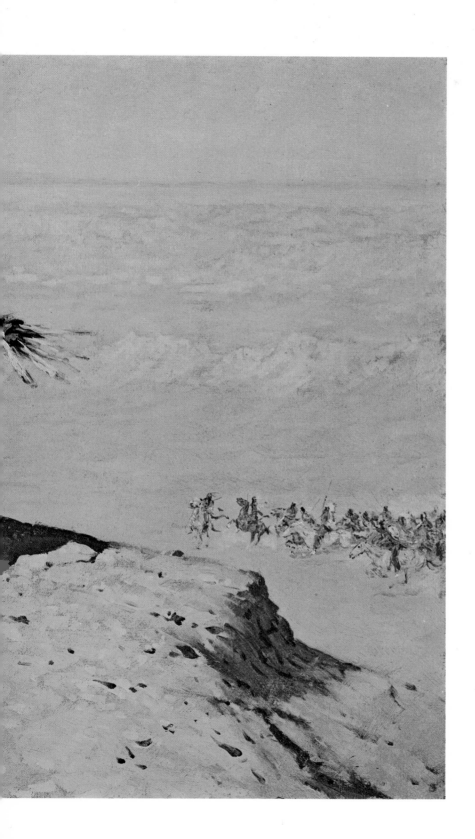

42. Ridden Down

In pre-contact years on the Great Plains, intertribal warfare was a necessity. The Sioux and other Indian nations, pushed onto the prairies by the encroaching whites, were forced to contend with each other for their own self-preservation. Coexistence did not come without bloodshed, and, even when a relatively stable territorial arrangement took shape, fighting between the various tribes continued as a means of status seeking. For most young braves, war became the essence of their self-expression, their raison d'être. Only through combat could they attain social prestige among their own people; only with an honorable death could they expect to achieve rapport with their gods. The Crow brave depicted here braces himself stoically for the ultimate. He and his spent pony, put to the final test, have been "ridden down"; it is now the Sioux's turn to figure destiny.

1905. Oil on canvas. 30¼ x 51⅜″ (76.8 x 130.4 cm.)

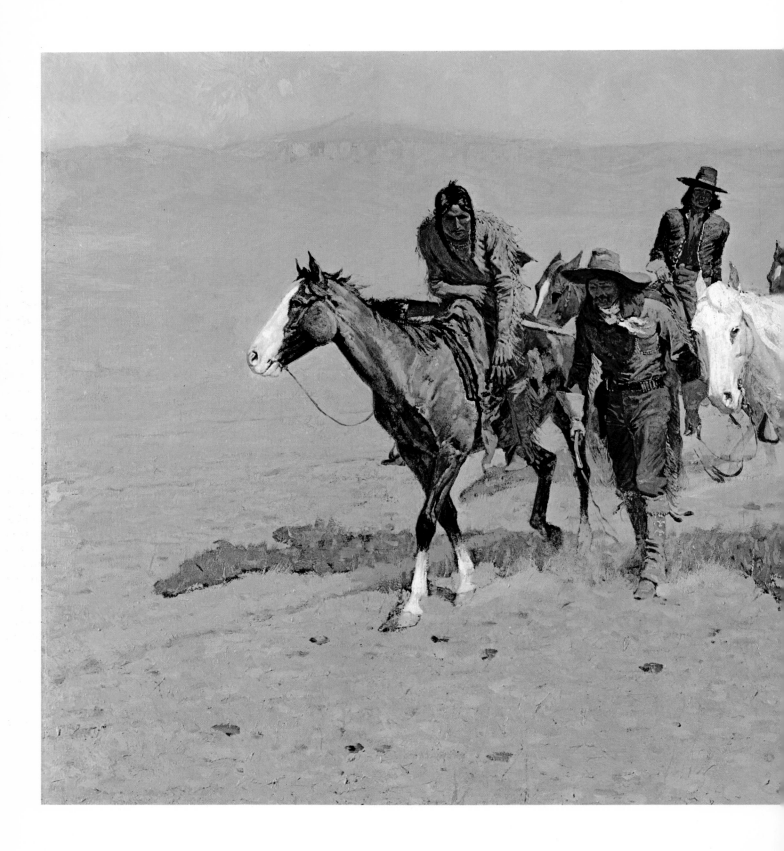

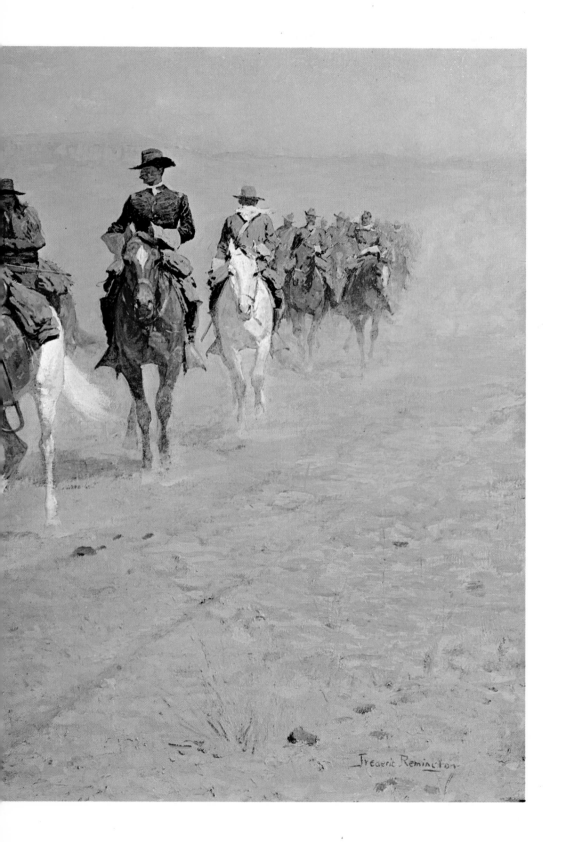

43. Pony Tracks in the Buffalo Trails

A group of scouts, in advance of a column of soldiers, intently searches the dusty floor of the prairie for signs of Indians. Among the complex crisscross of buffalo trails, a rounded hoof print, a discarded scrap, or a scattered bit of horse dung might alert the scouts to the direction in which the hunted party is traveling and set the troop on a new course.

This painting was the eighth in a series of twelve large oils made especially for *Collier's* to depict various phases in the Louisiana Purchase period of American history. The actual purchase of the vast tract of land, which took place under Jefferson's direction in 1803, proved to be the simplest chapter in that region's history. To own the giant piece of real estate, encompassing the drainage of the Missouri, Platte, Arkansas, and Red rivers, involved raising about $15 million; to explore, settle, and ultimately bring that area into the American body politic provided the nation's greatest challenge for the next hundred years. Remington felt a particular fascination for the saga that unfolded with the development of the American West, and he was able to capture in paint one of the important chapters, the military take-over of the Indians' domain.

1904. Oil on canvas. 30¼ x 51¼" (76.8 x 130.0 cm.)

44. *Apache Medicine Song*

The plaintive, high-pitched wail of an Apache song, punctuated by the pulsating monotone of a drum cadence, fills the dry chill of the Arizona night. Perhaps in the shadows of the adobe structure a shaman works his wonders on someone who has fallen ill, while the singers around the fire become more and more entranced by the sparkling flames and the whine of their own voices.

This painting is a fine example of Remington's late, Impressionist style. The jade-green moonlight enshrouding the seated figures beautifully complements the coppery gold of the Indians' skin as highlighted by the fire. Although the composition is remarkably sedentary for Remington, the free handling of paint and the circular arrangement of the figures combine to give the work both freshness and strength.

Sid W. Richardson Foundation Collection. 1908. Oil on canvas. 27¼ x 30″ (76.2 x 79.2 cm.)

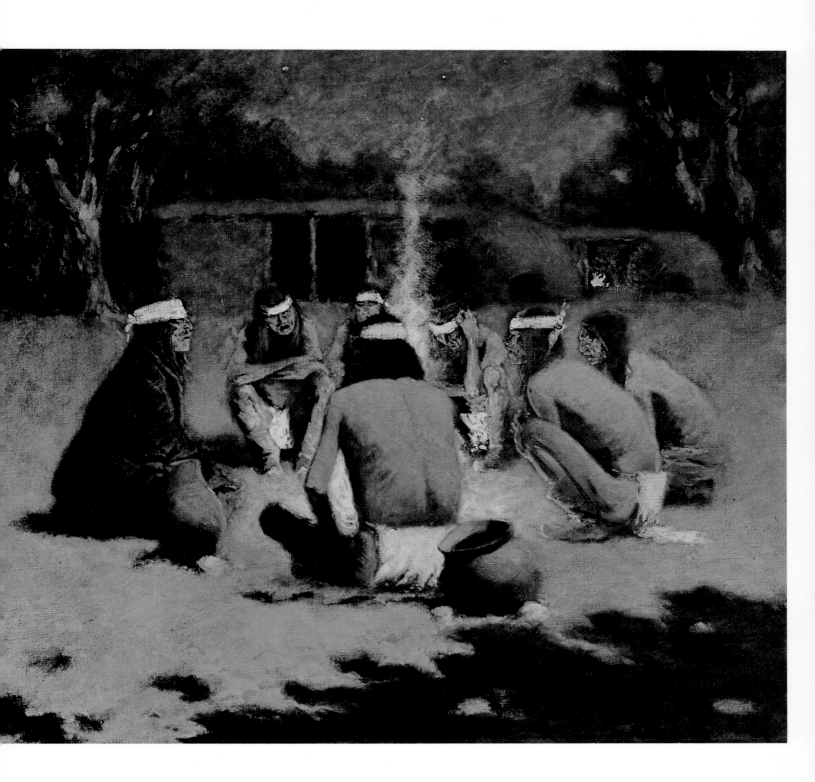

45. A Taint in the Wind

In December of 1906 Remington held his second one-man exhibition in the M. Knoedler and Company galleries. Eleven paintings represented the artist's latest Impressionist work, and several of the canvases were nocturnals, a pictorial form which had won for him increasing favor as a painter. His friend Childe Hassam, the noted American Impressionist, visited Knoedler's galleries that winter and came away very enthusiastic over Remington's progress. "I went to your show," he wrote Remington shortly thereafter, "and I think they are *all* the best things that I've seen of yours—for sure! You are sure to have lots of success with them too—Nobody else can do them." One picture in particular, *A Taint in the Wind,* caught Hassam's notice, and he continued his letter with a few critical comments about Remington's handling of paint. "I don't remember titles, but I was interested in the coach coming down the hill. The only thing to say in criticism is your stars look 'stuck on' and your foreground shadows are a bit black. Too much paint for stars, perhaps—too much pigment I mean. . . . "

Remington had success with an earlier version of a coach at night, the Amon Carter Museum's *Old Stage Coach of the Plains,* painted in 1902 (plate 37). There is a difference of four years in the dates of the two works; placed together, they provide a comparative study of Remington's development as a painter. In the later canvas, *A Taint in the Wind,* the artist has achieved a far greater degree of freedom and breadth in handling.

Sid W. Richardson Foundation Collection. 1906. Oil on canvas. 27⅜ x 40⅛″ (69.3 x 102.1 cm.)

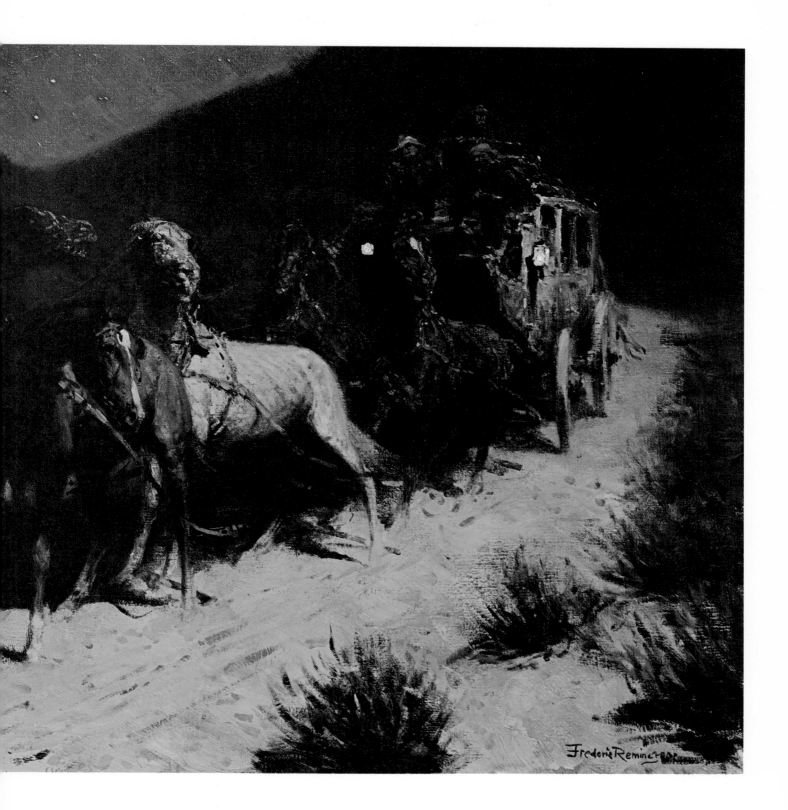

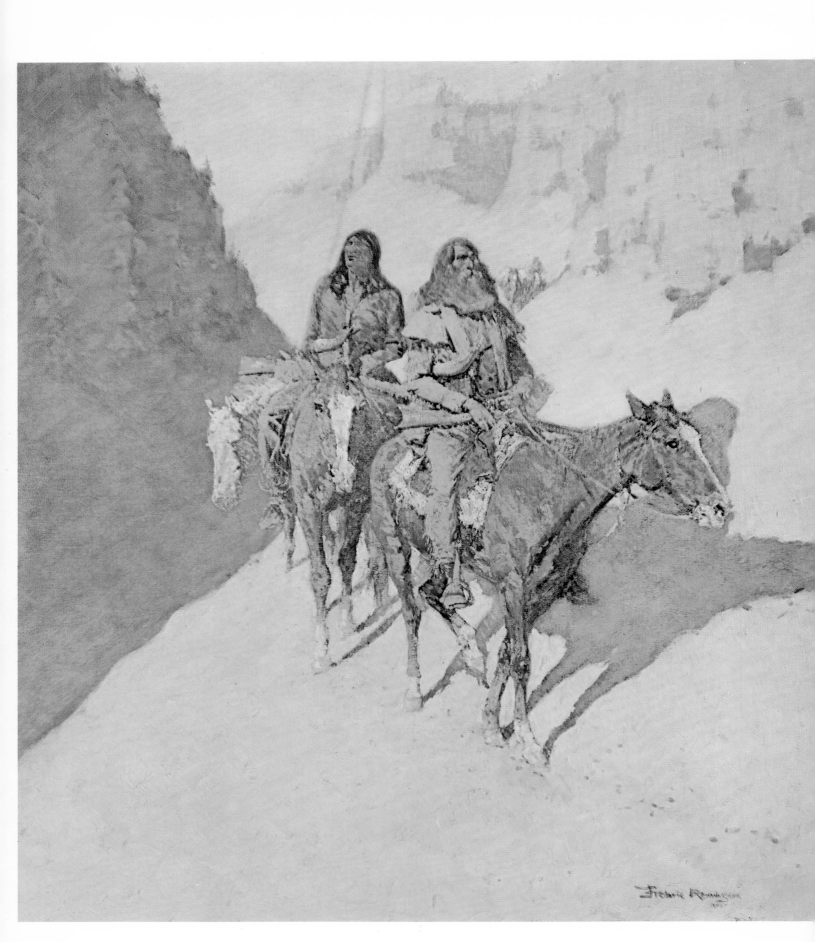

47. *The Unknown Explorers* (original version).
From the cover label for
Remington's portfolio,
Four Masterpieces in Color

1906. Oil on canvas. Dimensions unknown;
painting destroyed by the artist in 1908

46. The Unknown Explorers

As part of his *Collier's* contract a series of ten works was initiated in October of 1905 to portray the exploits of the first white men to venture into the American West. Entitled the Great Explorers, the series was published over the ensuing ten months and included renderings of such adventurers as Cabeça de Vaca, Hernando de Soto, Coronado, Radisson, La Salle, La Verendrye, Mackenzie, Lewis and Clark, Zebulon Pike, and Jedediah S. Smith. Remington capped off the esteemed procession with a final painting, *The Unknown Explorers,* which, although not numbered with the initial series, was thematically related. These anonymous characters were "bearded, grim men on horseback, skirting a mountain side . . . in the gathering darkness. They are like primitive Norse adventurers, bad men to meet in a ravine, gloomy of face, and ready for a fray."

Unfortunately, the popularity of this painting, and the explorer series as a whole, did not allay Remington's

ultimate dissatisfaction with the entire lot. It must have come as a shock to Remington's devotees to learn that the artist destroyed all but one of the eleven oils devoted to the American explorers. In one of the final entries for Remington's diary of 1908 he lists the sixteen "paintings which I burned up"; among them was the original picture of *The Unknown Explorers.*

However, the spirit of these forgotten mountain men lingered in Remington's mind well after the flames had consumed their fragile outlines on canvas. Soon he was back at his easel working on a second version. This time he lightened his palette, changing the somber blues and rusts of the first painting to aquas and honey gold. He even ennobled the explorers, offering them a more prominent role in the composition.

Sid W. Richardson Foundation Collection. 1908. Oil on canvas. 30½ x 27⅜" (76.7 x 69.4 cm.)

48. The Grass Fire

In 1908 Remington painted a group of pictures for *Collier's,* as he had done religiously for the previous five years. Two of the paintings, *The Grass Fire* and *Shot Gun Hospitality,* were begun in the spring of that year and evinced a new romantic turn in the artist's handling of light and color. Whereas in the past Remington had occupied himself with either the brilliant, fractured quality of light on the plains or the ethereal, suffused tonalities of moonlight nights, he now attempted to capture the essence of the reflected glow of fire.

Even in his first paintings of this sort, Remington proved himself a master of firelight and shadow effects. *The Grass Fire* was displayed in his 1908 exhibition at Knoedler's, and the New York papers had nothing but rave reviews claiming that Remington had finally achieved a place in the forefront of American painters.

This painting depicts a technique of offensive warfare used by Plains Indians during their long years of conflict with the encroaching whites. When the wind was sufficiently strong to ensure a sweeping blaze, the Indians would set a torch to the grassy tinder, making certain that the enemy was to leeward. They then followed the smoke, using it both as camouflage and as a device to stifle the invader. Usually set just before dawn, the fires proved "particularly effective in the open country, where the chances of surprising a watchful enemy were exceedingly small." In the painting one inquisitive Indian pony peers out at the viewer, as if asking him to release his imagination that it may enter the fiery scene and become part of the episode which is about to unfold.

1908. Oil on canvas. 27⅛ x 40⅛" (68.7 x 102.0 cm.)

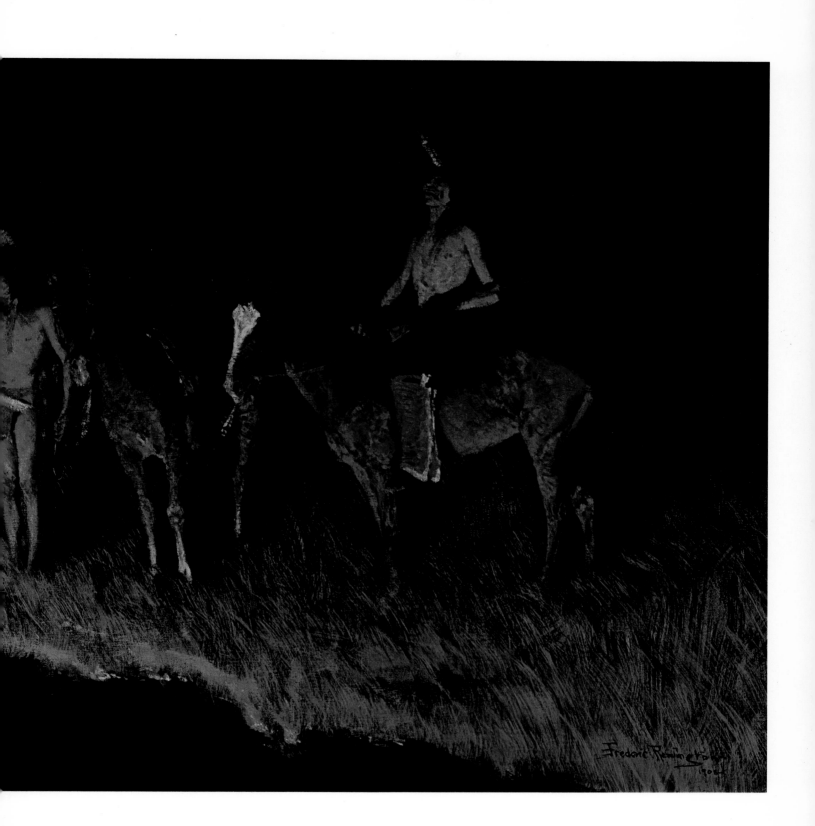

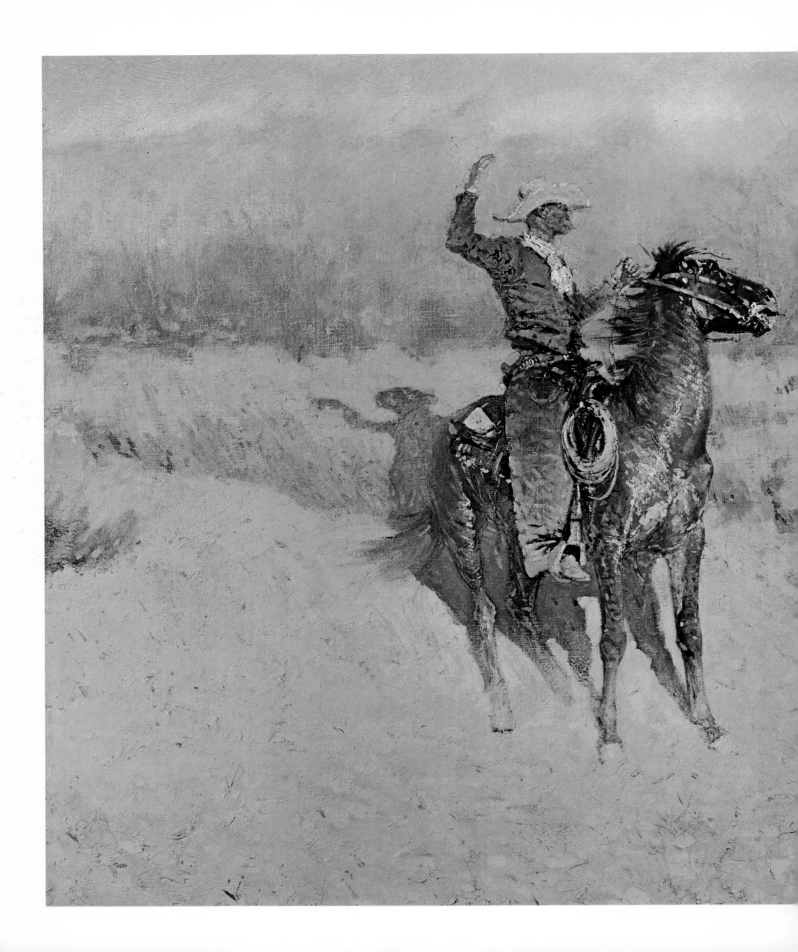

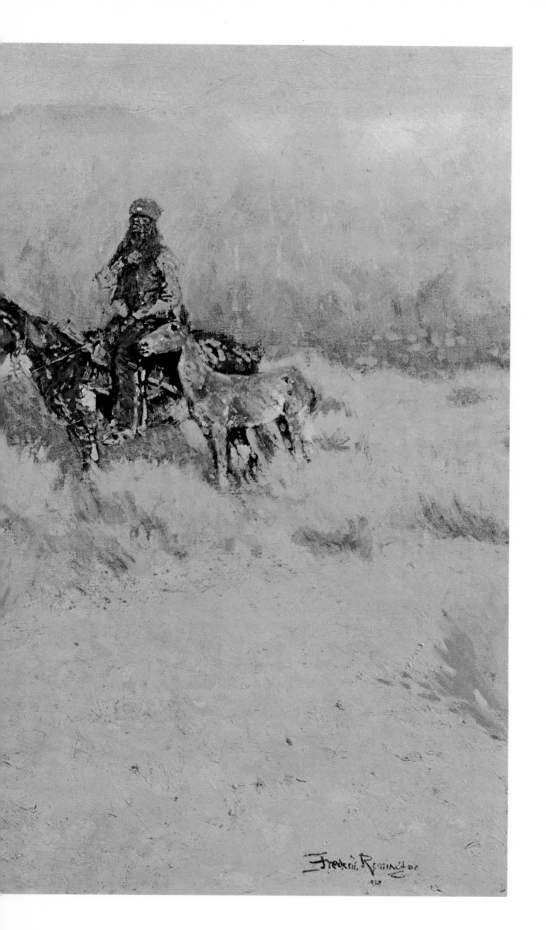

49. The Long Horn Cattle Sign

The three earliest cattle trails in the West—the Sedalia, the Chisholm, and the Western—followed a course north from the grassy prairies around the Nueces River valley of Texas to the railroads in Missouri and Kansas. Literally millions of rangy mavericks, pushed on the Long Drive by a trail boss and his weathered crew of cowboys, made the dusty trek to market along these paths. All three trails had one disadvantage in common—they crossed the Indian Territory, a checkerboard of reservations. Each reservation was the sovereign domain of a separate Indian nation with which the drover had to negotiate in order to gain permission to traverse the red man's land. The Chisholm Trail, for example, crossed the territories of no less than five Indian peoples: the Kiowa Comanche, the Chickasaw, the Sauk and Fox, the Osage, and the Pawnee.

Understandably the Indians resented the intrusions. Drovers soon learned that the price of the shortcut could be dear and that diplomacy paid off better than six-guns. One way to placate the disgruntled Indians proved to be the payment of cattle for the privilege. Remington perhaps knew of this appeasing device of cowboy politics from firsthand experience. He has depicted in this painting a trail boss, riding at some distance in advance of the main drive, "making the sign which indicates that a herd of long-horn cattle is approaching, and the Indian with the clenched fist over his heart is completing the answering sign, showing that he is willing that the herd should cross the reservation."

1908. Oil on canvas. 27⅛ x 40⅛″ (68.9 x 101.6 cm.)

50. Commemorative stamp
with detail of *The Smoke Signal*

51. *The Smoke Signal*

The Plains Indians possessed remarkable prowess in communications. They developed a code, utilizing a small number of practical devices, which enabled them to transmit messages over enormous distances. At close range, for instance, a blanket or robe might be employed to relate the movement of a buffalo herd when two or more parties were involved in the hunt. With larger expanses, of a mile or so, reflections from a mirror or polished metal blade could alert comrades to some impending danger, such as the approach of enemy forces. On clear, relatively windless days when the span to be bridged was especially great, smoke was used as a signaling device. By burning buffalo chips or prairie grass for tinder, the Indian found the billowing tele-graph practical even in terrain where the line of vision between sender and receiver was impeded by hills or treetops.

In celebration of the one-hundredth anniversary of Remington's birthday, in 1961 a commemorative stamp was issued bearing a detail from this painting (plate 50). Proceeds from the sale of the stamps went for the worthy cause of maintaining the Remington Art Museum in Ogdensburg, New York. To philatelists the four-cent stamp was important as the first in which the United States Post Office Department reproduced a work of art in full color.

1905. Oil on canvas. 30½ x 48¼″ (77.2 x 122.6 cm.)

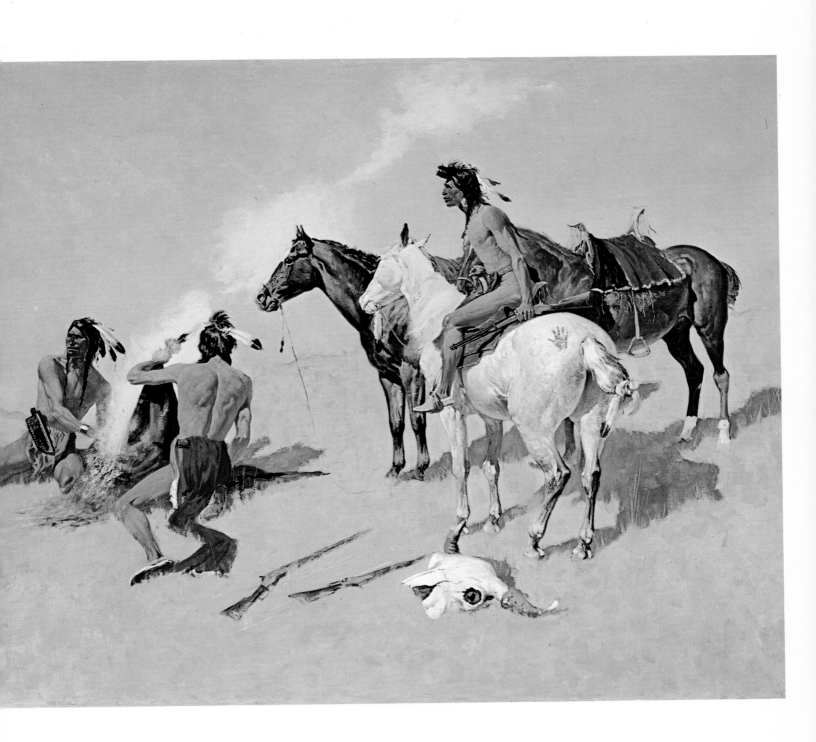

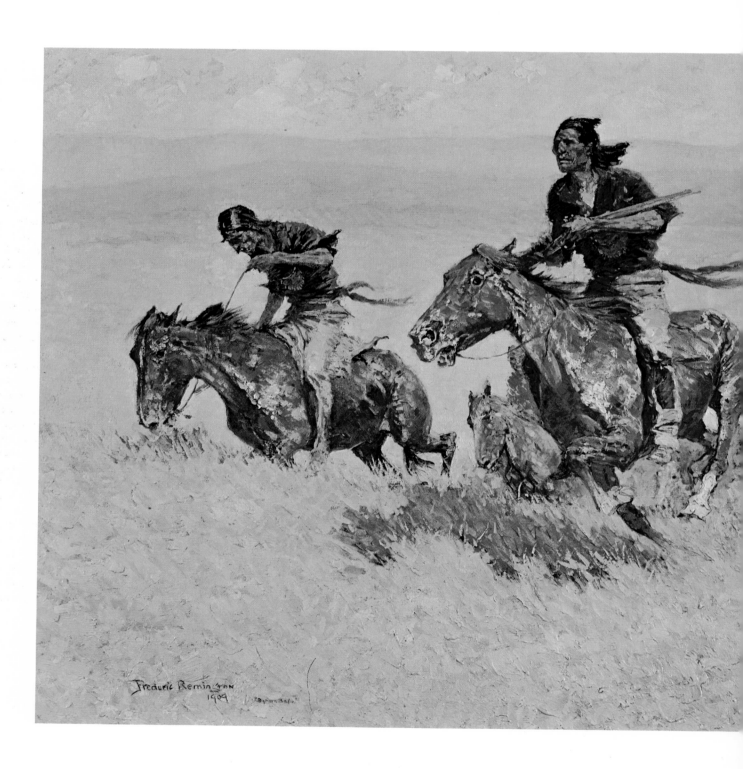

52. The Buffalo Runners, Big Horn Basin

It is difficult for an artist to know when, in any one painting, he has achieved the full realization of his hopes as a painter. The canvas, perched on the easel or hung in the gallery, is usually too close and the aesthetic aspirations too firmly a part of the artist's fiber for the painter to put either into proper perspective until some substantial amount of time has passed. But from July 6, 1909, the day Remington wrote in his diary that he had "pulled 'The Buffalo Runners' into harmony," he must have known that he had achieved a high plateau in his painting career. This truly was one of his best.

In 1909 Remington had an exhibition at Knoedler's that included *The Buffalo Runners*. In reviewing the show Gustav Kobbé discussed this painting as a zenith of the artist's puissant Impressionism. "For impetuous motion, such as Mr. Remington's admirers are accustomed to from his illustrations, it was only necessary to turn to 'Buffalo Runners, Big Horn Basin.' This showed the dash of a crowd of mounted Indians just coming over the brow of a hill, the yellow prairie rolling away in the distance. The reddish brown of the two leading horses—color notes that seemed evolved from the same growth over which the crowd was dashing forward—the buckskin trousers of the mounted braves, the red shirt of the leader, who is looking straight ahead, the greyish blue shirt of the brave next to the lead, the tension of their features, the forward leap, the sense of motion conveyed in the picture—all these things attracted, interested, and impressed the beholder."

Sid W. Richardson Foundation Collection. 1909. Oil on canvas. 30⅜ x 51⁷/₁₆" (77.1 x 30.7 cm.)

53. The Sentinel

Night has fallen, and the blue-green shades of moon-light color the shadows which move gently in the wind. A lone figure, bundled against the cold, rides slowly across an open meadow. Perhaps he is a sentinel, or perhaps, from his solemn expression, he is a luckless hunter.

Sid W. Richardson Foundation Collection. 1908. Oil on canvas. 30⅛ x 21⅛" (76.5 x 53.8 cm.)

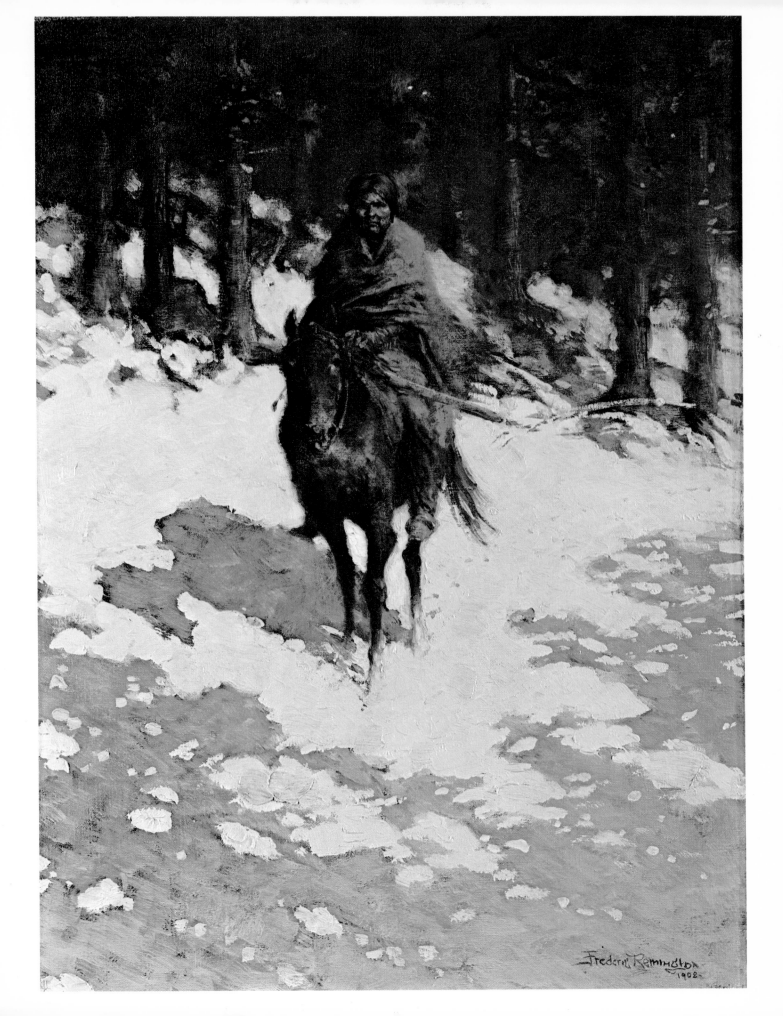

54. The Luckless Hunter

The theme of the painting is similar to one related by Remington in "The Story of the Dry Leaves." In this tale, a young Chippewa and his bride decided unwisely to remain in the old hunting grounds after their fellow tribesmen had moved on. Autumn came and persisted. It was dry, and the hunter found that the "dead leaves rattled under his moccasins." The moose and elk could not be tracked. His small family weakened with hunger. When finally the first snows fell, quieting the leaves, his wife had perished; "the dry leaves had lasted longer than she."

The artist's handling of the gray-green transparency of night air, a stylistic proclivity in his late works, became very popular. But in this canvas there was something more—an air of mystery and poetic despair. "I hardly know which is more moving in his picture of 'The Luckless Hunter,' " wrote Royal Cortissoz, "the stolidly resigned rider, huddling his blanket about him against the freezing night air, or the tired pony about which you would say there hung a hint of pathos. . . . " In the battle of man against the elements which Remington loved to portray, the human figure, though beleaguered and worn, remained focal. Remington, unlike Winslow Homer in his later paintings, placed man at the center of the composition.

Sid W. Richardson Foundation Collection. 1909. Oil on canvas. 27⅛ x 30⅛" (69.0 x 76.5 cm.)

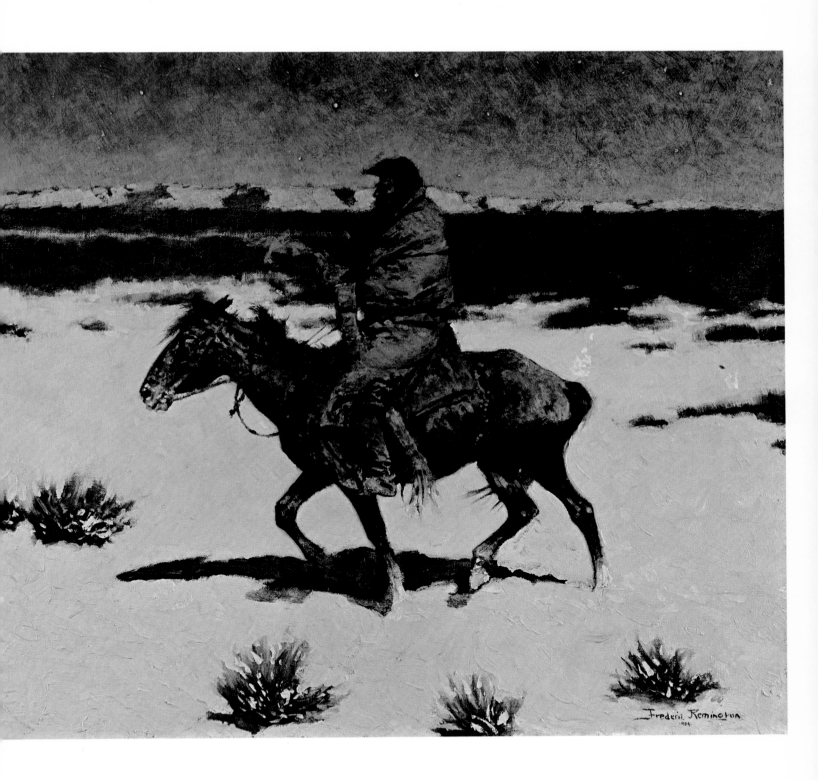

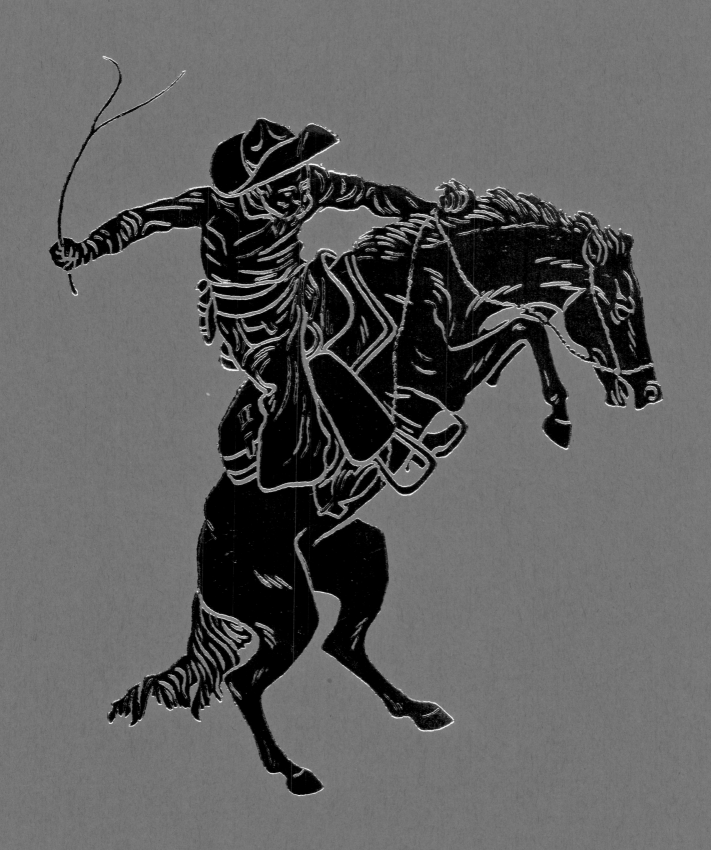

BRONZES

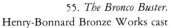

55. *The Bronco Buster.*
Henry-Bonnard Bronze Works cast

Plate 55: *The Bronco Buster.* 1895. Bronze. Height 23½″ (59.7 cm.) including artist's base measuring irregularly 1¾ x 15¼ x 7½″ (4.4 x 38.7 x 19.1 cm.). Signed on base: *Frederic Remington,* and below, in two lines: COPYRIGHTED BY *Frederic Remington.* Founder's mark: CAST BY THE HENRY-BONNARD BRONZE CO. N.Y. 1895. No. 32

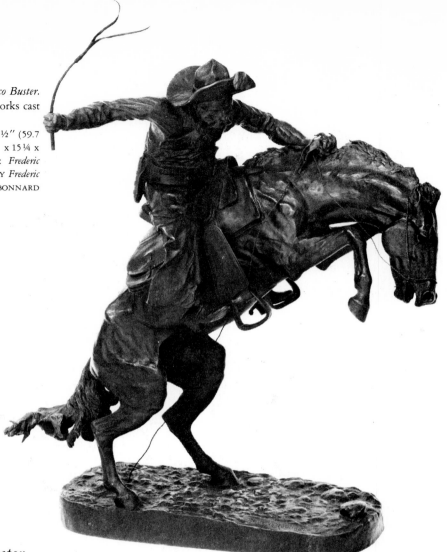

56. *The Bronco Buster* *(Roman Bronze Works cast)*

The first and most popular of Remington's bronzes was *The Bronco Buster,* conceived and executed during the summer of 1895 and copyrighted in the autumn of that year. The cowboy on a bucking horse, unique in American sculpture both because of its subject matter and its dynamic composition, won the hearts of the American public.

Sculpture was new to Remington when he produced *The Bronco Buster,* but his success with the medium was immediate. The critic Arthur Hoeber recognized that the bronze represented an important new direction for Remington and for the history of American sculpture. "Now . . . the energy and restlessness that actuated the work of Mr. Remington have found another vent, and the transition is not altogether surprising or unexpected.

Breaking away from the narrow limits and restraints of pen and ink on flat surface, Remington has stampeded, as it were, to the greater possibilities of plastic form in clay, and in a single experiment has demonstrated his ability adequately to convey his ideas in a new and more effective medium of expression."

1895. Bronze. Height 23¼″ (59.2 cm.) including artist's base measuring irregularly 1⅞ x 15⅝ x 7½″ (4.8 x 39.7 x 19.0 cm.). Signed on base: *Copyrighted Frederic Remington,* and inscribed: A'ENRICO CARUSO II COMre CELESTINO PIVA PRESID DELL'ISTITUTO ITALIANO DI BENEFICENZA NEW-YORK 18 FEBRAIO 1905. Founder's mark: Roman Bronze Works N.Y. No. 40

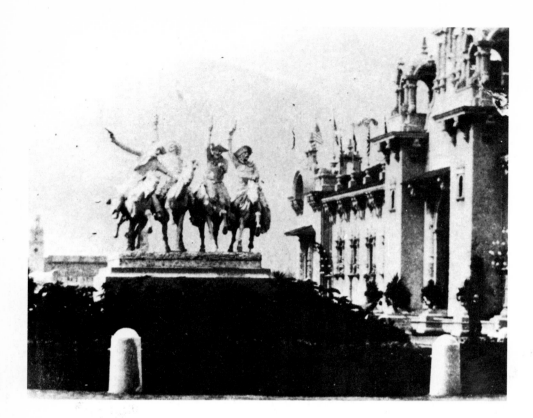

57. *Shooting Up the Town.*
Heroic-size plaster replica of *Coming Through the*
situated at the entrance to the 1905
Lewis and Clark Exposition in Portland, Oregon

58. *Coming Through the Rye*

Cowboys hoorahing the town were as much a part of the cattle-frontier legend as the lariat, the long horn, and the red bandana. In sight of an outpost of civilization, the boss had no way of restraining his men, who for weeks had drunk nothing but dust washed down a couple of times a day with the rust-colored water they called coffee.

Remington's bronze *Coming Through the Rye* pictures the opening of a well-deserved celebration. With its jubilant air, it became his most popular multifigured statue, though of necessity priced above the means of most collectors. Along with his bronze *The Mountain Man,* it was purchased by the Corcoran Gallery of Art in 1904 and represented the first work of Remington's ever procured by a museum.

In 1904 a heroic-size plaster replica of the piece was erected on the grounds of the St. Louis Exposition. A year later a similar model was installed at the entrance to the Lewis and Clark Exposition in Portland, Oregon (plate 57). They called it *Off the Trail* in St. Louis and *Shooting Up the Town* in Portland. But wherever the place or whatever its title, the sculpture struck a festive note, recalling "the days when the Saturday night frolic of the cowboys who came to town was the chief social institution of the week in border towns."

1902. Bronze. Height 30⅞" (78.4 cm.) including artist's base measuring irregularly 3 x 27¾ x 19⅛" (7.6 x 70.5 x 48.6 cm.). Signed on base: *Copyright by Frederic Remington.* Founder's mark: ROMAN BRONZE WORKS N–Y–. No. 12

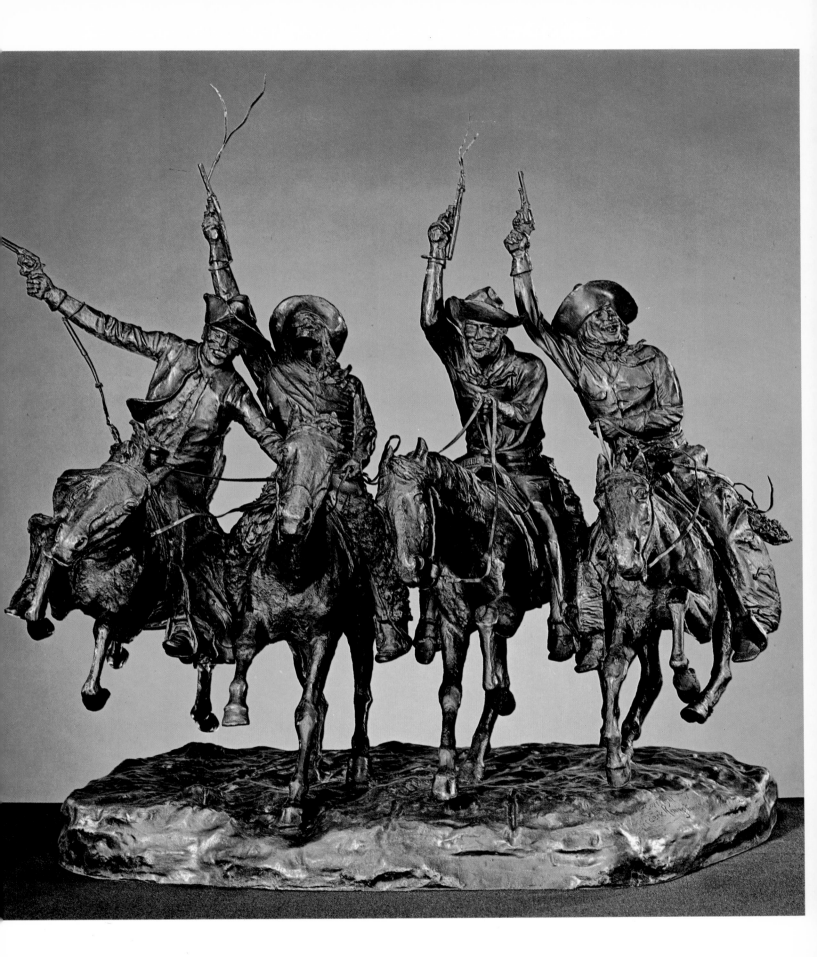

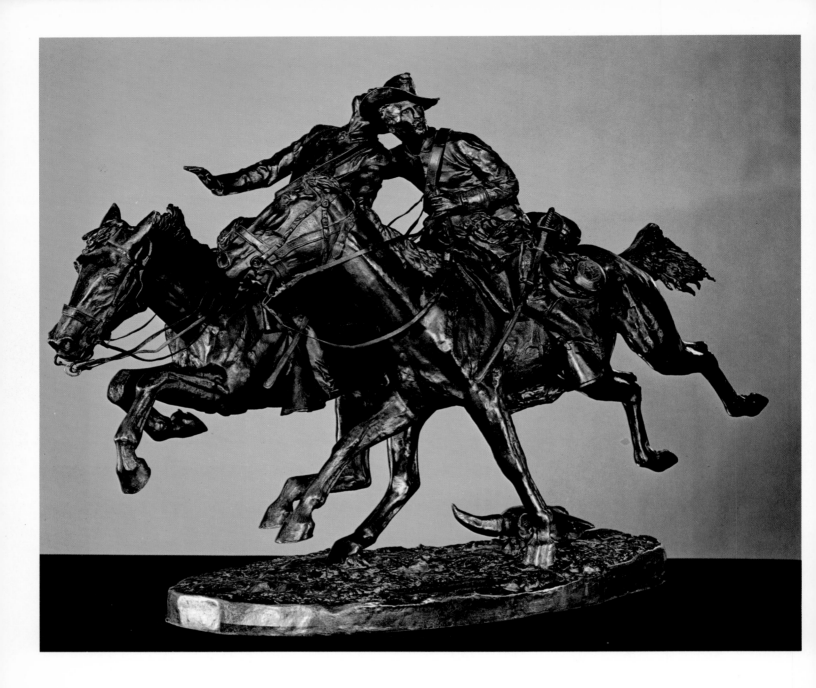

59. The Wounded Bunkie

Remington's second venture into sculpture was copyrighted less than a year after his first. Entitled *The Wounded Bunkie,* this bronze manifested the same intricate handling of form, detail, and dynamic action. But there were also some important new developments. An article in *Harper's Weekly* noted that "in his second exploit . . . into sculpture, 'The Wounded Bunkie,' Mr. Frederic Remington has chosen for his theme a tragic incident of frontier adventure which marks a distinct advance over his somewhat humorous statuette, the 'Bronco Buster'"

Technically, the second bronze also represents a substantial advance in Remington's sculpture. The two horses are supported by only one leg apiece, thus expressing the plunging motion of full gallop. Remington's contrast of live and dead weight is perfectly stated in the rendering of the two figures, and he has achieved a compositional unity unprecedented even in many of his paintings.

1896. Bronze. Height 20¼″ (51.4 cm.) including artist's base measuring irregularly 1¼ x 22½ x 11⅞″ (3.2 x 57.2 x 30.2 cm.). Signed on base: *Frederic Remington,* and *Copyrighted by Frederic Remington 1896.* Founder's mark: CAST BY THE HENRY-BONNARD CO. FOUNDERS. N.Y. 1899. No. 1

60. *The Wicked Pony*

Almost two years elapsed between the copyrighting of Remington's second and third bronzes. But the sculptor had not been idle, and in 1898 two new works made their debut, *The Wicked Pony* and *The Scalp* (plate 62). Of the two, *The Wicked Pony* is the rarer, for only ten castings were ever made. It has been asserted that this limited number is accounted for by the destruction of the original plaster model in the 1898 fire at the Henry-Bonnard foundry, but this seems questionable. Remington's bronzes went on exhibition at Knoedler's in 1905. In the catalogue for that sale, *Bronzes by Frederic Remington,* now in the Knoedler Library, *The Wicked Pony* is listed as number VI. Figures in the margin adjoining that listing indicate that one casting was on hand, one could be obtained within ten days, and

additional castings would be produced in six weeks. Quite obviously the model was still intact.

Here Remington depicts a fallen rider who in retaliation has caught hold of the pony's ear, hoping to throw the horse to the ground. According to the artist, who attested to having witnessed this confrontation, the cowboy should have left well enough alone. Shortly after this scene, the horse reportedly reacted with one of his lashing kicks, summarily ending the bronco buster's career.

1898. Bronze. Height 22″ (55.9 cm.) including artist's base measuring irregularly 1⅝ x 18¾ x 8¾″ (4.1 x 47.6 x 22.2 cm.). Signed on base: *Frederic Remington,* and *Copyrighted by Frederic Remington 1898.* Founder's mark: THE HENRY-BON-NARD BRONZE CO. FOUNDERS—NY—1898.—. No. 4

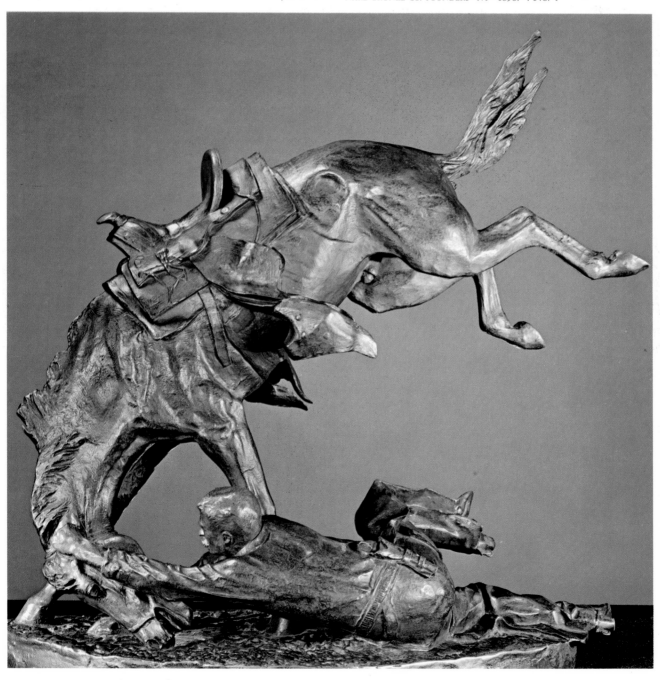

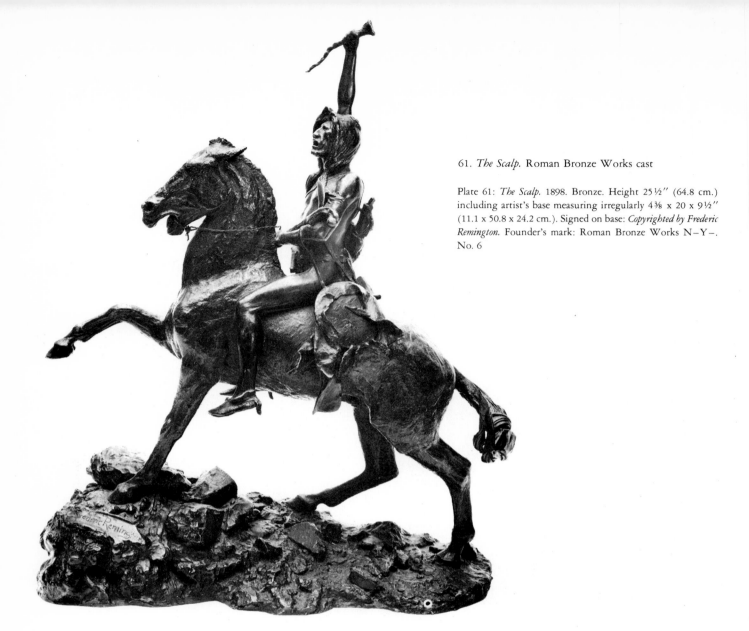

61. *The Scalp.* Roman Bronze Works cast

Plate 61: *The Scalp.* 1898. Bronze. Height 25½″ (64.8 cm.) including artist's base measuring irregularly 4⅜ x 20 x 9½″ (11.1 x 50.8 x 24.2 cm.). Signed on base: *Copyrighted by Frederic Remington.* Founder's mark: Roman Bronze Works N–Y–. No. 6

62. *The Scalp (Henry-Bonnard Bronze Company cast)*

This statue is unexpectedly stylized for Remington. The stiff, pawing gesture of the horse's foreleg and his rigidly held head and neck suggest less animated movement than the sculptor's previous figures. Charles Coffin, a critic for *Harper's Weekly,* commented that the bronze represented "a serious attempt to express a moment's energy by methods reposeful and dignified." These were terms not often used to describe Remington's work. And yet the figures embody an energy and force which

reaches a climax in the clenched fist triumphantly waving the symbol of victory.

1898. Bronze. Height 25⅞″ (65.7 cm.) including artist's base measuring irregularly 3½ x 16 x 7½″ (8.9 x 40.7 x 19.1 cm.). Signed on base: *Frederic Remington,* and *Copyrighted by Frederic Remington. 1898.* Founder's mark: THE HENRY-BONNARD BRONZE CO. FOUNDERS. N-Y. 1899. No. 10

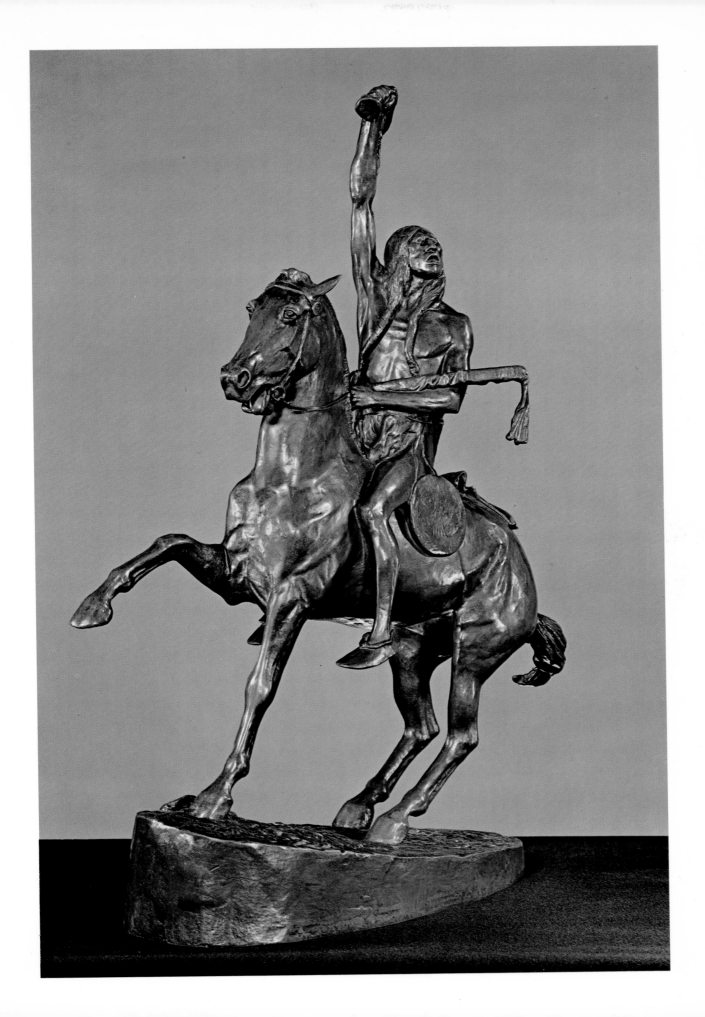

63. The Cheyenne

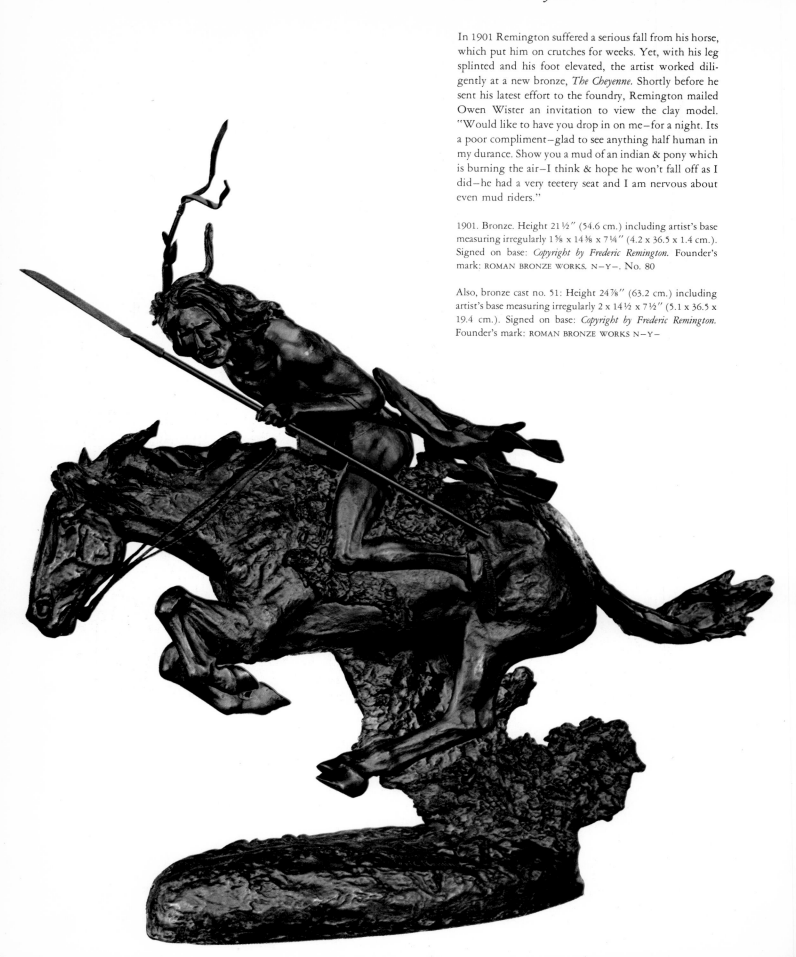

In 1901 Remington suffered a serious fall from his horse, which put him on crutches for weeks. Yet, with his leg splinted and his foot elevated, the artist worked diligently at a new bronze, *The Cheyenne.* Shortly before he sent his latest effort to the foundry, Remington mailed Owen Wister an invitation to view the clay model. "Would like to have you drop in on me—for a night. Its a poor compliment—glad to see anything half human in my durance. Show you a mud of an indian & pony which is burning the air—I think & hope he won't fall off as I did—he had a very teetery seat and I am nervous about even mud riders."

1901. Bronze. Height 21½″ (54.6 cm.) including artist's base measuring irregularly 1⅝ x 14⅜ x 7¼″ (4.2 x 36.5 x 1.4 cm.). Signed on base: *Copyright by Frederic Remington.* Founder's mark: ROMAN BRONZE WORKS. N–Y–. No. 80

Also, bronze cast no. 51: Height 24⅞″ (63.2 cm.) including artist's base measuring irregularly 2 x 14½ x 7½″ (5.1 x 36.5 x 19.4 cm.). Signed on base: *Copyright by Frederic Remington.* Founder's mark: ROMAN BRONZE WORKS N–Y–

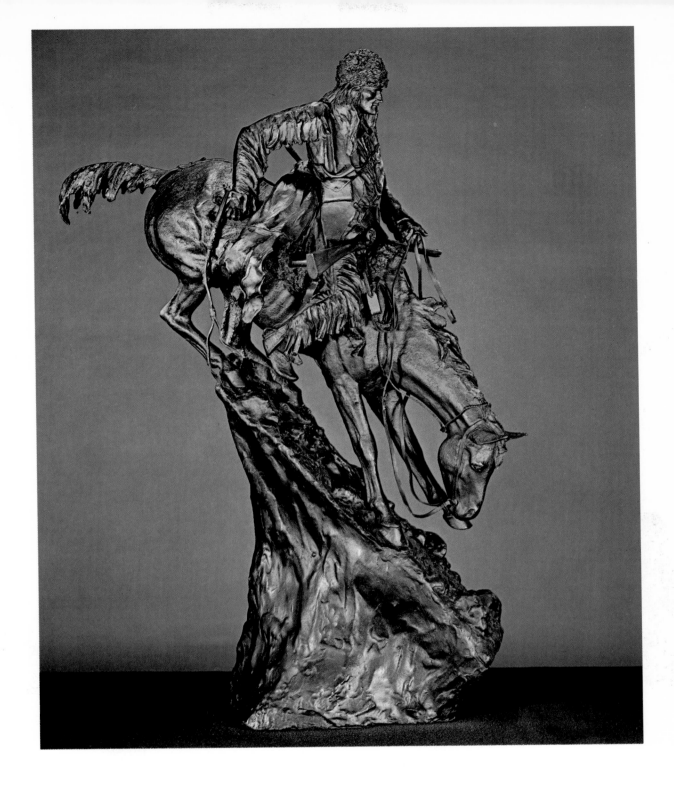

64. The Mountain Man

In 1903 Remington supervised the casting of a bronze which portrayed one of his most revered Western types, the fur trapper. The following year he wrote to F. B. McGuire, Director of the Corcoran Gallery of Art, who was responsible for adding that sculpture to the museum's collection: "The Mountain Man I intend as one of those old Iriquois [*sic*] trappers who followed the Fur Companies in the Rocky Mountains in the '30 & 40'ties

[*sic*]." It is a masterly depiction of balance, surefootedness, and accurate detailing of costume.

1903. Bronze. Height 28⅞" (73.4 cm.) including artist's base measuring irregularly 15⅝ x 12¼ x 11" (39.7 x 31.2 x 28.0 cm.). Signed on base: *Copyright by Frederic Remington.* Founder's mark: ROMAN BRONZE WORKS N‑Y‑. No. 34

65. *The Old Dragoons of 1850*

Remington could catch the drama of battle in bronze as well as in paint. The twisting of contours, stretching of muscles, and headlong plunges of horses were perfect subjects to be depicted three-dimensionally. In sculpture the artist could mass groups of figures without losing the individuality of any one. Each figure embodies its own expression of action, and as the viewer moves around the bronze, the figures take life.

This is especially true of the large bronze Remington copyrighted in December of 1905, *The Old Dragoons of 1850*. Because of the size and complexity of the work, probably fewer than ten castings were ever made.

1905. Bronze. Height 25⅜″ (64.5 cm.) including artist's base measuring irregularly 6 x 4¼ x 17½″ (15.3 x 107.3 x 44.4 cm.). Signed on side of base: *Copyright by Frederic Remington*. Founder's mark: ROMAN BRONZE WORKS N.Y. No. 5

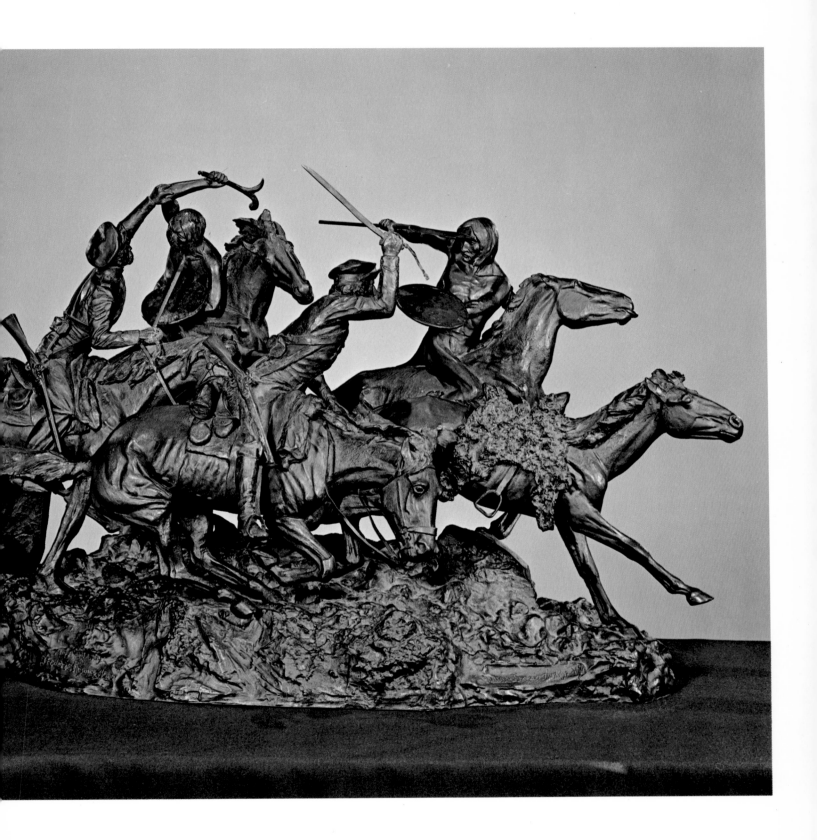

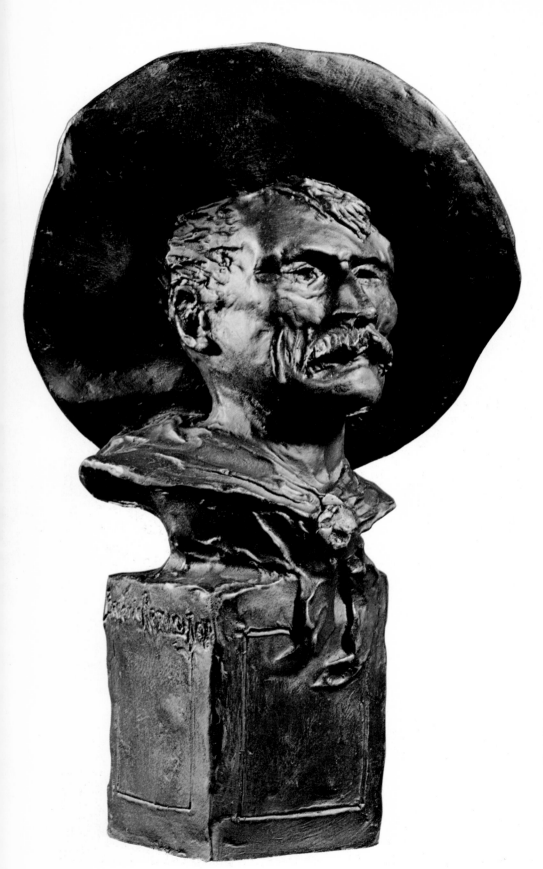

66. The Sergeant

The smallest of Remington's works in bronze, *The Sergeant* stands less than eleven inches high and three inches wide at the base. Yet this bust of a tough, sharp-nosed sergeant in the service of Roosevelt's Rough Riders transcends its small physical dimensions with a boldly conceived form, making it visually as large as anything Remington ever sculptured.

1904. Bronze. Height 10⅛″ (25.7 cm.) including artist's base measuring 3⅜ x 2¾ x 2⅝″ (8.6 x 7.0 x 6.7 cm.). Signed on side of base: *Frederic Remington.* No cast number

67. The Rattlesnake ▶

The Rattlesnake (sometimes referred to as *The Snake in the Path*) is Remington's most graceful, sculptural rendition of the bucking horse in motion. The powerful thrust of the frightened horse and the desperate counterbalancing of the rider are expressed with a vigorous sweep and flow that make this bronze both eloquent and powerful. All movement and attention focus on a central point. All lines within the swirling configuration are directed toward one thing, the inconspicuous but deadly rattler in the foreground.

1905. Bronze. Height 23⅞″ (60.6 cm.) including artist's base measuring irregularly 2¾ x 17⅛ x 11¼″ (7.0 x 43.4 x 28.6 cm.). Signed on base: *Copyright by Frederic Remington.* Founder's mark: ROMAN BRONZE WORKS NY. No. 41

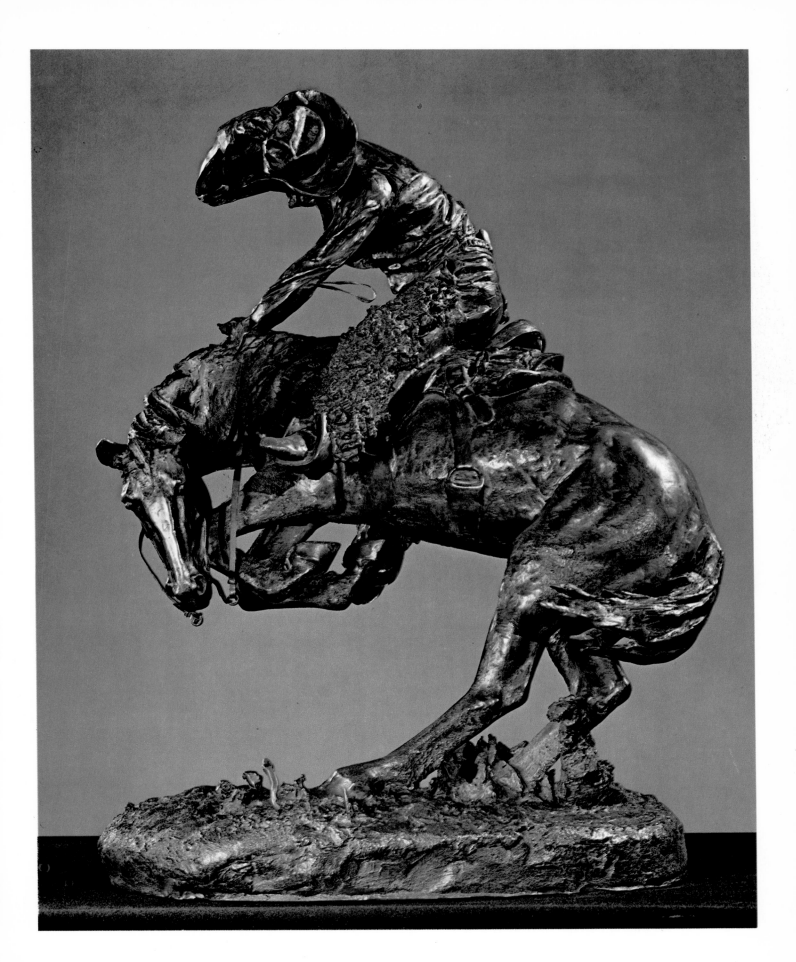

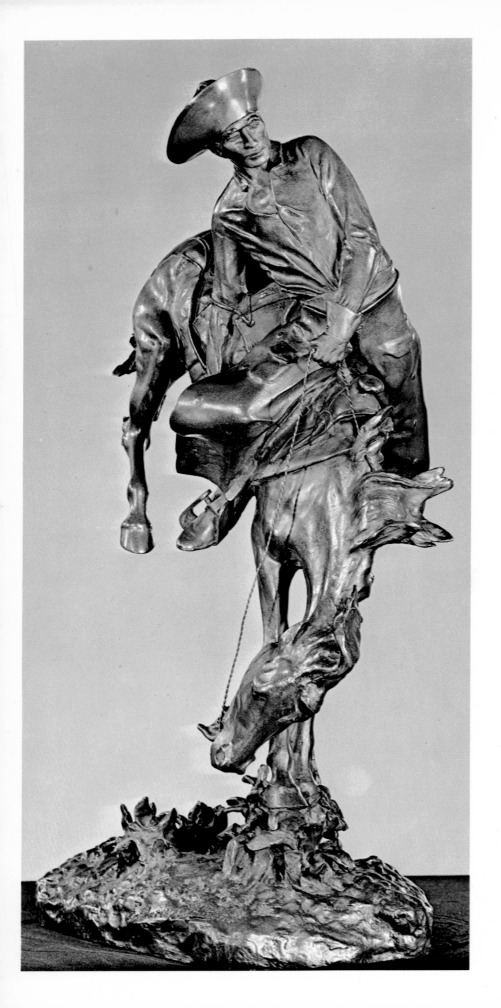

68. The Outlaw

Riding a bronco requires extraordinary physical balance and mental composure. This cowboy demonstrates both, and Remington's able handling has given the figures credibility and life.

The bronze, copyrighted in May of 1906, was a technical tour de force. The horse was almost entirely balanced on one foot. Bertelli used to complain that Remington, in his search for realistic interpretation, wanted his mounts posed with all four feet off the ground. This was a simple enough order when the artist dealt with two-dimensional representations on canvas. In sculpture, such inclinations were impossible in compositions with only one figure. *The Outlaw*, however, came as close to Remington's goal as was physically possible while still maintaining structural soundness.

1906. Bronze. Height 22¾″ (57.8 cm.) including artist's base measuring irregularly 2½ x 13½ x 7⅞″ (6.3 x 34.2 x 20.0 cm.). Signed on base: *Copyright by Frederic Remington.* Founder's mark: ROMAN BRONZE WORKS N.Y. No cast number

69. The Savage ▶

This study of physiognomy is indicative of Remington's general conception of the red man. The deeply set, enigmatic eyes and the snarling mouth with its bitterly upturned lips suggest all the qualities of savagery and defiance with which Remington characterized the Indian. Yet somewhere under the sneering facade lies a nobility which the artist also understood as part of the image he portrayed. *The Savage* symbolizes both Remington's man with the "bark on" and the Indian's inherent pride and resolve.

1908. Bronze. Height 10¾″ (27.3 cm.) including artist's base measuring 3¾ x 4¼ x 4⅛″ (9.5 x 10.8 x 10.5 cm.). Signed on base: FREDERIC REMINGTON 1908, and *Copyright Frederic Remington.* Founder's mark: ROMAN BRONZE WORKS NY. No.

12

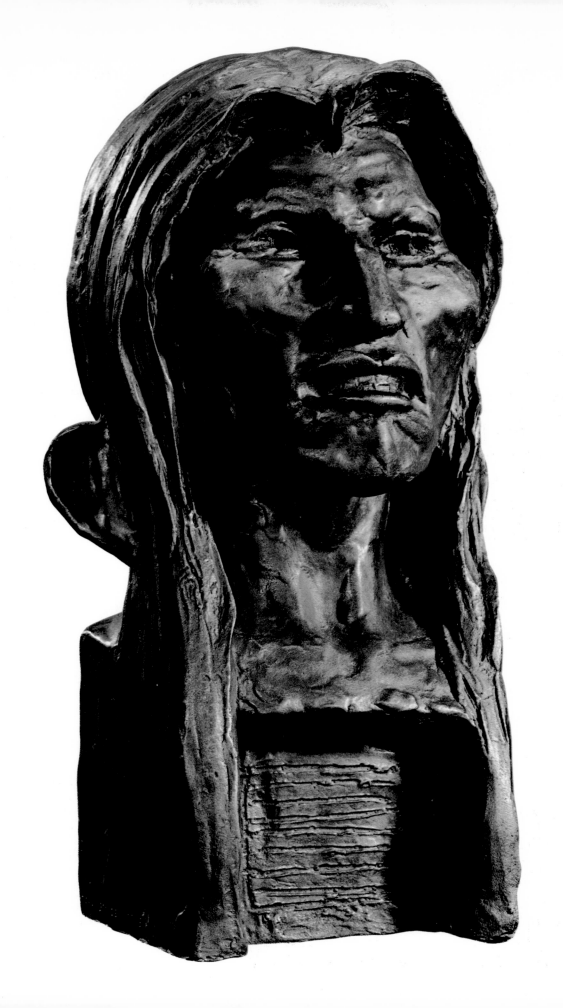

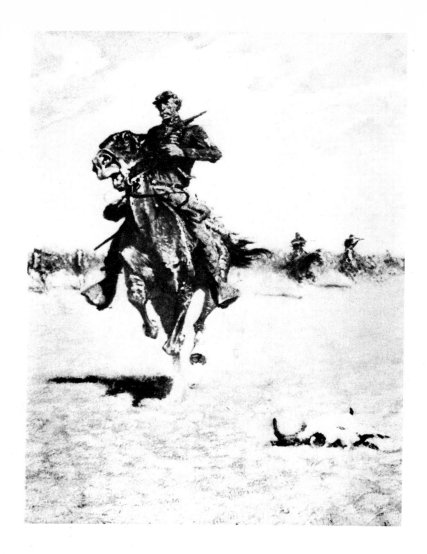

70. *A Stampede* (detail).
1908. Oil on canvas. 57 x 45".
Courtesy of The Detroit Club, Detroit

71. *Trooper of the Plains, 1868*

Being a cavalry trooper on the plains in the 1860s required stamina, horsemanship, and self-reliance. Remington had ridden among their ranks and knew of what he spoke when he described the trooper on horseback. "His heroism is called duty, and it probably is. On the long march it is his task to nerve his tired muscles and keep in place. It is his duty to eat the scanty fare and perchance to carry off a vicious bullet wound or be buried in the sands of Mexico."

This bronze was copyrighted in January of 1909, less than a year before Remington's untimely death. He adapted the figure from a painting he had done the previous year, *A Stampede* (plate 70). It is interesting to compare the treatment of the two in different mediums and to realize that Remington was able to render a more vigorous portrayal in paint than in bronze.

1909. Bronze. Height 26¼" (66.7 cm.) including artist's base measuring irregularly 2 x 19¾ x 8" (5.1 x 50.2 x 20.3 cm.). Signed on base: *Copyright by Frederic Remington.* Founder's mark: ROMAN BRONZE WORKS N–Y–. No. 11

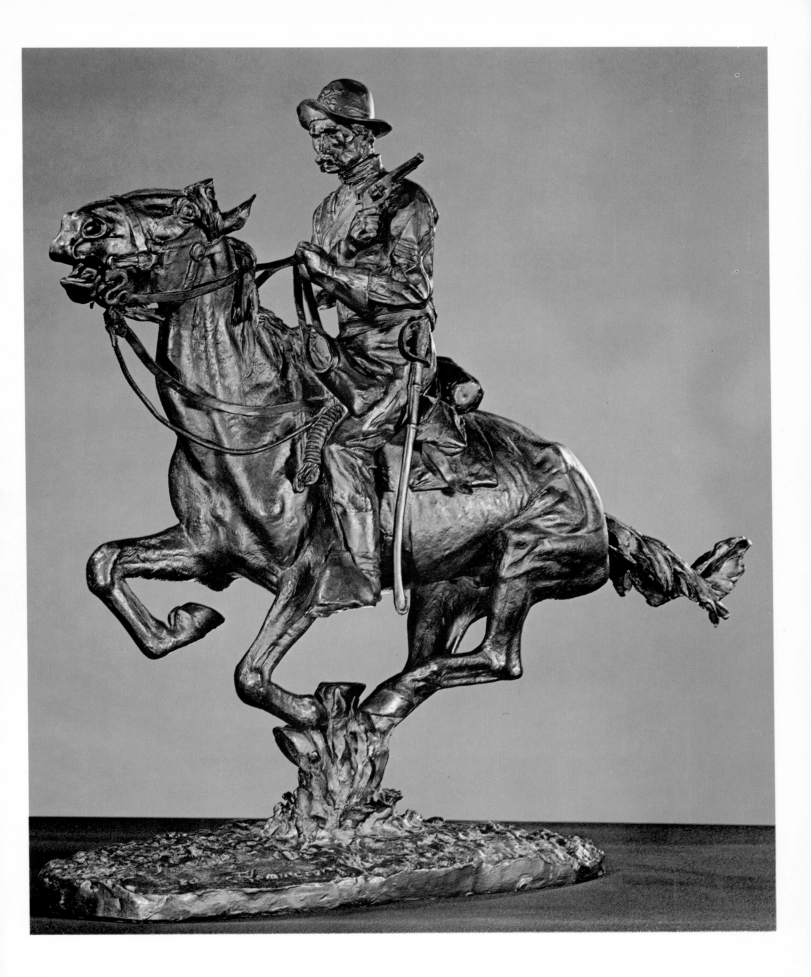

72. *The Bronco Buster*
(large version)

Such success had Remington achieved with his initial casting of *The Bronco Buster* that in 1909 he decided to produce a second version about half again as large as the first. As work progressed he wrote Bertelli that "this size lends itself to my hand much better than the smaller." When he finished the model, he enthusiastically scribbled off a note to the foundry.

Say Bertelli
 You ought to see the 1½ Bronco Buster—It will make your eyes hang out on your shirt.

Get ready to retire the small one—mind you.

Only about twenty castings of this large variation were made. Despite Remington's hopes, the earlier bronze remained the more popular of the two.

1909. Bronze. Height 32½" (82.5 cm.) including artist's base measuring irregularly 1½ x 18 x 13⅝" (3.8 x 45.7 x 34.9 cm.). Signed on base: *Copyright by Frederic Remington.* Founder's mark: ROMAN BRONZE WORKS N.Y. No. 16

73. *The Stampede (overleaf)*

The sweep of a stampeding herd carries a helpless cowboy and his pony on a desperate ride. Should the horse stumble or tire, he and his rider will surely perish in the pounding surge.
 The Stampede was the last piece of sculpture Remington attempted. Apparently he completed the model

before his death, but no castings were made during his lifetime.

1910. Bronze. Height 22⅜" (57.5 cm.) including artist's base measuring irregularly 4 x 44⅝ x 14¾" (10.2 x 113.3 x 37.5 cm.). Signed on base: *No 5 Copyright Frederic Remington.* Founder's mark: ROMAN BRONZE WORKS. No. 5

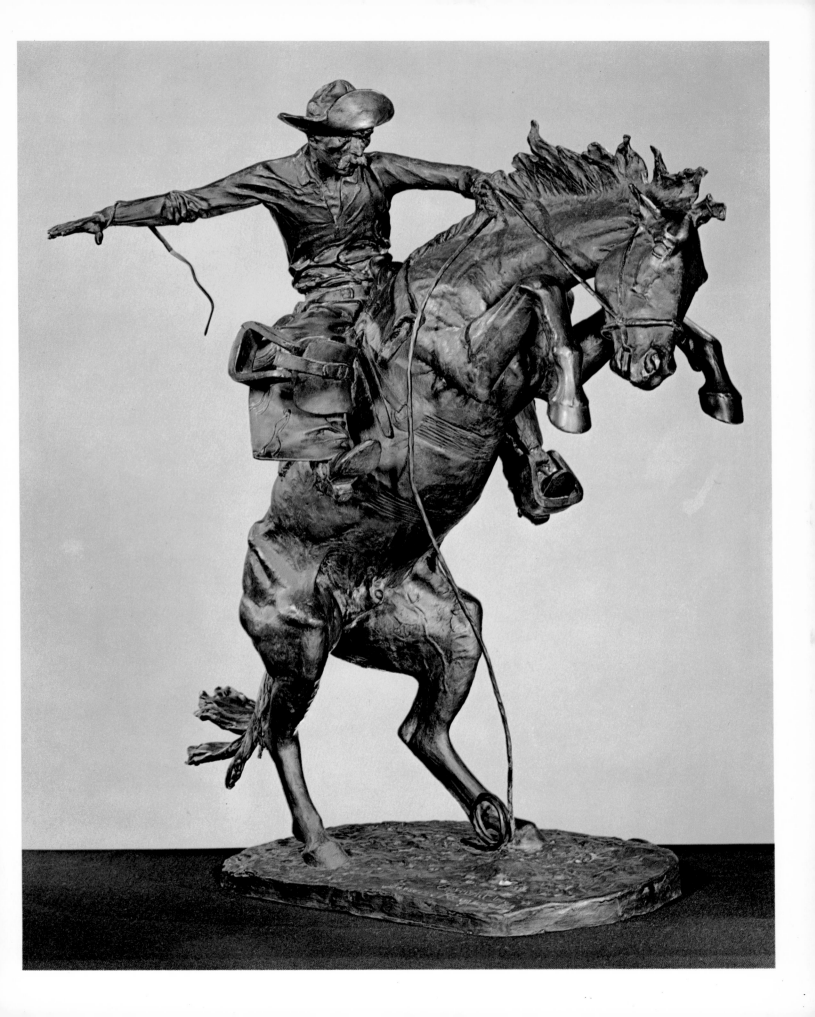

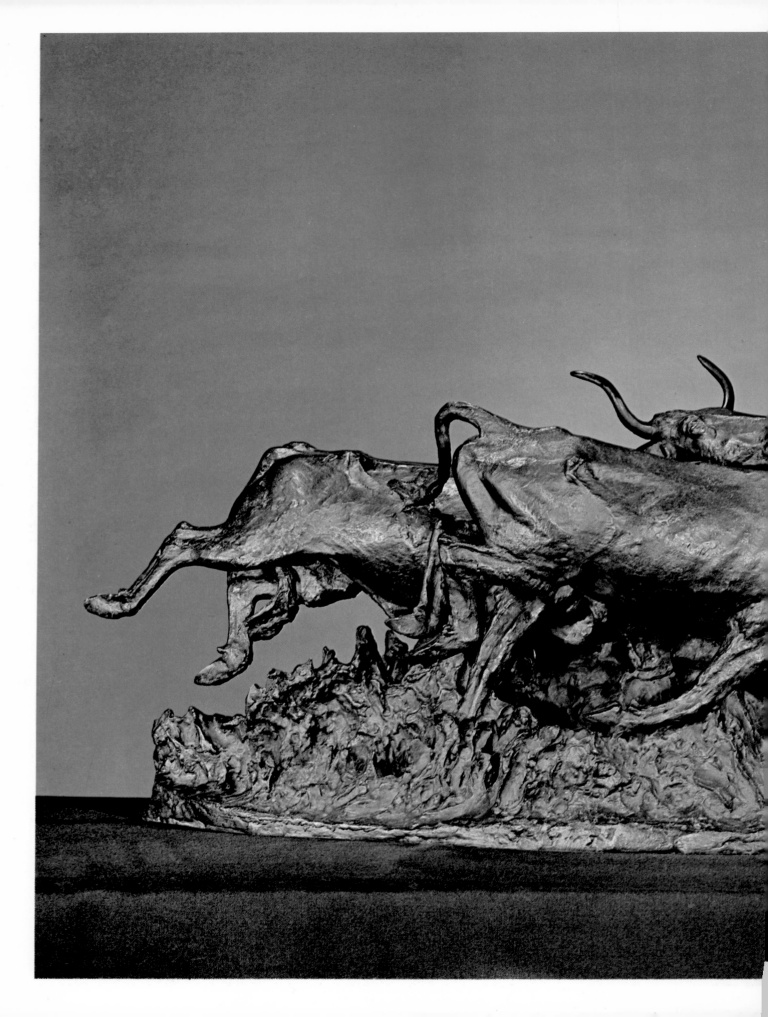

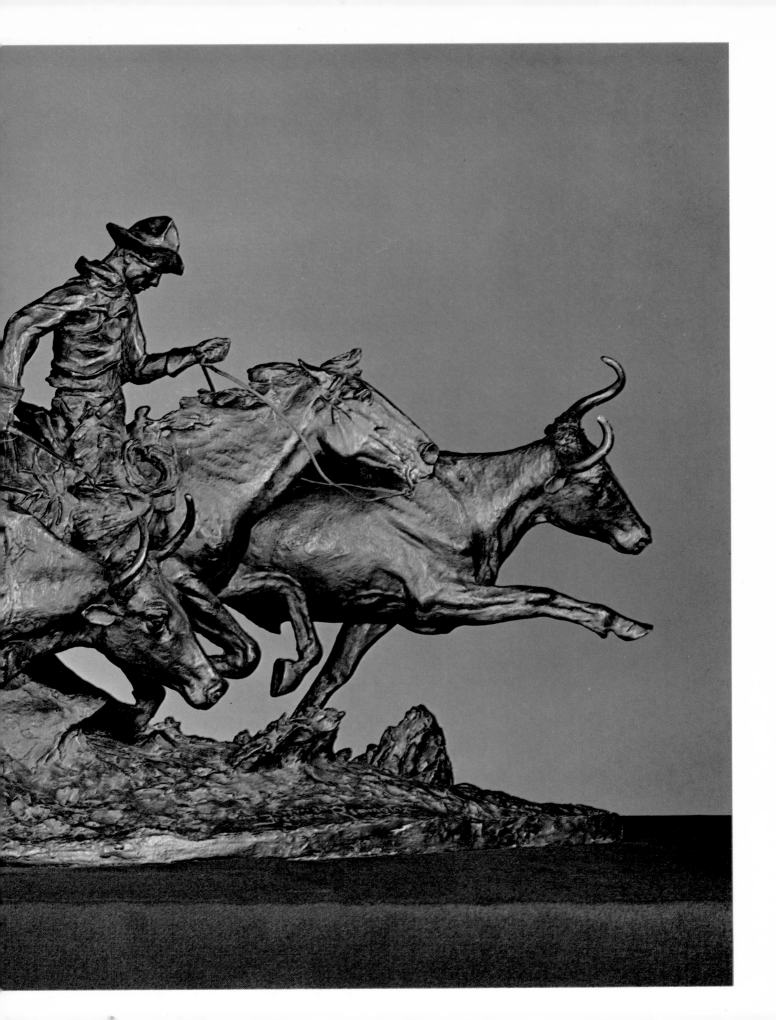

LIST OF ILLUSTRATIONS

Colorplates are indicated by asterisks (*).